AIR PHOTOGRAPHY AND ARCHAEOLOGY

AIR PHOTOGRAPHY AND ARCHAEOLOGY

D.N. Riley

upp

University of Pennsylvania Press
Philadelphia

First published in the United States 1987
by the University of Pennsylvania Press, Philadelphia

ISBN 0-8122-8087-3

First published in Great Britian 1987 by
Gerald Duckworth & Co. Ltd.
The Old Piano Factory
43 Gloucester Crescent, London NW1

© 1987 by D.N. Riley

Library of Congress Cataloging in Publication Data

Riley, D. N. (Derrick N.)
Air photography and archaeology.

Bibliography: p.
Includes index.
1. Aerial photography in archaeology.
I. Title.
CC76.4.R55 1987 930.1 87-13768
ISBN 0-8122-8087-3

Contents

Preface

Many years ago, during my service in the Royal Air Force, I met and had a long conversation with Dr O.G.S. Crawford, who did so much to further the use of air photography in archaeology. In a letter, he later said that he hoped I would write a book one day. That remark was the origin of this general book on the subject, but the day has been long delayed and the book has been easier to plan than to produce. It would have been impossible to write it successfully without the help of many people, and I now have great pleasure in thanking them.

I must first mention W.G. Edwards and J. Pickering, who helped me to re-start air photography after a long break in my flying career. Financial aid, first from Kodak Ltd and then for a number of years from the Department of the Environment, later enabled me to fly systematically, and the photographic help of the National Monuments Record's Air Photograph unit, directed by J.N. Hampton, ensured that the results were well recorded. Professor P.J. Fowler discussed the outline of the book, which was then helped on its way by Professor K. Branigan. During the lengthy process of writing it, R. Palmer was a major source of advice and encouragement. The chapters on flying, photography and mapping benefited from the advice of W. Mills, G. Warburton and W.K. Kilford respectively. Dr P.J. Curran advised on remote sensing. In the later chapters, information was given about the Mucking excavations by M.U. Jones and about ancient land use by H.C. Bowen and Dr W.M. Bray. Dr G. Webster, G.S. Maxwell and R. Goodburn gave advice on the Roman sites in Britain and Dr D.L. Kennedy about those in the Middle East. Help has come from R. Agache in France, C. Léva in Belgium, Oberstleutnant O. Braasch in West Germany, Dr J.A. Brongers in the Netherlands, Professor M. Evenari and Dr T. Levy in Israel, and J.I. Ebert and Dr J. Grady in the USA. Although this list is long, it could be greatly extended, and my debt to all those who have so kindly and patiently helped me, including my wife, is considerable.

The illustrations are a very important part of the book, and I am therefore grateful to the individuals and institutions mentioned below for permission to reproduce photographs and drawings. In all cases copyright is reserved.

Aerial Archaeology Publications, Fig. 18. R. Agache, Service des Fouilles, Figs 16, 101, 102. Air Photograph Archives, Topographical Service, Delft, Fig. 85. Ashmolean Museum, Oxford, Figs 3, 57, 75. Oberstleutnant O. Braasch, Figs 12, 17, 19. Cambridge University Committee for Aerial Photography, Fig. 67. T.J.W. Gates, Fig. 64. R.H. Hardwick, Fig. 49. Professor M. Evenari and the Harvard University Press, Figs 5 and 83. Institute of Archaeology, University of London, Figs 4, 52, 91, 94. Ministry of Defence (Crown copyright), Figs 63, 84. South-West Cultural Resources Center, National Park Service, US Department of the Interior, Figs 39, 48. Royal Commission on Historical Monuments (England) (Crown copyright), Figs 1, 8, 86, 87. Royal Commission on the Ancient and Historical Monuments of Scotland, Fig. 98. C. Stanley, Figs 20, 24. Survey of Israel, Fig. 93.

D.N.R.

Introduction

I sometimes think that never blows so red
The Rose as where some buried Caesar bled;
That every Hyacinth the Garden wears
Dropt in its Lap from some once lovely Head.

E. Fitzgerald's translation
of the Rubáiyát of Omar
Khayyáam, verse 18

From the lofty viewpoint of the aeroplane the land surface below can be seen from a distance and at a steep angle. Much is visible and easily appreciated that an observer on the ground may find hard to understand or even to detect. Archaeologists make use of the aerial view to find and record previously unknown remains of the work of early man, and to examine structures which can be seen only in part on the ground, but are visible as a whole from above. Systematic aerial reconnaissance and photography is the main source of information, but it is also possible to use aerial surveys made for other purposes if they happen to record archaeological sites.

Early remains have now been recorded from the air in a very large number of places, and great collections of photographs have been accumulated. Knowledge of the past has thereby been enlarged in many ways, but more use could be made of the information if both its scope and its limitations were better appreciated. Three points are worthy of special attention. The first is the sheer bulk of the material that aerial survey produces. The second is the need always to take into account the influence of local conditions on the discoveries made in a given area. The third is that these discoveries must be seen not only as individual 'sites', but also as contributions to the study of the whole landscape inhabited by early man.

The purpose of this book is to outline the relatively simple procedures that are normally followed in archaeological surveys from the air and to discuss the significance of some of the results. The earlier chapters are mainly concerned with method. They deal with subjects such as flying and photography, which are of direct importance only to a limited number of people, but are also of interest to those who use the photographs and need to understand the constraints that affect the work of the aviator. The later chapters, which are concerned with results, deal with archaeology from the viewpoint of the air photographer. They are intended more to emphasise the potential of aerial exploration and describe the effects of various factors that influence the results, than to discuss the archaeology of the various sites. It would have been interesting to include chapters on related subjects, such as methods of remote sensing other than photography, and the integration of air photography with methods of ground survey, such as geophysical testing or field walking. This has not been done, however, because the former have at present few direct archaeological applications, and the latter would better be the subject of another book.

My flying experience has been in Great Britain, and this book is therefore mainly based on British conditions. However, various examples of work in other countries have also been included. Aerial exploration and photography have the potential to make important contributions to archaeology in many more countries, provided that the methods used are adapted, if necessary, to local conditions.

9

1
Historical Background

The present state of the subject and the limited areas so far surveyed will best be appreciated if we take a brief look at the work done so far. What follows is less an account of the photographers and their discoveries, something which has already been written about (Crawford, 1954; Schorr, 1974; Downey, forthcoming), than an examination of the stages through which research has passed in various countries.

A few very early archaeological air photographs are known, but as a technique of value to archaeology, air photography first developed in the latter part of the First World War, when the recording and mapping of enemy positions were matters of the highest priority. The first archaeological results were records of ruined towns and cities, which could hardly have been missed by an interested person flying over them. In 1917 some photography was done by German military aviators in Sinai on the instructions of Dr T. Weigand. The excellent pictures taken then (Crawford, 1954, plate 5) have been followed in recent years by much more extensive surveys by the Israelis, from which Fig. 93 has been chosen. In the same year, a British officer, Lt. Col. G.A. Beazeley, became interested in early remains in Iraq, including the vast ruins of the city of Samarra and the canals shown in Fig. 82. Among those who read the reports he later wrote (Beazeley, 1919 and 1920) was the archaeological explorer Sir Aurel Stein, who realised how much more he would have achieved had an aircraft been available during his journeys in Chinese Turkestan before the war (Stein, 1919). The opportunities in Central Asia have never been followed up, but Stein was later able to fly in the Middle East.

Archaeological work from the air really began in the 1920s with the researches of Dr O.G.S. Crawford in England and Père A. Poidebard in Syria, then under French administration. For a long time neither man was aware of the activities of the other, but the methods they evolved were very similar and provided the basis from which most subsequent work has evolved. Both realised the great value of the aeroplane for reconnaissance, the advantages of shadows thrown by low sunlight to emphasise inconspicuous structures, and the aid given by vegetation at certain times of the year in revealing buried remains. They also had in common the importance they evidently gave to field work on the ground and their attention to prompt publication of results (e.g. Crawford, 1924; Crawford and Keiller, 1928; Poidebard, 1934; Mouterde and Poidebard, 1945). The large plate cameras then in use ensured that the photographs taken by these pioneers were of a good standard of definition (Fig. 1). They are valuable records, as many of the sites have since been damaged.

Poidebard's explorations in Syria were mainly concerned with the Roman Empire's eastern frontier, which extended over a vast territory (Fig. 2). He flew in French military aircraft and received much official support. A similar pioneering investigation was later made in Jordan and northern Iraq in 1938-9 by Sir Aurel Stein, who was also given government support and was granted the services of a Royal Air Force detachment consisting of aircraft, pilot and ground crew. Sir Aurel Stein died in 1943, leaving a report of his work which has recently been published (Gregory and Kennedy, 1985). The results of a contemporary American campaign of air reconnaissance in Iran were issued in a large volume (Schmidt, 1940) with many splendid illustrations. Since then, the Second World War and subsequent political upheavals have put a stop to further archaeological work in the air in the Middle East, except in the small country of Israel.

In England, after the First World War, the possibilities offered by a less restrictive situation were taken up by Crawford, who had the advantage of previous flying experience as a navigator in the Royal

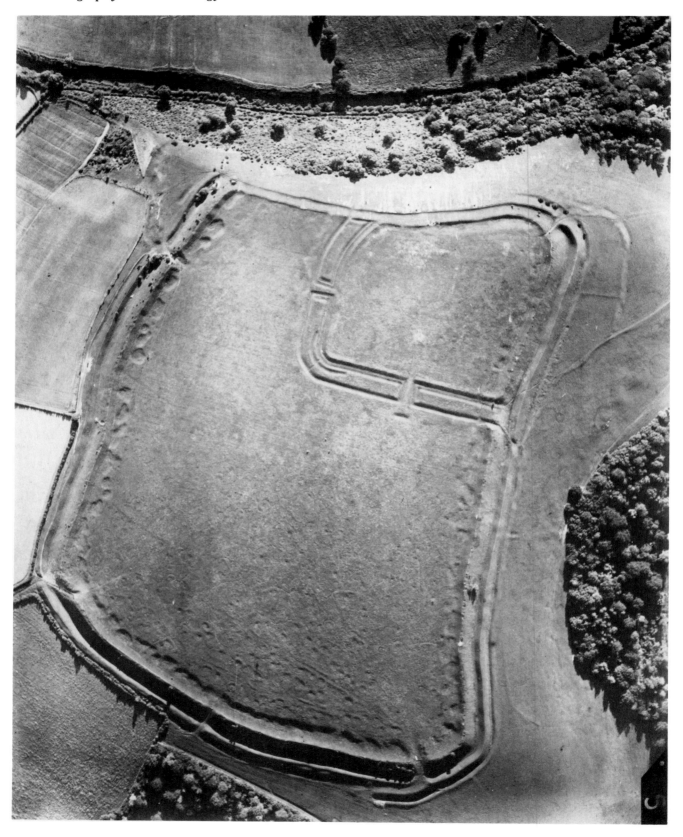

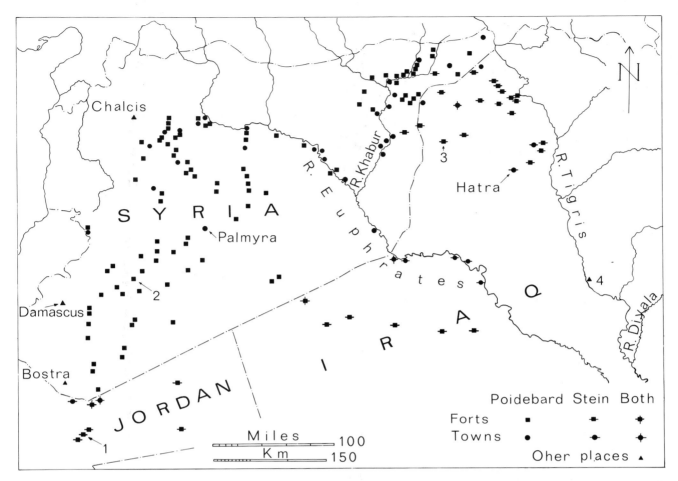

2. The work of Père A. Poidebard and Sir Aurel Stein in the Middle East. The symbols show sites illustrated or mapped in their books and a few others. 1 – Azraq, 2 – Han al Manqoura, 3 – Tell al Ghail, 4 – Samarra.

Flying Corps. His mapping of sites seen on Royal Air Force photographs (Crawford, 1924) was much in advance of his time, and his classic campaign of photography in Wessex (Crawford and Keiller, 1928) aroused general interest, which in 1933 provided the impetus for Major G.W.G. Allen to begin work in the Oxford region. Allen's investigations produced revolutionary results, the most important of which was the demonstration of the frequency of previously unknown archaeological sites shown by marks in growing crops on farm land. Many of his photographs depict sites which have since been destroyed by gravel

1. Hod Hill, Stourpaine, Dorset. Within the Iron Age hill fort a Roman fort was erected during the conquest period. The ramparts and ditches of both forts are shown well by shadows and highlights. In the foreground the slight remains of many Iron Age structures can be seen. The *titulum* protecting one gate of the Roman fort is very clear, but that outside the other gate is almost invisible because of the direction of the sunlight. This fine photograph is plate 1 of *Wessex from the Air* by O.G.S. Crawford and A. Keiller, who took it at 7 p.m. on 14 July 1924.

pits, roads, housing, ploughing and many other causes. Allen had no previous archaeological experience, but, flying his own light aircraft, he stole a march on those who had. He began what may be described as the primary phase of aerial investigation in England, in which great numbers of discoveries were made at unexpected places, e.g. the site shown in Fig. 3. Later, general patterns began to emerge, such as the frequency of early remains shown by marks in crops (usually termed crop marks) growing on soils above gravels in river valleys. Unfortunately, Allen's untimely death in 1940 brought his work to an end. He left unfinished a short book, which was later edited both by O.G.S. Crawford and J.S.P. Bradford, but has only recently been published (Allen, 1984).

The Second World War, like the First, caused a

13

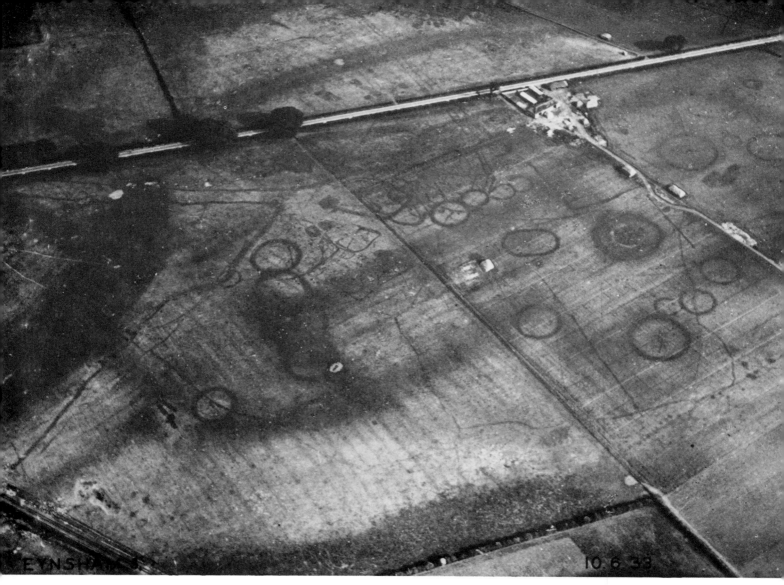

3. Foxley Farm, Eynsham, Oxfordshire. Marks in cereal crops in the fields on the right and in grass on the left show numerous ring ditches of Bronze Age type in the foreground, and behind them the enclosures and lanes of a settlement, probably of Iron Age or Romano-British date. On the right, one of the ring ditches has a dark centre, caused by the remains of a barrow. Near it is an ovate, and to the left in the grass field are indistinct marks of a second ovate, which is shown much better by a later photograph, taken when the field was under cereals (Fig. 24). Grass marks also show medieval ridge and furrow. Photograph by Major G.W.G. Allen, 10 June 1933.

great increase in aerial activity. During army service in Italy, Bradford was presented with many opportunities while working on the interpretation of air photographs. The enormous number of photographs of Europe taken for intelligence purposes by the Royal Air Force have since been found generally rather disappointing archaeologically, but for parts of some Mediterranean countries the reverse is true.

Bradford made important discoveries in Italy and Yugoslavia (Fig. 84), which he later published (Bradford, 1957). After the end of hostilities, but before the British forces had left Italy, he was able to fly and take photographs of the very extensive crop marks found in parts of Apulia. It thus became clear that in Italy aerial exploration could produce results as important as those that had already become known in England. However, Italy is another country in which aerial research has been limited by restrictive controls on air photography.

In England, during the war, I spent about two years as a flying instructor at airfields near Oxford, and was able almost every day to view archaeological sites of the kinds discovered by Allen. Observations of crop marks made at the time (Riley, 1946, 5) have helped me greatly while writing parts of Chapter 2 of this book.

After the Second World War, the work of Professor J.K. St Joseph showed the full possibilities of aerial exploration for archaeology. His appointment as Curator in Aerial Photography and later as Professor in Aerial Photographic Studies at Cambridge University established the first professional post in the subject, and his flying campaigns in all parts of the British Isles and some areas of Northern Europe resulted in a great archive of photographs. Much of his work can be regarded as a continuation of the primary recording begun by Allen, but on a far larger scale. Many of his photographs showed previously unknown sites and confirmed the remarkable amount of information that could be recorded by systematic programmes of aerial survey in a country with a long history of human occupation.

With the growth of private and commercial flying in Great Britain from the 1960s onwards, it has become relatively easy for local archaeologists to mount campaigns of primary exploration and photography in their own regions, and work of this type has resulted in the discovery of further large numbers of ancient sites. There is much to be said for locally-based specialists, who are fully informed on the detailed topography and archaeology of their regions and can operate economically by keeping flying time to a minimum. Their photographs were, however, difficult for others to consult until the establishment of an archive in London by the Air Photographs Unit of the National Monuments Record, where photographs by English local aviators are filed and available for study. The archive also holds a very large number of photographs taken by a team led by J.N. Hampton, until recently head of the Unit, in a series of campaigns conducted on behalf of the Royal Commission on Historical Monuments (England). There is a parallel archive in Edinburgh held by the Royal Commission on Ancient and Historical Monuments (Scotland), which includes the important recent results of G.S. Maxwell. The total number of archaeological photographs in the archives at Cambridge, London and Edinburgh exceeds one million.

Before the Second World War, Great Britain was the only European country in which there was active interest in archaeological air photography. This has now changed; there is considerable activity in several countries, of which France is probably the most important. French work after the war began in North Africa, with the recording of Roman military and civil sites in Algeria by Col. J. Baradez (Baradez, 1949) and the mapping of the Roman system of land division by centuriation which covers so much territory in Tunisia (Caillemer and Chevallier, 1954). Political changes in North Africa, as in the Middle East, have brought archaeological air survey to a halt there, but since 1960 remarkable results have been achieved in France itself. In this large country, local specialists operating in various regions have been responsible for campaigns of primary exploration, flying in light aircraft and recording sites by oblique photography in a very similar manner to their British colleagues. The results of R. Agache in North-Eastern France have been particularly notable for the great number of large Gallo-Roman villas that he found (e.g. Figs 101 and 102) and for the prompt publication of much of his work (e.g. Agache, 1970, 1978; Agache and Bréart, 1975).

There has been a similar sequence of events in West Germany since 1960, an impression of which may be obtained from publications dealing with the Rhineland (Scollar, 1965) and Bavaria (Christlein and Braasch, 1982). Aerial exploration has also taken place in Belgium, the Netherlands and Switzerland. It is interesting to note that the underwater remains recently photographed from the air in the Lake of Neuchatel in Switzerland were first recorded by good quality aerial photographs as early as 1927 (Egloff, 1981). In all the countries of Western Europe where aerial reconnaissance and photography have been possible, it is clear that the primary campaigns have produced an 'information explosion'. We can be certain that the same would result if similar flying took place in the countries of Eastern Europe. The possibilities of the Danube basin in Roumania, for example, are suggested by the rare glimpses of that country from the air given by photographs taken in 1918 near Constanza by German aviators (Crawford, 1954, plate 6) and others of recent date which show sites west of Bucharest (Cătăniciu, 1981).

Air photographs are records of special value, not least in the numerous cases where they show sites that have since been damaged. However, much of the information they contain cannot be fully understood until it has been drawn on maps. This is particularly the case with oblique photographs. Maps are the best way to show the results on large areas, and thus do justice to the very extensive surveys that have been made from the air.

Mapping of the results in England, like exploration and photography, has proceeded in stages. The pioneer maps of the 'Celtic' fields on large areas of land in Wessex, published by Crawford in 1924, have already been mentioned, but until the 1970s there were few maps of areas rather than sites, in spite of the numbers of photographs that had by then accumulated. The first important mapping project at that time was for the valley of the Warwickshire Avon (Webster and Hobley, 1965). It was based on photographs by A. Baker and J. Pickering, who had made many discoveries in the Midlands. This was followed by the mapping of the great zone of Romano-British occupation in the Fenland of Cambridgeshire, Lincolnshire and Norfolk (Phillips, 1970) and of the crop marks on the Thames gravels from Windsor upstream to Cirencester, 100 km to the west (Benson and Miles, 1974; Gates, 1975; Leech, 1977). The Fenland maps were published at the scale of 1/25,000 and the Thames Valley maps at from 1/17,000 to 1/20,000 approximately, which is too small for details on complex sites to show well, but they gave for the first time a general view of the large amount of information that had been recorded in those particular areas of England. This was a great advance. Many other parts of the country have since been mapped at 1/10,000 or similar scales by county archaeological units.

The Fenland investigation supplied a great deal of information on early land use, about which air photographs are particularly valuable sources of information. Other studies of the early landscape in parts of North Nottinghamshire and South Yorkshire (Riley, 1980a), and part of Hampshire centred on the hill fort of Danebury (Palmer, 1984) have since been published.

There are still quite large areas of Great Britain that have yet to be properly explored from the air, or are still in the primary stages of exploration. However, in many areas it is possible to proceed to a second, problem-based stage, in which work is directed towards adding detail to established frameworks and solving problems. These two stages are mainly a feature of the investigation of crop marks, which cannot be recorded quickly.

In North America, the sites of mounds at Cahokia, Illinois, were photographed from the air as early as 1921, though little new information appears to have been obtained (Fowler, 1977). Since then there has been only limited work on aerial exploration of archaeological sites. The vast size of the continent and its much less intensive use in early times compared to the Old World has militated against the development of aerial work on the same lines as in Europe. Valuable results in the investigation of an early road system have, however, been obtained using vertical photography in the Chaco Canyon area of New Mexico. Elsewhere, the examination of verticals taken for other purposes has brought to light the huge earthworks at Poverty Point, Louisiana (Deuel, 1971, 227). Marks in crops on archaeological sites have very seldom been reported. They may, however, await discovery, e.g. on the sites of Indian villages, of the kind which is shown as an earthwork on Fig. 48, but which in other places must have been levelled by agriculture.

The most interesting aspect of air photography in the United States has been in the investigation of the natural environment in relation to early settlement, e.g. work in Colorado (see below, p.78) and Alaska (Ebert et al., 1980) and some of that reported in the volume edited by E.Z. Vogt (1974). Investigations of this kind have given work in America a different emphasis from that in Europe, where so much less remains of the original vegetation.

In Central and South America, the remains of the pre-Hispanic civilisations can often be profitably explored from the air. Earlier work on them has been described by Deuel (1971, 169-222), and recent investigations of the remains of early agriculture (see below, p.113) indicate how much is still to be done. As in other parts of the world, research on early fields and land boundaries is particularly dependent on aerial exploration.

This chapter has described the gradual extension of aerial investigation. The need for a medium for the publication of articles on the subject has been met by the journal *Aerial Archaeology*, edited by D.A. Edwards. Annual volumes have appeared since 1977, a sign of the growth of this field of research.

2
How Sites Show

The archaeological photographer sees a wide range of subjects to record from the air. They range from old towns and large earthworks, which are prominent in the landscape, to less conspicuous earthworks and ruins, to the traces of ancient work which appear only under certain conditions. All are important, but the special field of archaeological air photography lies in the inconspicuous remains and those that are visible only from the air. A good knowledge of the ways in which such sites show is essential both when planning flying campaigns and in searching for sites during a flight. Furthermore, in order to appreciate the evidence fully, those who use air photographs must understand the means by which the early remains that they are studying have been made visible.

The sites described in this chapter are of two general types: sites on which there are standing remains and sites that have been levelled by agriculture. The former, which are also visible on the ground (either easily or with difficulty), are best investigated by a combined operation of air photography and field work on the ground. The latter, which include many sites shown by vegetation, can normally be seen only from the air and present many problems, making aerial investigation necessarily a separate preliminary stage, which should be largely complete before field work and excavation begin. In this chapter vegetation marks on cultivated land, known as 'crop marks', are described in more detail than the other phenomena because of their complexity.

Low earthworks and patterns of stones

Photographs of large standing earthworks and ruins are valuable records, which make it easier to appreciate their nature, but such sites are usually already known to archaeologists, and the more specialised applications of the aerial view concern low earthworks and remains of walls, which are difficult to find on the ground but easily seen from the air under the right conditions. They show up in various ways. Where the colour of the surface is relatively uniform, as on grass-covered earthworks, the shadows thrown by low sunlight provide most information. In arid regions where there is little vegetation, the differences of colour between the stones of ancient ruins and their surroundings may stand out when seen from above. Under certain conditions low earthworks may also be revealed by snow and frost effects, by differences of vegetation and by partial flooding of the land around them.

Colour differences

On arid land with little plant cover, the colour of the surface provides the most important, though not the only, means by which ancient structures may be detected. The walls shown in Fig. 4 are different in colour from the material around them, and they are recorded very clearly by differences of tone on the black-and-white photograph. The banks and piles of stones seen in Fig. 5 similarly show well because of the quantity of flint fragments they contain; though elsewhere in the same region, on land with a surface of limestone debris, uniform in colour, shadows were found more useful when photographing the early remains. In countries where there is more vegetation, ruined walls may still stay bare at some sites, and show because of the differences between the rocks of which they are made and the grass growing around.

Differences in the colour of the soil in barren areas may also indicate former excavations, e.g. the old canals and waterways shown diagrammatically in Fig. 82.

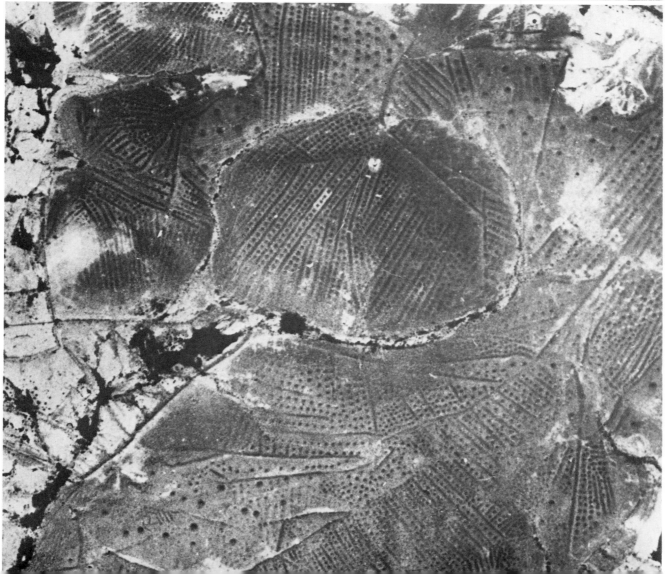

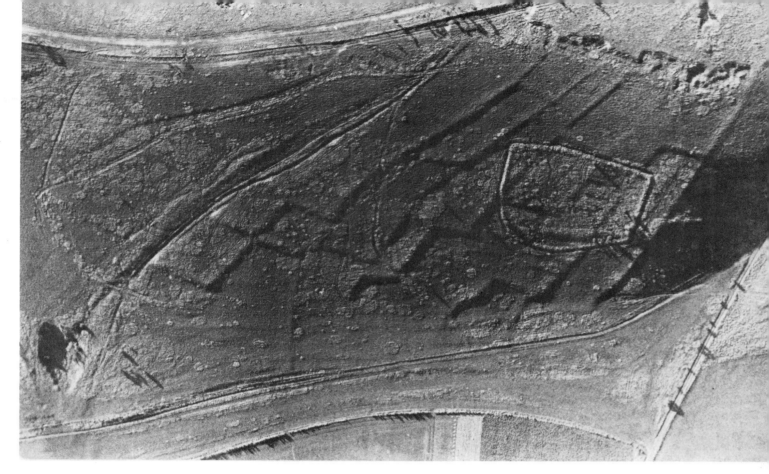

Shadows and highlights

Earthworks shown by shadows were recorded from the early days of air photography, and were termed 'shadow sites' by Crawford (Fig. 1). Even where there are colour differences, shadows may help to emphasise features on the ground (Fig. 52). Dark shadows are the principal source of information (Fig. 6), but they are also complemented by highlights, i.e. by light reflected from slopes facing the sun. On some south-facing hillsides, earthworks may be shown by highlights alone (Fig. 7), though not with much contrast.

4. (*left above*) Masada, Israel. Three of the eight temporary camps and part of the wall of circumvallation built by the Roman army besieging the Jewish fortress of Masada in AD 71-2. The stone walls of the camps stand on bare rocky ground, on which the very sparse vegetation is shown by dark spots. Photograph by the Royal Air Force, *c*. 1924-8.

5. (*left below*) Near Shivta, Negev, Israel. Patterns of heaps and banks of stones, caused by the clearance of surface debris from hill slopes by ancient farmers, in order to allow better run-off of rain water into channels leading to irrigated fields in the valleys. After Evenari, Shanan and Tadmor, 1971, fig. 83. Reprinted by permission.

6. Burderop Down, Chiseldon, Wiltshire. Lynchets of ancient fields shown by deep shadows on a north-facing slope. Superimposed on them is a later enclosure, perhaps an eighteenth-century sheep penning. Photograph by the author, 8.30 a.m. (GMT) on 22 October 1943.

Banks and ditches running in the same direction as the sun's rays do not cause shadows, and are therefore difficult to see. If possible, complicated earthworks should be photographed on two occasions, with the light coming from different directions; perhaps on a summer evening and at midday in midwinter (Figs 34 and 35). Allowance must also be made for the slope of the ground, and where earthworks are on hillsides the time of day may have to be chosen with care, so that the sunlight is at the right angle.

Some of the most distinct shadow sites are on pasture land where the grass has been kept short by grazing animals (Fig. 54). When the vegetation is long, much less is seen, though good pictures may be taken in winter, after the tall growth has died down or been flattened by snow. Shadow effects may also be disappointing on very broken or rocky ground because of the distraction of a multitude of small shadows.

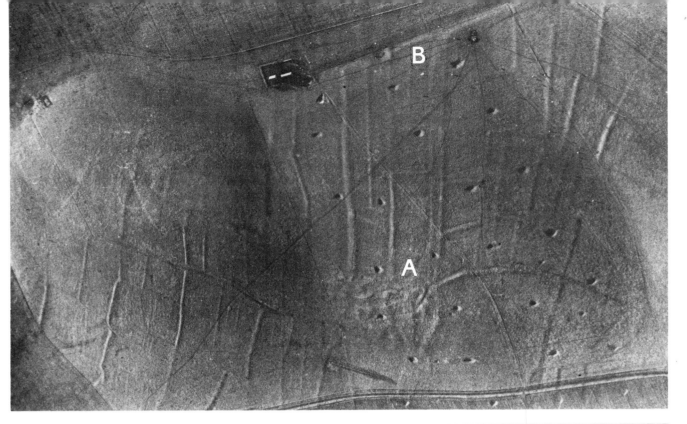

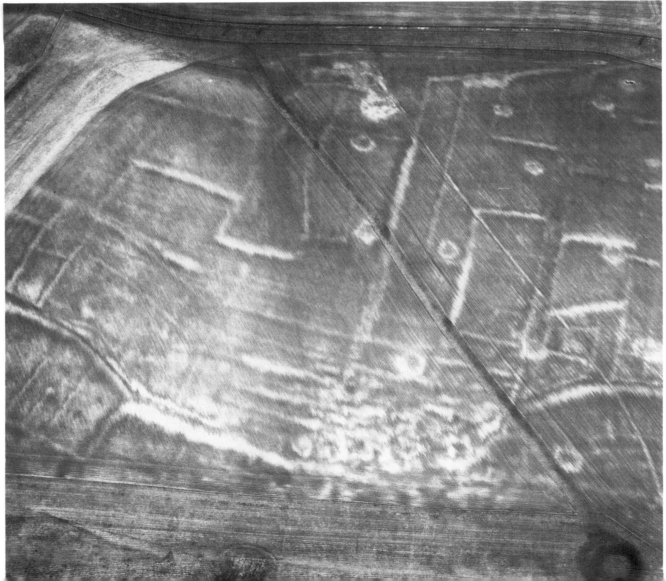

7. (*left*) Green Down, Childrey, Oxfordshire. Lynchets of ancient fields shown by highlights on a south-facing slope, across part of which are lines of large pits, dug at some later date to obtain chalk to spread on the land. Near A is a probable settlement site, which is approached from point B by a path running between the fields. Lynchets have formed on both sides of this path, which is of the type called a double lynchet way. On the left there are traces of medieval ploughing. Photograph by the author, 8.30 a.m. on 25 November 1943.

Snow

Several useful effects are caused by snow. A light covering provides a uniform surface on which shadows show particularly well. A thin powdering may stay unmelted in hollows and thus show the positions of minor earthworks very clearly. The same effect is produced by the remains of a heavier snowfall after a thaw (Fig. 10), but this may melt unevenly if the original thickness has been altered by drifting.

An interesting phenomenon, sometimes seen after a light snowfall, is the faster rate of melting of snow on stones, which makes walls appear as dark lines on a white ground. Very extensive marks of this kind have been observed from the air on Bodmin Moor, Cornwall (Holleyman, 1948) and at Grassington, North Yorkshire, where the grass-covered walls or stony banks of ancient fields show very distinctly as dark lines of melted snow (Fig. 11). No doubt similar marks occur at many other places, though they have seldom been reported. The same snow marks have been noted at Grassington by an observer on the ground (Raistrick, 1938, 167).

Vegetation marks

The positions of earthworks may be shown by differences in the vegetation growing on them, which may take various forms according to local circumstances. In temperate countries, such as Great Britain, the grass may be greener at the base of ditches and paler on banks (Fig. 75), and on upland areas differences in the positions of patches of heather, gorse, grass and other plants may reveal old walls (Fig. 86). In arid areas, the scanty vegetation

8. (*left*) Green Down, Childrey, Oxfordshire. The same land as shown in Fig. 7, here seen after ploughing. The lynchets are shown by white marks, sometimes accompanied by dark marks. This photograph shows some details which cannot be seen in Fig. 7. Photograph by the National Monuments Record (England), 10 March 1982.

may similarly show the positions of ancient remains; shrubs may grow in favoured places at the base of ruined walls (Fig. 83), and vegetation may be denser in ditches but almost absent on banks (Fig. 91). Partially obscured features may be revealed in countries such as Syria and Iran by vegetation marks after the beginning of the winter rains and again when drought begins to burn plants in the spring (Poidebard, 1934, 5; Schmidt, 1940, 14). These marks are similar to the much more important marks in growing crops on cultivated land, described on pp.27-35.

Standing water

Occasionally flood water outlines earthworks: they may protrude from a sheet of water on low ground, or the water may fill hollows.

Underwater remains

Submerged remains in lakes or the sea may be regarded as underwater earthworks. They can be seen by differences of colour or tone, and may be photographed successfully provided that the water covering them is shallow, clear and calm (Fig. 12).

Marks in bare soil on cultivated land

When land on which there are standing earthworks is taken into cultivation, ploughing levels the ground and in the process brings to the surface soil of different hues. The plans of former earthworks are shown by the resulting patterns of *soil marks*, which are unfortunately often seen because of the number of ancient sites that are being damaged by modern agriculture. Colour variations of this type are caused by differences in the mineral and organic content of the soil. They disappear when repeated ploughings have made the surface uniform in composition, though the positions of buried ditch fillings may still be shown in some places by variations in the water content of the soil, which also affect its colour. Wetter or drier patches may form above these buried features producing darker or lighter marks which are usually described as *damp marks*. When the soil dries they fade out.

On rare occasions, differential melting of snow may produce *snow marks* above buried features on

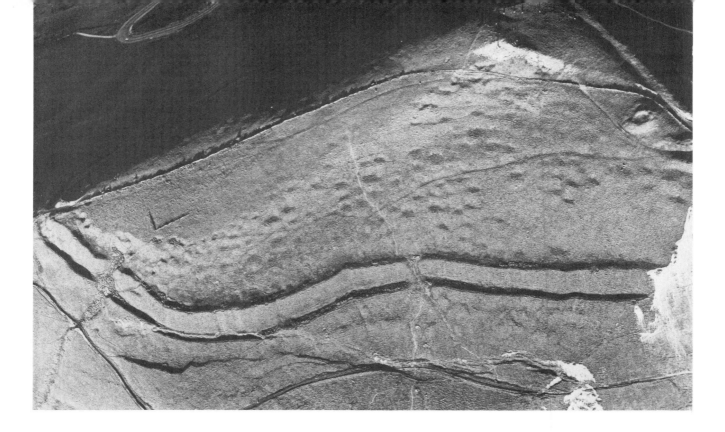

9 and 10. Mam Tor, Castleton, Derbyshire. Summer (*above*) and winter (*below*) views of the northern side of the hill fort, showing the ramparts and many small platforms, which were dug on the steep slope to provide flat ground for huts. The snow photograph gives the more striking impression of the site, but shadows provide more information. Photographs by the author, 6 July 1976 and 22 February 1983.

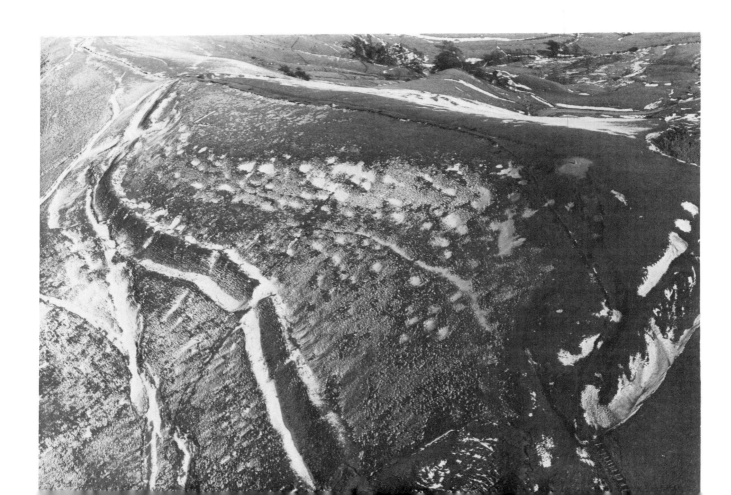

11. Sweet Side, Grassington, North Yorkshire. Dark lines caused by the rapid melting of the snow on field boundary walls and banks after a light snow fall. These snow marks give the plan of Iron Age or Romano-British fields. Photograph by the author, 27 December 1982.

cultivated land, resembling the similar marks above earthworks, which we have already discussed.

The buried features which cause soil, damp and snow marks to develop may also cause vegetation marks to form at different seasons of the year.

Soil marks

Soil marks are important sources of information, which may show features that are not clear on photographs of the former earthworks on the site. As an example of the distinct marks formed on soils above chalk, Figs 7 and 8 show the results of ploughing the low earthworks of a system of ancient fields. The plan of the fields shown by highlights (Fig. 7) may be compared with a similar plan caused by the plough cutting into the underlying chalk at many places (Fig. 8).

As a general rule, old ditches are shown by dark lines where material from their fillings has been brought to the surface (Figs 13 and 69). The remains of banks and mounds usually make lighter-toned marks (Fig. 14). These marks are comparable to the crop marks described below, but they are not identical, and the information from soil and crop marks may be complementary (Figs 70 and 71). Photographs of soil marks often need careful interpretation, because many natural features also influence soil colour (Evans, 1972). On Fig. 13 the broad dark bands are caused by deeper soil filling depressions in the underlying chalk.

The mixing of the surface soil by ploughing is demonstrated by a close examination of Figs 8 and 13. On both photographs it can be seen how the soil has been moved forwards and backwards in alternate furrows, as well as being turned over. Less disturbance, and therefore less distinct marks occur on land prepared by modern minimal cultivation methods. The disappearance of soil marks as a result of the mixing of the soil by repeated cultivation may not be final, since they will be formed again if deeper ploughing brings a fresh slice of the ancient deposits

23

12. Starnberger See, Bavaria, West Germany. Three lines of piles (date unknown) submerged by shallow water near the shore of the Roseninsel. Photograph by Oberstleutnant O. Braasch, 7 May 1981.

13. Thwing, North Humberside. Soil marks of a triple ditch (A to B) of late Bronze Age or Iron Age date and of medieval ridge and furrow. The movement of soil during ploughing is shown by the zig-zag lines of the marks. The darker colour of the field in the lower right corner of the photograph results from shallower ploughing. The broad dark bands on the upper part of the photograph are caused by deeper soil, which has not allowed the plough to reach the chalk. Photograph by the author, 2 October 1984.

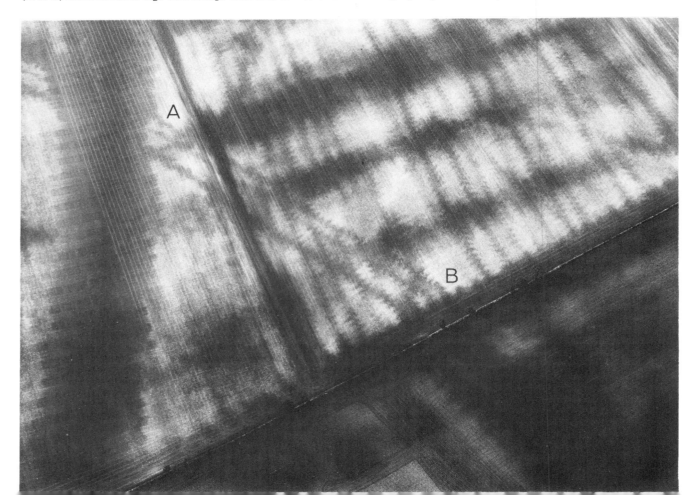

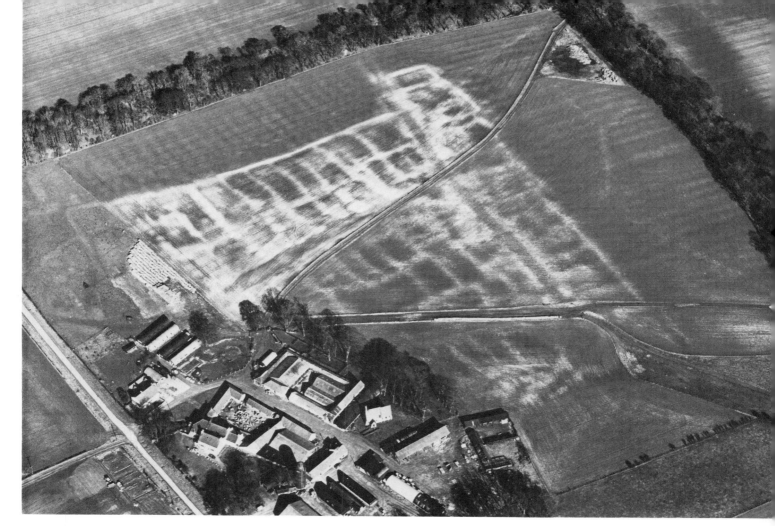

14. Cowlam Manor Farm, Cottam, North Humberside. The plan of the deserted medieval village of Cowlam is given by soil marks formed on the chalk banks of the crofts, through which ran the village street, with a T-junction to the right. Outside the village are faint marks of the ridge and furrow of the medieval open fields. Among the modern farm buildings can be seen the stone-built church, in which there is a fine Norman font. Earlier photographs, taken before the field was ploughed, show well preserved earthworks on the site (Beresford and St Joseph, 1979, 125). Photograph by the author, 5 March 1982.

to the surface, something which is not difficult with the powerful farm machinery now in use. Eventually only the fillings of the deepest ditches remain below the surface.

The months when soil marks are to be seen depend on the methods of land preparation adopted in different places and for different crops. There are usually large areas of bare soil to be seen in all but the summer months, when nearly all arable land is covered by crops. Marks on ploughed land are obscured by harrowing and by drilling seed, but after an interval they reappear.

Land which has been stripped of its covering of soil in preparation for quarrying or civil engineering work may show very distinct soil marks, such as those in the gravel pit in Fig. 15. The light-toned area of this photograph is bare gravel, on which the dark marks of the fillings of ditches and a line of pits stand out. The warning given by this photograph of the damage at the site enabled a rescue excavation to be arranged.

Damp marks

When bare soil is drying after a wet spell, variations in its moisture content often cause darker or lighter patches to appear. Most of these damp marks have little archaeological meaning, but sometimes they show important buried features. An increase in moisture makes the soil darker, and it seems that dark marks may result when the filling of a buried ditch acts as a reservoir of moisture below the surface. Light-toned marks may indicate better drained areas:

25

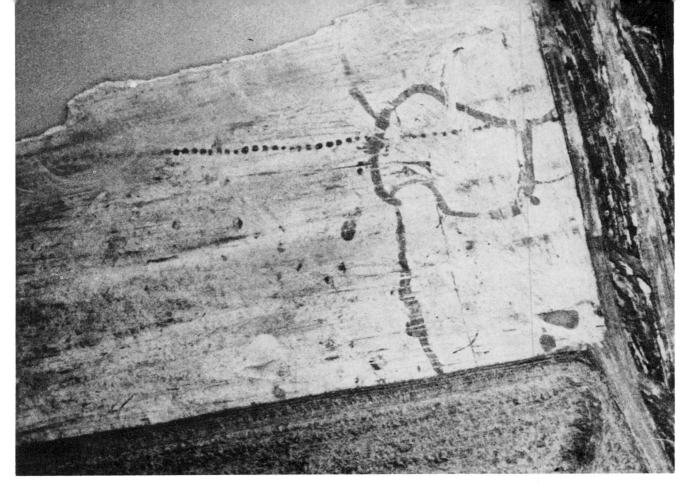

15. Langford Downs Farm, Langford, Oxfordshire. Soil marks in a gravel pit, which give the plan of a curvilinear enclosure of very irregular outline and an alignment of large pits. On excavation, the enclosure was found to date from the Iron Age. The date of the pit alignment was uncertain, but it was later than the enclosure (Williams, 1946-7). Photograph by the author, June 1943.

the positions of land drains below ploughed land are sometimes revealed by light lines.

The observations of Agache in North-Eastern France are our main source of information about damp marks, or *taches d'humidité*, to use his term (Agache, 1963). Agache has recorded many very distinct dark marks of this type on thin soils above chalk (Fig. 16) and smaller numbers of sites with light-toned marks on deeper soils. In that region, the best conditions for the appearance of the marks often occur in early spring, at times when the ground is drying after a wet spell. The marks are usually very fugitive and may disappear the same day. Agache also mentions *taches de rosée* (dew marks), which can be seen in the morning but vanish as the ground dries.

Damp marks have been recorded much less often elsewhere, but they have been reported in West Germany (Christlein and Braasch, 1982, 30) and were first noted in England many years ago on chalky soil (Crawford, 1934). It is my experience that damp marks show only on certain soils in England. On the silts of the Fenland there are in the spring very extensive and distinct damp marks, which last for weeks, but on many other formations, such as soils above gravel, they are rare.

It is noticeable that damp marks tend to be sharp and distinct in outline, not zig-zag lines or blurred lines like the soil marks formed when ploughing exposes soil and subsoil of different compositions. However, there is no doubt that in some cases dark marks of the latter type are reinforced by lines of dampness.

Snow marks

The positions of remains buried below cultivated soil are sometimes shown by dark lines or patches of melted snow, like those seen in Fig. 11, or by white lines of unmelted snow (Fig. 17). The former tend to appear early in the winter and the latter during a

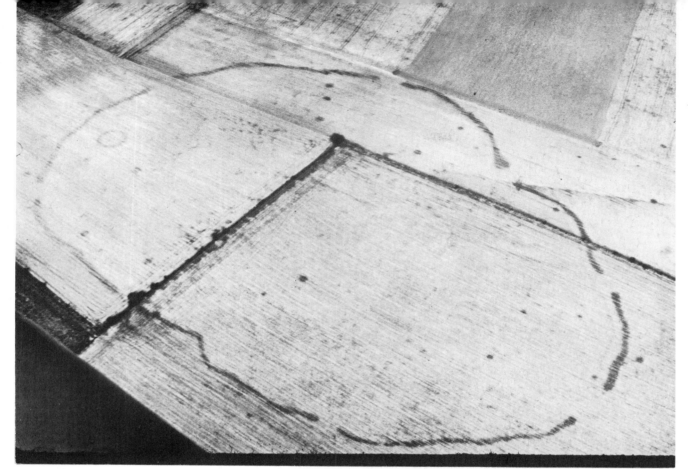

16. L'Etoile, Somme, France. Damp marks above the ditch of a Neolithic causewayed enclosure. The faint line of a probable palisade trench is visible inside the ditch. The marks appeared during a period of good weather after a very wet spell (Agache, 1978, 84). Photograph by R. Agache, Service des Fouilles, March 1971.

thaw after a long cold period (Braasch, 1983, 16). The marks are usually caused by the fillings of buried ditches, but may also appear above wall foundations.

Vegetation marks on cultivated land

The most important way of finding buried remains on farmland is by their effects on the vegetation growing above them. Buried ditch and pit fillings cause plants to grow better, while buried wall foundations or other obstructions to their roots have an adverse influence. On cultivated land, these areas of different growth are called *crop marks*. Similar differences appear on grassland, which may be termed *grass marks* when it is necessary to describe sites in detail.

The purpose here is not to try to explain the reasons for vegetation marks, which are complex, but to give guidance on practical matters affecting the search for early sites. Among the variables which have especially important effects are the kind of crop and its date of sowing, the type of soil and the rainfall.

Considerable differences may be seen between marks recorded in the same field in successive years and in adjacent fields in the same year. The marks may be distinct, or faint, or may not develop, and it is seldom safe to make any but the most general predictions about the manner or date of their appearance. An area in which crop marks are being studied must be watched for a number of years to ensure that all parts are being seen under good conditions. The discovery and recording of crop marks are therefore much more time-consuming than the study of other types of sites (Fig. 99).

Areas of better growth are termed *positive marks* (Riley, 1946, 6). Their most frequent archaeological causes are lines of deeper soil over old ditch and pit fillings (Fig. 18), which produce better conditions for the plants growing above. Positive marks are typically darker green in colour (Fig. 19), taller and of denser growth, though not all these properties are necessarily present in a particular case. An area of worse growth is termed a *negative mark*. Here the plants tend to be stunted, paler green and less dense in growth (Fig. 20). It is necessary to distinguish marks caused by

27

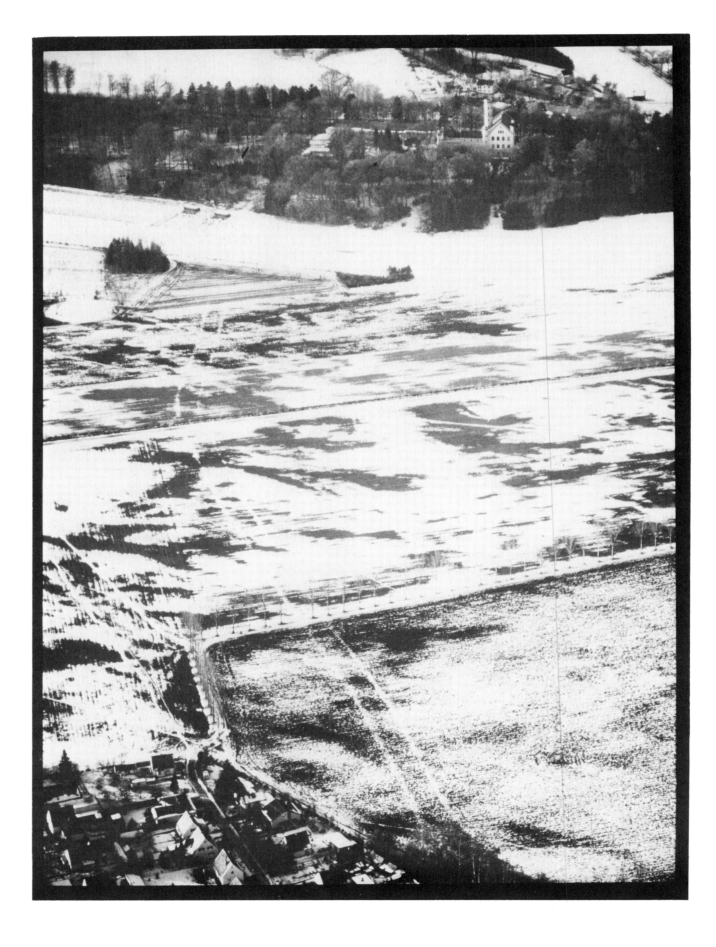

17. (*left*) Wellenburg, Augsburg, Bavaria, West Germany. Snow marks on ploughed land show the lines of the side ditches of a Roman road running southwards from Augsburg. Photograph by Oberstleutnant O. Braasch, 2 February 1982.

18. (*right*) Spong Hill, North Elmham, Norfolk. Section of a positive crop mark in barley, growing above the filling of a Romano-British ditch. Photograph by D.A. Edwards, 2 July 1977.

modern farm work from the marks on archaeological features that are meant when crop marks are referred to in this book.

Crops

Almost any crop will develop marks if the conditions are right, but the most important are the cereals – barley and wheat, and occasionally also oats and rye. However, maize – also a cereal but a rather different plant – has only occasionally been reported to have shown crop marks. Cereals are deep-rooted plants, which are affected considerably by differences in the depth of soil. The importance of root development is sometimes demonstrated by deep ploughing; fields

19. (*below*) Harting, Regensburg, Bavaria, West Germany. Positive crop marks in a field of green wheat show the post holes of many long houses on a Neolithic settlement site. Photograph by Oberstleutnant O. Braasch, 24 June 1981.

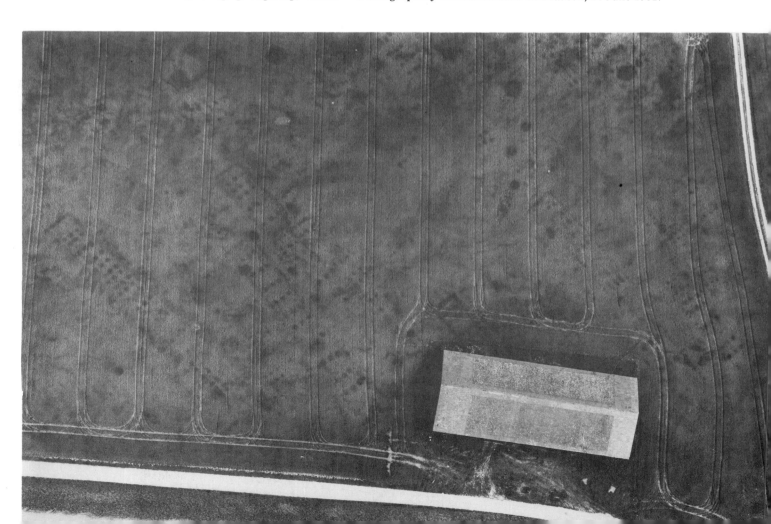

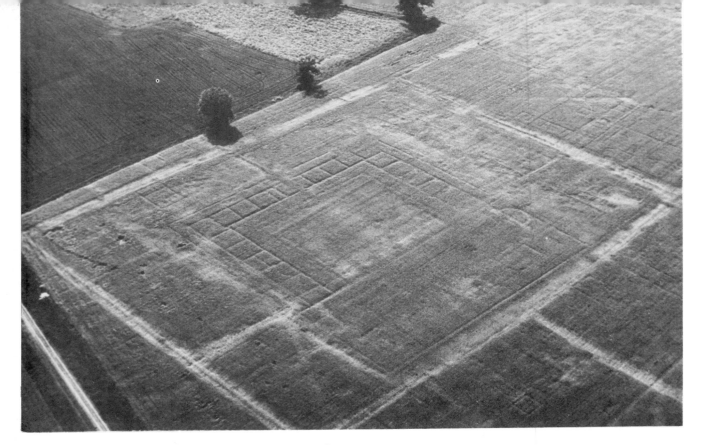

20. Silchester, Hampshire. Negative crop marks of the foundations of the forum of the Roman town and of the roads round the rectangular insula, or town block, on which it stood. Photograph by C. Stanley, 17 June 1975.

which have been blank occasionally start to show crop marks after deep ploughing has disturbed the soil to a greater depth.

Many other crops are also important for the marks they show, but none is grown on a scale approaching that of the cereals. Sugar beet, whose roots penetrate the ground to a good depth, develop distinct marks (Fig. 89), which have also been noted, though less often, in other root crops. Peas, beans and fodder crops, such as lucerne, may also develop good marks. Oilseed rape tends to mature too early, but marks have been seen in dry spring weather. Potatoes appear to show marks only in the driest summer weather. Few of these crops, however, develop such well-defined marks as barley and wheat; all the crop marks illustrated in this book were in fields of cereals except those shown in Fig. 89 and part of Fig. 45. As archaeological air photography extends more widely, however, other crops will no doubt be found worth watching.

Not all crops are of the same interest. In Northern Europe, bulbs, cabbages and similar plants, and market garden crops only very rarely produce evidence of the remains in the ground beneath them. In Southern Europe there are different market garden crops, such as tomatoes, which cover much land near towns and are most unlikely to show marks.

Grass and weeds

Grass is less responsive to differences in the soil beneath it than many other plants, but both positive and negative marks occur in very dry weather. The marks in grass are often called parch marks, but this term may cause confusion with negative marks in other crops, such as cereals, which are also due to parching. As mentioned earlier, the term *grass marks* is preferable.

The same field, first under grass and then under a cereal crop, is seen in Figs 3 (left side) and 24. The marks were more distinct in the cereal crop. This is an example of a site which produced marks in both grass and cereals, but it is much more usual for marks to be noticed only in cereals. There are many instances of fields which are not recorded to have shown any marks when under grass, but which produced distinct marks when ploughed up and sown with cereals.

Marks caused by weeds have sometimes been

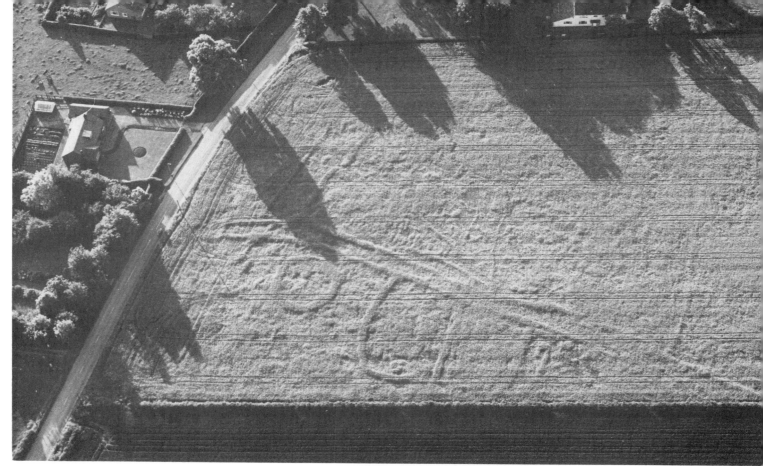

21. Kirk Smeaton, North Yorkshire. Positive crop marks, visible only as differences of height, shown by shadows on a green field. The marks reflect the unevenness of the upper surface of the limestone rock below the soil, including various ditches on the site of an early settlement, perhaps of the Iron Age. Photograph by the author, 6 a.m. on 21 June 1984.

recorded. I have seen lines of yellow buttercups marking the low places of earthworks in meadows and red poppies or yellow charlock vividly emphasising positive crop marks in cornfields, but that was years ago, and the modern use of selective weedkillers normally prevents the development of such 'weed marks'. An account of weed marks by Bradford refers particularly to marks he observed in Puglia, Italy (Bradford, 1957, 25 and 90).

Development of marks in cereal crops

Quite a complex series of events is seen in the cereal crops – barley, wheat, oats and rye – as they grow and ripen. The aerial observer sees a long growing stage, during which the plants are green, a short ripening stage, when they change from green to yellow, and a ripe stage, in which the whole crop has become yellow,

ready for the harvest. Crop marks are found at all times, but become common only when growth is well advanced.

In the early part of the growing stage, marks occasionally appear as areas where more seeds have germinated. Factors similar to those that produce damp and snow marks are probably responsible for these 'germination marks'. They are normally darker green, but occasionally there are lines of paler green where growth has been impeded, perhaps by an excess of water in buried ditch fillings.

As the crops grow, it may be found that areas of taller plants occur (Fig. 21). These local variations at first may not be marked by colour differences. Later in the growing stage, marks shown by differences of colour begin to appear much more often. This is the time before the ears of grain emerge, when shortage of water affects the plants most (Jones and Evans, 1975, 8). The marks may at first be faint (Fig. 22), but dry weather soon causes a great increase in contrast (Fig. 23). The air photographer (but not the farmer) welcomes a drought at this time. On the other hand, in wet weather the marks may stay faint or disappear.

During the growing stage, the appearance of the

31

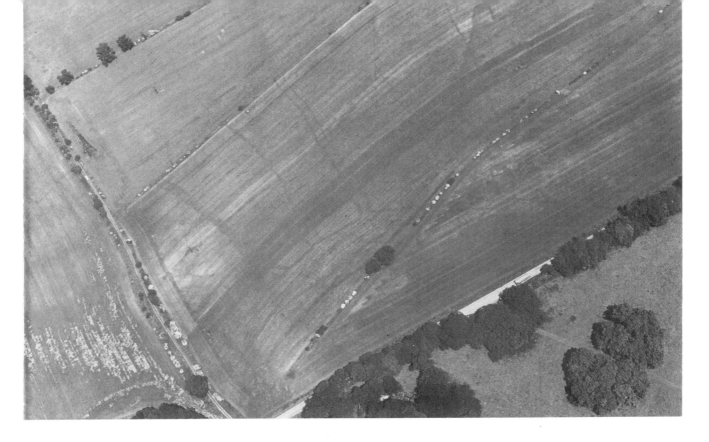

22 and 23. Ledston, West Yorkshire. Two views of the same site, the second taken two weeks after the first. In the interval the crop marks have changed from faint to very distinct. The crops seen on the earlier photograph (*above*) are green and those on the later (*below*) are turning yellow, with green marks remaining to show the positions of the ditches of various enclosures and two lanes, and of a large cluster of storage pits of Iron Age date. These features were cut in the limestone rock below the soil. Photographs by the author, 26 June and 10 July 1976.

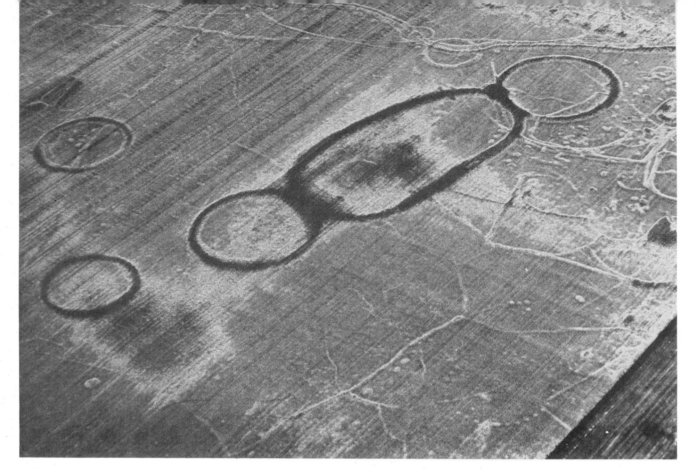

24. Foxley Farm, Eynsham, Oxfordshire. Unusually distinct positive marks in a cereal crop which was turning from green to yellow. This is part of the same field as that seen on the left side of Fig. 3. The photograph shows several ring ditches and an ovate ditch very clearly because they were still green when the rest of the field was yellow. On the lower right corner light yellow 'reversal' marks show a ring of post holes and the irregular lines of probable periglacial frost cracks. On the upper right are the pits and ditches of an early settlement. The medieval ridge and furrow seen on Fig. 3 has left no traces. Photograph by C. Stanley, June 1982.

different cereal crops is similar but not identical. It has been noted that barley often shows marks with the greatest contrast, probably because its greater leaf area makes it more sensitive to drought.

When cereals have grown tall, they are likely to be beaten down by rain and wind. Crop marks are often denser and higher than the rest of the field, and they are particularly liable to be damaged in bad weather, after which they may show as lines or patches which have been 'laid' or 'lodged' (Fig. 68). Marks of this type may be misleading, because other parts of the field may be beaten down at the same time.

At the ripening stage, cereals change from green to yellow. The positive crop marks often, but not always, change colour rather later than the rest of the field, and can be seen as green lines on a yellow background. The opposite applies to negative marks. At this stage the marks may for a few days show better than at any other time (Fig. 24).

In the ripe stage, when growth has ceased and the whole field has become yellow, the marks may disappear, but quite often they still show (Fig. 25). Positive marks, which were originally darker green lines in a field of lighter green, may become lighter yellow lines in a slightly deeper or 'muddier' yellow field. These are usually called *reversal marks*. It is probable that such marks are caused both by lighter coloured straw and by areas of denser growth, where the plants are crowded together more and reflect more light. Negative marks at this stage may appear as darker lines. After harvest, occasional marks still show in the stubble.

The typical colour differences of positive and negative marks in barley, wheat and similar crops are summarised in the Table 1 on p.34. This table gives the usual colours, but no firm rules can be given because the exact patterns of growth vary so much. For example, after an exceptionally dry spring the

33

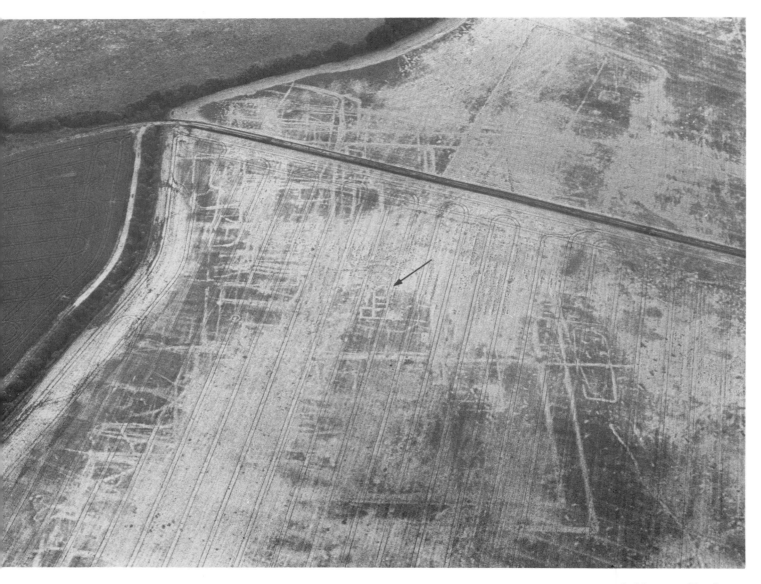

25. Cromwell, Nottinghamshire. Positive 'reversal' marks in a crop of barley, which show the plan of a Roman villa (marked with an arrow) and its surroundings, though much is obscured by light-coloured patches where crop marks are absent. These patches, which are probably caused by deeper soil, always affect the amount of detail visible at this site, but less is seen in some years than in others. Photograph by the author, 28 June 1982.

Table 1. Colour differences of marks in cereal crops

	Growing stage	Ripening stage	Ripe stage
Positive marks	Darker green	Stay green	Lighter yellow
Negative marks	Lighter green	Turn yellow first	'Muddy' yellow
The field in general	Medium green	Changing colour	Yellow

plants in germination marks in fields of spring-sown cereals have been observed to develop much faster than the rest of the field, and later to ripen much earlier, becoming yellow lines in green surroundings, the reverse of the usual pattern. It is therefore always advisable for interpreters of photographs to consult records from more than one year, so that anomalous crop marks do not cause confusion.

Development of marks in other crops

The interpretation of marks in most other crops is simpler, since they do not display the complicated colour changes that take place during the ripening of cereals. Positive marks in other crops are formed by greener and larger plants, and negative marks by paler and smaller plants. Early in the season germination marks may be seen, but, as with cereals, most marks appear during the summer months.

Time of appearance

Forecasts of the dates when crop marks are likely to be at their best can only be very approximate. This is unfortunate because expensive flying time is wasted when a site is visited at the wrong time. In most parts of England the best time for cereals is between June and early August, the best time for root crops is from mid-July to mid-September, and the best time for grass is August. There are many variations from the norm; for example, observations made in Nottinghamshire between 1974 and 1979 showed a difference of about five weeks between the earliest and latest dates for the start of the period when the marks were best developed (Riley, 1980a, 7). In countries further south the best periods are earlier and to the north they are later. The normal time for harvest is June in the south of Italy, July in the south of England, and August in Scotland.

The date when a cereal crop is sown may have a considerable effect on the date when marks appear. The autumn-sown crop is always in advance of the spring-sown, so the former normally shows marks first. The two crops may, however, be influenced very differently by the weather. After a wet spring followed by a July drought, for example, the spring-sown crop may show distinct marks in the period of drought, while the autumn-sown may not, having passed through the critical stages while the ground was wet. There are many complications of this kind, but it is normal for marks to appear in both autumn-sown and spring-sown cereals, provided that they develop at all.

Soils and underlying geological formations

The material in which the plants grow has a very important influence on the development of crop marks. This is demonstrated by Fig. 26, a map of a large area showing a simplified version of the geological formations and a summary of the crop marks that I recorded (Riley, 1983). The airfield from which I fly is also shown because its immediate surroundings have necessarily been examined very often.

Proceeding from the south-east to the north-west corner of the map, crop marks are very common on soils above the gravels near the river Trent, then very rare on the clayey soils of the band of country where the Keuper Marl outcrops and again very common on the Bunter Sandstone belt. Beyond this they occur sparingly on the limestone belt and on the Coal Measures. To the north-east and near the lower course of the Trent are recent deposits of silt, clay, alluvium and peat which seldom carry crop marks of archaeological importance in this region.

The crop marks on the limestone are as distinct as those on the sandstone and gravel, but less numerous. The explanation for this difference is probably that the limestone rock below the surface was too hard in most places to encourage the digging of ditches and pits by the early inhabitants, and that most of the ancient boundaries on it were made by banks and stone walls which have been swept away by later agriculture. Walled enclosures still survive in woods in a few places. More details about part of the limestone and Coal Measures belts are given below on pp.85-8 and Fig. 58.

The distribution of crop marks on the Coal Measures is as sparse as on the limestone. The Coal Measures are a complicated formation, made of alternating strata of clays and shales, coal and sandstones. Most of the marks are on soil above sandstone, but a few are on clay, which is interesting in view of the rarity of crop marks on the clays of the Keuper Marl belt. It is difficult to comment on crop

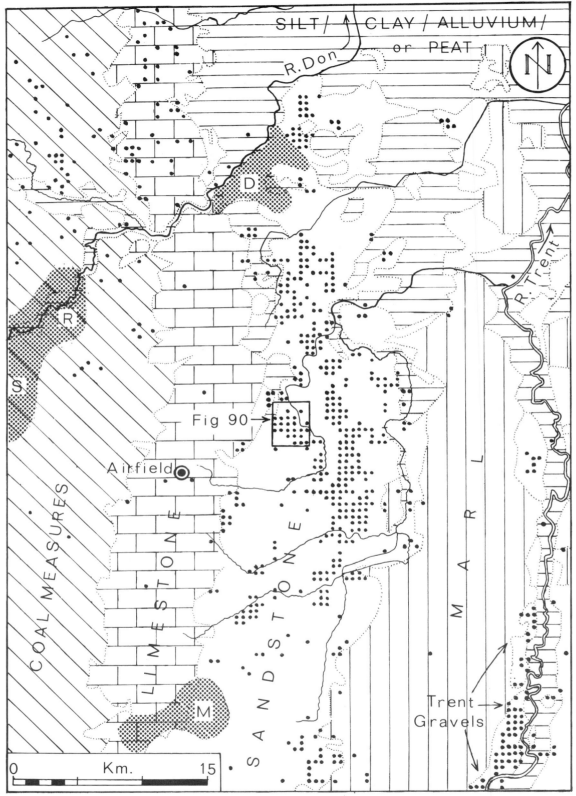

SILT / CLAY / ALLUVIUM / or PEAT

R.Don

R.Trent

D

R

S

Fig 90 →

Airfield

COAL MEASURES

LIMESTONE

SANDSTONE

M

A R L

Trent → Gravels

0 Km. 15

S = Sheffield R = Rotherham D = Doncaster M = Mansfield

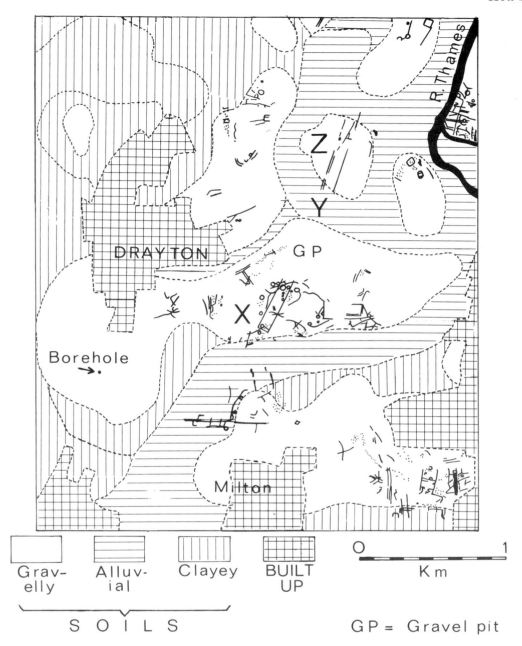

Grav- Alluv- Clayey BUILT 0 1
elly ial UP
 K m

S O I L S GP = Gravel pit

26. (*left*) Simplified geological map of the country to the west of the Lower Trent valley, showing areas with crop marks. Each spot indicates a 0.5 km square on the national grid in which crop marks were photographed in the ten years 1970–79. Gravel, sand and sandstone are left white; the other formations are marked.

27. (*above*) Simplified map of soils near Drayton, Oxfordshire, on which crop marks are shown. Nearly all crop marks are on soils above terrace gravels. At X and Z, crop marks give the positions of parallel ditches interrupted by an old gravel pit (marked GP) and by low ground at Y. The position of this map is shown on Fig. 56.

marks on clay, because although they are usually rare on this material, they are common on clayey soils in the Lincolnshire Fens. No certain explanations will be possible until a number of sites on clay have been excavated and the ditch fillings examined, but on the low-lying Fenland clays, and possibly elsewhere, the cause of the crop marks may be the presence of humose or peaty fillings formed in wet conditions.

The rarity of crop marks on the north-eastern part of the land covered by Fig. 26 is no doubt a result of its

low level. There were extensive areas of marshland here, which must have been little inhabited before their drainage in the seventeenth century. Even part of the sandstone belt here is without recorded crop marks. Moreover, near the river Trent much of the original land surface is buried by very recent deposits caused by the nineteenth-century practice of 'warping', in which farmers improved their land by allowing mud to settle on it from tidal waters.

Only a general impression can be given by a map as small in scale as Fig. 26. It does not explain many important points, for example that some of the blank areas on the southern part of the sandstone belt are due to modern land usage. There are large forested areas where trees, not crops, cover the ground. A much larger scale is needed to explain crop mark distribution in any detail.

Where large-scale maps of soils are available, it is possible to draw combined maps of soils and crop marks, which enable their relationship to be studied more closely. Fig. 27 is a map of this type covering the land south of Abingdon, Oxfordshire, on which the soils have been divided into three types: well-drained soils above terrace gravel, alluvial soils on low ground near the river, and clayey soils. It is immediately obvious that nearly all the crop marks are concentrated on soils above gravels, and are surrounded by alluvial and clayey soils with very few marks. Even on the gravels, however, there are parts that are blank, notably the land south of the village of Drayton. In this area the results from a borehole show that below the surface soil there is a layer of silt, which covers a thin and clayey layer of gravel. Elsewhere near Drayton the gravel is thick and sandy. This is a reminder that the composition of gravel varies and that it cannot be assumed that all gravel deposits are equally favourable for crop mark formation.

It is also instructive to examine the crop marks of the parallel ditches on soils above gravel at X and Z on Fig. 27. The long parallel-sided and square-ended feature at X, part of a Neolithic cursus (compare Fig.59), appears to be continued by two other parallel ditches on the same alignment at Z. Between X and Z there is a gap in the crop marks caused by an old gravel pit (marked GP) and by low ground with alluvial soils at Y. Excavations in the gravel pit in the 1930s found a continuation of the cursus ditch. Recently, sections have been dug in the alluvial soils at Y in the hope of finding more evidence of a link between the two sets of parallel ditches; a continuation of one ditch was indeed found, beneath a layer of silt, which had also preserved its accompanying bank (Thomas and Wallis, 1981). It is not clear whether a single longer cursus or two shorter cursus formerly existed here, but the recent excavation has demonstrated the way in which features represented by crop marks on gravel may continue in other soils on which crop marks do not form. The crop marks on the gravel-based soils must be regarded as a series of windows, between which much of interest remains invisible.

Effects of soil moisture

It has already been mentioned that dry summer weather greatly encourages the formation of crop marks. In these conditions the ground dries out as a result of transpiration of moisture to the air through the leaves of growing plants. On thin soil the available moisture may become exhausted, so that the plants suffer from moisture stress and therefore wilt, leaving the healthier plants on deeper soil to stand out as crop marks.

The rainfall in Britain is not markedly different in the various seasons, but losses of moisture from the soil by transpiration vary greatly, rising from a negligible figure in the winter to a considerable amount in the late spring and the summer. These losses can be estimated and, when they are compared with the rainfall, it is found that there is a large moisture deficit in the average year on much of the land used to grow crops (Fig. 28). The deficit can be expressed as the amount of rainfall needed to bring the land back to saturation point, or 'field capacity'. This is referred to as the 'potential soil moisture deficit' (abbreviated to SMD); the word 'potential' is included because it is a calculated deficit. The amount can be correlated with the appearance of crop marks in many places where the soil is suitable (Jones and Evans, 1975, 7). In Nottinghamshire and Yorkshire an SMD of about 100 mm corresponds to the development of very extensive crop marks (Riley, 1980a, 6).

The great differences in the frequency of crop marks on different soils, demonstrated by Figs 26 and 27, are to a great extent explained by the contrast in the ways in which sandy and clayey soils give up moisture to the roots of plants. Sandy soils release moisture until

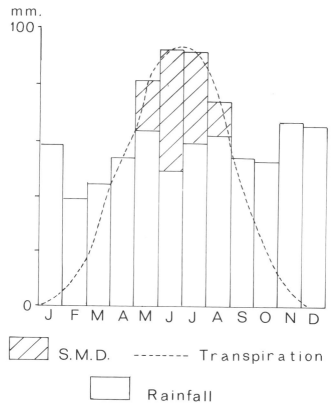

mm.

S.M.D. -------- Transpiration

Rainfall

28. The mean monthly rainfall 1959-72 and the average potential transpiration for Newport, Shropshire. In the months May to August potential transpiration exceeds rainfall, so there is a potential soil moisture deficit (SMD). After Jones and Evans, 1975, 2.

all available supplies have been exhausted, at which point the plants begin to wilt. Clayey soils, on the other hand, release moisture continuously, but at a progressively reduced rate as the amount of available water decreases (Jones and Evans, 1975, 3).

It must be emphasised that the SMD is a calculated figure, which assumes average conditions. The actual situation at any given place is greatly influenced by the moisture-holding capacity of the soil. In places where the soil is thin above the underlying deposits, less water is held in reserve than where it is thick. On sandy or loamy soils over gravel or limestone, for example, it is found that crop marks often appear very distinctly in places where the soil depth is about 30 mm, but become rarer as the depth increases. Where soil depth reaches one metre, crop marks are very rare.

The moisture reserves of the soil are also influenced by its composition, being much greater per unit volume of fine silty soil than coarse sandy soil. The fine silty soils of part of the Fenland probably store enough moisture to provide an adequate supply for crops throughout an average summer. The well-defined crop marks seen on these soils usually occur at unusually early dates and are probably mainly caused not by shortage of water, but by differences in germination. These are no doubt due to the differences between the silty soil and the humose deposits in many former Romano-British drainage ditches, which became filled by vegetable matter under waterlogged conditions after they were abandoned (see p.125).

It has been suggested that some anomalies in the appearance of crop marks on soils above river gravels in flood plains may be due to ground water reaching the roots of crops. Thus, although the SMD explains much about the development of crop marks, other possible factors must be remembered.

Primary and problem-based stages of aerial surveys

A crop mark survey is a surprisingly long-term project, to judge by experience in Great Britain,

France and West Germany. Marks can appear almost every year in certain fields where conditions are very favourable, but even on well-explored land there may be fields on which crop marks have been seen only once. Between these extremes are fields on which marks have appeared in several years of a decade (Fig. 99). The survey must last long enough to ensure that the majority of the fields have been seen under the right conditions.

Taking an area well known to me, the belt of sandstone shown in Fig. 26, most of the very extensive crop marks were recorded in the four summers between 1974 and 1977 (Riley, 1983, 61). This period would no doubt have been longer, but for the exceptionally dry summers of 1975 and 1976. As the results were mapped, many problems were found: indistinct crop marks, inadequate control points for mapping and the absence of any marks in certain areas. From 1978 onwards it became a matter of priority to examine these points in detail and improve the map of crop marks. At the same time a watch was kept for new sites, though the rate of discovery fell markedly compared with the start of the survey. After eleven years it was found that the region was still not fully explored, for a few more new sites were found in 1984 while this book was being written. By then, however, the time spent searching and the expense of flying had increased greatly in relation to the

additions made to the knowledge of the area.

This sequence of events illustrates the two phases of exploration of a region: the primary phase and the problem-based phase. The early flights in a new area are voyages of discovery, on which there is little or no previous information to give guidance, but later it becomes necessary to refer increasingly to the results of previous flights. This division into two phases is a useful concept, which makes it easier to plan air reconnaissance, but it is not suggested that there is any firm division between them. The primary phase may start again in part of the region if some change in agriculture takes place, for example if large tracts of grassland are ploughed up and sown with cereals.

A rather similar sequence of events takes place in the investigation of earthworks. The most prominent banks, ruined walls and ditches are normally recorded well by the initial surveys, but there is usually much more to be found. On hillsides facing the sun, for example, only the steeper slopes generally show as highlights and the lesser features cannot be seen. Further visits to such sites are necessary when the sun is at the right angle. Unlike crop marks, 'shadow sites' can be identified from the ground, and before beginning detailed investigations air photographers would be well advised to reconnoitre at least some of the sites on the ground with a local fieldworker in order to get to know the problems.

3
Flying and the Archaeologist

Although much of the complex business of flying is outside the scope of this book, certain matters are of special importance to the archaeologist because they limit freedom of action or influence the results that can be obtained, and because of the need to keep costs to a minimum. The most important are the facilities offered by various types of aircraft, the procedures followed in the air, some aspects of air traffic control and the constantly changing problems caused by the weather.

The aircraft is needed for three purposes: as a moving observation post from which to examine the ground below, as a platform for photography, and as a means of transport to and from the area under investigation. Light aeroplanes fulfil these requirements and are relatively cheap to operate. They are the means by which almost all aerial research is done by archaeologists. The bigger aeroplanes used for cartographic survey work by commercial mapping firms and government agencies are too expensive for normal archaeological surveys. Helicopters meet the requirements, but they too are usually expensive to operate and are not normally used. Kites, model aircraft and balloons have occasionally been used, but they provide no more than a platform for photography and are very restricted in application.

Choice of aircraft

Air reconnaissance and photography can be done in many types of aircraft, though some are more suitable than others. The essentials are a good view of the ground from the cabin, convenient apertures through which the camera can be aimed, and a cruising speed fast enough to reach the objective in a reasonable time, but not too fast for effective observation of the ground. Most single-engined aircraft of the types described below are convenient for oblique photo-

graphy from the cabin windows.

High-wing, single-engined light aeroplanes (Fig. 29) give an excellent view of the ground (Fig. 30). The Cessna 150 and 152, which are often used, carry two people seated side by side, while the equally well known larger Cessna models take up to four people seated as in a car. Cruising speeds for these and similar aircraft range from 80 to 130 mph (130 to 200 kph). The endurance is about three to five hours, or more when long-range tanks are fitted.

Low-wing, single-engined light aeroplanes of similar seating capacity, speed and endurance are also widely available, and are preferred by some operators (Dassié, 1978, 30). The view from the cabin sideways towards the horizon is good, but it is less satisfactory downwards because part of the ground is below the wing (Fig. 30). These aircraft seldom have the convenient opening window in the side of the cabin usually found in high-wing machines, but there is usually little difficulty in having a small opening with sliding cover made in one of their fixed windows. When taking oblique photographs it is necessary to bank the aircraft fairly steeply in order to keep the wing tip out of the picture.

Twin-engined light aeroplanes are used when greater carrying capacity and longer range are required. They can have either high or low wings and their cabins take four or more. The engines are usually fitted on the wings, one on each side of the cabin, where they obstruct the sideways view, though allowing a good forward view because there is no engine in front of the cabin. Twin-engined aeroplanes are considerably more expensive to operate than single-engined machines. Compared with single-engined aircraft, most twin-engined planes are less satisfactory for oblique photography, but they are good for vertical work, because the extra power and cabin space allow them to carry the very large vertical

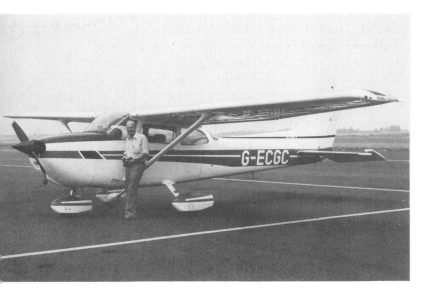

29. A high-wing, two-seater light aeroplane, the Cessna 152, with the pilot, J. Pickering. Photograph by the author, 13 July 1982.

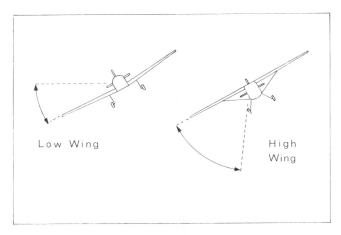

30. The sideways view from low-wing and high-wing aircraft.

cameras that take 240 mm film (see below, p.55). However, the Cessna 347 high-wing, twin-engined aeroplane owned by Cambridge University is convenient for both obliques and verticals because the engines are mounted at the front and rear of the cabin, instead of on the wings. This permits a good sideways view for oblique photography from the cabin, and when seats are removed there is space for the 240 mm Wild RC8 camera and a crew of two (pilot and photographer). The aircraft has a cruising speed of about 150 mph (240 kph) and at least six hours' endurance.

Motorised gliders, i.e. gliders fitted with a small engine, are not often used by archaeologists, though some good work has been done in them (Krahe, 1982). The inexpensive Motor Falke glider has a cruising speed of from 50 to 70 mph (80 to 110 kph) and takes fuel for up to three hours' powered flying, after which it can still be flown as a glider. Two people are carried side by side. The design is of the low-wing type, with the advantages and disadvantages already described, but as the wings are unusually long, extra care must be taken to keep them out of photographs. The glider is cheap to fly, the cost per hour being less than half that of a small two-seater single-engined aeroplane.

Helicopters give a good view in all directions. They fly slowly, and their ability to hover is a great advantage, though it is necessary to maintain some forward speed to give them a safety margin in case of emergency. There is more vibration than in a fixed-wing aeroplane, but this is serious only in piston-engined machines. Unfortunately, helicopters are expensive to operate.

Microlight aircraft, on the other hand, are cheap. Good photographs have been taken from them, but their range is limited.

Crew

Various combinations of duties are possible for the crew, which may vary from one to three persons in aircraft of the types just described. Solo flying has disadvantages because it is not possible for a single person to keep as good a watch for archeological sites and for other aircraft as can be done by a crew of two. It is, however, quite easy for a solo pilot to take oblique photographs, because modern high-wing aircraft are usually very stable in the air. On occasions, when unexpectedly good weather offers opportunities and other crew members are absent, it may be necessary to make solo flights. Two pairs of eyes are much better than one, however, and a crew of two enables better results to be obtained, with the pilot and photographer keeping a good watch on both sides of the aircraft and sharing map reading if necessary. When the aircraft is large enough to allow room for a crew of three, it is best for an archaeologist to sit beside the pilot and act as observer, taking the main part in map reading and recognising sites on the ground. The photographer works in the space behind, one or more seats being removed to give more room.

An archaeological training is advantageous for the pilot, but in most cases he contributes only his flying skills; if so, he should as far as possible be the same person during a series of flights, so that team work can develop and he can learn to recognise ancient sites, play a part in reconnaissance and be ready for the directions given by the photographer. At times the pilot may be very busy, but on long flights, though he must always keep a good look-out, he is likely to have much time to spare which should be used.

Airsickness is sometimes a problem, particularly for people who are not used to flying in light aircraft. If necessary, a doctor may be asked to prescribe travel sickness pills, but after a few flights the trouble may go away.

Availability of aeroplanes

The various options open when a flying programme is planned include the ownership of, or a share in, an aeroplane, the hire of an aeroplane flown by a pilot with a commercial flying licence, or membership of a flying club which has machines available for the use of its members. These alternatives cover a considerable range of costs; shared ownership or the use of a club aircraft are usually the cheapest. The single aircraft of a private owner has the disadvantage that it may become unserviceable, thus grounding the archaeologist, perhaps when the weather is at its best. In these circumstances, however, it may be possible to fall back on a commercial or club machine.

Maintenance

Regular users of aeroplanes should know something of the maintenance schedule, which must be allowed for when planning flying programmes. Most light aeroplanes in Great Britain are maintained in accordance with the requirements of a schedule published by the Civil Aviation Authority. Maintenance (both remedial and preventive) takes place after a specified flying time, usually every 50 or 100 hours, or after a calendar time. There is also a comprehensive annual check, and every three years the certificate of airworthiness must be renewed. Aircraft are not available for flying until these checks have been completed.

The length of time taken for the checks need not be long. The 50-hour and 100-hour checks can be done in

a day if all goes well and no unexpected problems arise. The annual check takes two or three days and the triennial certificate of airworthiness takes at least a week in a well-run workshop, though unfortunately there may be long delays in establishments which do not make suitable provision for spare parts.

Maps in the air

The standard maps used for air navigation are the 1/500,000 aeronautical chart and the 1/250,000 topographical chart. The former is essential for flying control information and the latter for finding the position of the aircraft by local map reading. Neither shows enough to locate the exact positions of small sites, for which more detailed maps are needed. However, the scale must not be too large; a 1/25,000 scale map can be used in a specific area, but the position of the aircraft moves too quickly for this scale to be practical on a long flight because far too many maps would have to be folded and unfolded. On reconnaissance flights the best compromise for the archaeologist, rather than the pilot, is the 1/50,000 map. The position of the aircraft can be followed easily, and small sites can be located to within 100 or 200 m. During the preparations for a season of flying, the outlines of earthworks and soil or crop marks can be pencilled in on maps at this scale, though the marks must be very small and no fine detail can be given. A set of maps marked in this way and kept up to date as new discoveries are made seems the best available aid to 'problem-based' flying and to the recognition of new sites in well-explored areas, though they are only a partial solution because detail is not shown.

UK aviation law and air traffic control

Civil aviation in the United Kingdom is governed by a considerable body of regulations, which have been framed to ensure that flying is done with care and under the safest possible conditions. There are a few regulations about which photographers should be aware, since they limit in certain ways their freedom to arrange flights. Similarly there are rules for civil aircraft in other countries.

Payments for flights can only be made when the pilot has a commercial licence. Holders of the private pilot's licence are not permitted to accept money for

31. Map of airspace information for Yorkshire in 1982. Zones controlled from ground level to a specified altitude are marked by continuous lines. MATZ = Military Air Traffic Zone. SRZ = Special Rules Zone. CTR = Control Zone. Areas controlled between two specified altitudes are marked by broken lines; only the lower altitude is given. SRA = Special Rules Area. CTA = Control Area. TMA = Terminal Control Area. The numbers are the lower altitude limits of Areas, and are given in hundreds of feet; thus 25 = 2500 feet (c. 750 m).

transporting members of the public, or doing what the Civil Aviation Authority terms 'aerial work'. In the event of an accident, however unlikely that may be, the insurance would be invalid if this rule were found to have been broken. These regulations are made to prevent dangerous practices, such as the carriage of passengers by inexperienced pilots, which it is supposed would take place.

The laws about minimum flying heights may be important on photographic trips. A powered aircraft may not fly closer than 500 ft (150 m) to any person, vehicle or structure, except when taking off or landing, which generally means that 500 ft is the minimum height above the ground. Very low-level pictures of buildings and excavations may therefore

be unobtainable. Over towns, cities or settlements it is required that an aircraft should maintain either a height of 1500 ft (450 m) above the highest fixed object within 2000 ft (600 m), or such a height that, in the event of engine failure, it could glide clear of the built-up zone to make a forced landing; whichever height is the greater must be flown. For the peace of mind of passengers, it must be mentioned that engine failures are exceedingly rare. There are also some sensible regulations about the minimum conditions of visibility for flying with a passenger.

Archaeologists wishing to examine the whole of a region may be dismayed by the extent of the land over which flying is subject to Air Traffic Control, where movement is not free. An example is given in Fig. 31, which shows an area well known to me. At the low levels where archaeological photography takes place there are various kinds of controlled air space, which may be divided into three main types, Areas, Zones and Airways. Details of all are marked on the 1/500,000 aeronautical charts, which give their upper and lower limits of altitude, and must always be consulted when planning a flight. Many Areas have lower altitude limits from 1000 to 4000 ft (300 to 1200

m), making it possible to fly beneath them in uncontrolled air space, though it is easier to operate where the limit is at least 2000 ft (600 m). Similarly, it is generally easy to operate under Airways, the lower limits of which are at fairly high altitudes for most of their lengths. All Zones and some Areas are, however, controlled to ground level; some of the busiest, such as the London Control Area, are completely restricted, but archaeological flying is possible in the remainder. The Military Air Traffic Zones (MATZ) round military airfields are often not operative in the evenings and at weekends, at which times flying in them is unrestricted. There are also relatively small Prohibited, Restricted and Danger Areas, which must be avoided, though some of the latter, e.g. firing ranges, are only in force for part of the time.

When flying in controlled air space, it is advantageous to have an aircraft fitted with a transponder. This is a radar device which enables the air traffic controller easily to identify a particular aircraft and removes any doubt about its position. Permission to fly in the Zones and Areas can be obtained more easily for an aircraft with this equipment.

Weather

The right kind of weather is the first essential when flying is planned. It is always necessary to ensure that no risks of unsafe conditions are taken at the base airfield, at the areas to be examined, or in transit from one area to another. Air photographers have to resign themselves to many days or even weeks when the weather is unsuitable for their work and can therefore expect to spend a lot of time obtaining weather forecasts and watching the sky to try to assess the prospects. In Britain there are the problems of wet weather in the summer, which spoils crop marks in many years, and of the infrequency of days with no cloud and good visibility, which are needed when earthworks are to be photographed in the light of the low sun.

The amount and height of cloud and the visibility are always important, both for navigation, which is mainly by map reading on archaeological flights, and for reconnaissance. Atmospheric haze is a special problem in many parts of the world, both because of the increased difficulty of navigation and because of the adverse effects on photography (see p.52).

The movement of the air mass has important effects. When the direction of the wind is at an angle to the heading of the aircraft, it will drift, i.e. move sideways as well as forwards. In a strong wind drift may be considerable. Turbulence, or bumpy air, occurs in many weather conditions, particularly on hot and sunny days, though it generally dies away in the evening.

Instruction on the elements of meteorology is given to pilots during their training. Those who intend to fly regularly as passengers may also find it helpful to learn something about the subject by reading the relevant parts of one of the handbooks used during flying training courses (e.g. Birch and Bramson, 1984, 67-106).

Flying procedures on reconnaissance flights

Flights undertaken to search for archaeological sites and take oblique photographs are usually made at heights of between 1000 and 2500 ft (300 to 750 m) above the surface. More ground detail is visible when flying at the lower level of this range than at the higher, but a lower height limits the amount of land to be seen at a given moment, and map reading is more difficult. I prefer a height of about 2000 ft (600 m), from which a strip of land up to about 2 miles (3 km) wide can be watched. This is also a convenient height for much oblique photography using a standard lens in a small or medium-format camera.

The route followed on a reconnaissance flight depends on the size of the area to be searched and the time available. The most thorough method is to fly systematically along a series of parallel tracks and 'weave' from side to side, so as to vary the direction of view. In order not to miss inconspicuous features, such as many soil and crop marks, when flying at 2000 ft (600 m) the parallel tracks should ideally be not more than 1½ miles (2 km) apart. In practice, however, there is generally far too much land to be covered in a limited time to do this, so it is necessary to compromise on tracks much further apart and to look for promising areas which can then be given extra attention. When reconnaissance is interrupted for photography, it is usually necessary to circle round, which gives the opportunity for a more thorough look at the land round about. Several visits to an area are advisable when crop marks are the objects of the search, and flight patterns may be varied so that new parts are flown over on later flights.

Flying for oblique photography

The placing of the aircraft correctly for oblique photography should not be very difficult, as the photographer can guide the pilot by hand signals or spoken instructions until the subject is seen from the right viewpoint and without any parts of the aircraft, such as wing struts, appearing in the picture. When the direction of view is not important, the pilot can often provide the best opportunities for the photographer by flying into wind, so that the aircraft is moving slowly over the ground. If necessary the flaps can be lowered by 10° and the airspeed reduced. When flying round the site to find the best direction of view, the pilot of a high-wing aircraft will probably bank it at about 30°, an angle which the photographer is likely to find convenient. At this angle it will complete a circle in about one minute. When flying at 100 mph (160 kph), the diameter of the circle will be about 850 m.

The drift caused by a strong wind is troublesome, and it may be found that instead of going to one side of the site or round it, the aircraft is blown almost over it, so that the subject may be seen at the wrong angle, or may even pass out of view. In these conditions the pilot must try to anticipate the effects of drift and manoeuvre the aircraft accordingly, though this can be difficult to do well.

Flying for vertical photography

As the camera for vertical photography is fixed to the airframe, pointing vertically downwards to the ground, the aircraft has to be flown accurately over the subject, a very different matter from oblique photography with a camera aimed by hand, for which the aircraft does not have to be in an exact position. In making a vertical survey of a large area, the aircraft must fly at a certain height above a series of parallel straight tracks on the ground, which are marked on a map prepared before the flight. The camera takes strips of overlapping photographs (Fig. 36A). As far as possible, a constant height and a level attitude must be maintained. There is almost always a side wind, which, if not allowed for, will cause the aircraft to drift to one side when flying in one direction and to the other when returning. Suitable alterations in the heading must be made to compensate for this (Fig. 36B), the alterations being in opposite directions on

the outward and return tracks. Final adjustments are made by the pilot, on the instructions of the navigator or photographer, to position the aircraft correctly on the photographic runs. The execution of a survey of this kind is a highly skilled matter, which requires good teamwork by the crew of the aircraft. In the more expensively equipped aircraft there are radar devices which enable the required track to be maintained with much greater accuracy than by conventional methods of navigation (Kilford, 1979, 101).

The following simple procedure for making a vertical survey, in which photographs are taken in one direction only, is more likely to be of practical value to archaeological aviators than the methods just described, which are practised by professional survey teams. The procedure involves some slight inaccuracies and the flying time is longer, but such careful navigational work is not needed. After each photographic run, the aircraft returns, with the camera switched off, to the start of the next photographic run, which is parallel to the first and in the same direction. Since photographs are taken only in one direction, the problems of drift apply only in a single direction. The heading on which the aircraft is to be flown must be worked out before the flight commences, using the forecast wind. Because this can never be entirely accurate, the tracks of the aircraft inevitably err to one side or the other of the planned lines along which the photographs should have been taken. However, no correction is made to the calculated heading during the flight, and if the flying has been accurate, the tracks should cover all the ground that was intended to be surveyed, except for one corner.

Single vertical photographs or short runs of a few photographs are not difficult to take, provided that the aircraft is equipped with a good vertical sight, with which the photographer can guide the pilot to fly exactly over the subject.

Keeping notes

However good your photography may be, the importance of keeping notes during flights must not be underestimated. The route followed should be noted, otherwise it may later prove impossible to identify the location of some of the places photographed or to be sure whether the reason why nothing was recorded in a certain area was because there were no archaeological sites there, or because the area was

not flown over. It is also useful to keep notes of conditions for photography, which vary as cloud cover and visibility change, and of the way sites show, which may be important when studying problems raised by the appearance or non-appearance of certain sites, particularly those shown by crop marks. These notes should be copied out soon after a flight and perhaps expanded by further information while it is still fresh in the mind.

Kites, model aircraft and balloons

If it is not possible to use an aeroplane, or if it is too expensive, the camera must be raised above the site by some other means.

Aerial photography has quite often been done with the aid of a kite. Descriptions have recently been published of kite photography of excavations in Syria (Anderson, 1979) and during the survey of farms of the Roman period in Libya (Allen, 1980). Various types of large kites can be used, and the camera is normally suspended from the line some distance below the kite. In the procedure used in Libya, the kite is flown to a stable height before the camera is attached to the line, after which more line is let out, so that it rises further, lifting the camera above the site. A 35 mm camera with a wide-angle (28 mm) lens is used, mounted in an aluminium box. It is fitted with a motor drive and operated by remote control with the aid of a small radio receiver. The apparatus is worked by a small team, consisting of an anchor man, who controls the drum on which the line is wound, a walker, who controls the camera, and a camera catcher, who ensures that the camera does not suffer any damage when it reaches the ground. Both vertical and oblique photographs can be taken by adjusting the angle at which the camera is mounted in its box. There are many practical problems in kite photography, and it is essential to gain operating experience in the field. Wind speed variations are a source of difficulty; for days on end there may be very light winds which will

not lift the kite and at other times they may be so strong and gusty that the kite is almost impossible to control.

Radio-controlled model aircraft can be adapted to carry cameras (Miller, 1979). A model with a wing span of 1.8 m and a 10 cc engine will take a 35 mm camera with motor drive and control equipment. The camera is placed on the fuselage at the centre of gravity in a mounting which includes a layer of foam rubber to minimise vibration. It can either point downwards through the fuselage to take vertical photographs, or sideways to take obliques when the aircraft is banked to circle a site. A flying height of 200 to 300 ft (60 to 100 m) is adequate when the photograph is to cover a small area, and more land can be covered from greater heights. It is convenient for the operator to stand on the site and control the aircraft so that it passes over him (verticals), or circles round him (obliques). Photographic conditions are best when the air is calm, so that the aircraft keeps a steady attitude; early mornings and evenings are often good. The whole film should be exposed to allow for the inevitable inaccuracies in aiming the camera.

Tethered balloons, which were much used for observation in the First World War, have a long history of use in the photography of archaeological monuments and excavations. They can ascend to considerable heights, from which a large area can be recorded, for example the environs of Knossos, Crete, photographed from 800 m by the Whittlesey Foundation expedition (Whittlesey, Myers and Allen, 1977), and can also be used at low level. In calm conditions a balloon can be flown from the site to be recorded, though the tethering rope may appear in the picture. In a light wind the balloon must be manoeuvred till it is over the site, but as the wind speed increases it becomes difficult to manage. Only balloons inflated by hydrogen or helium appear to have been used by archaeologists, not hot-air balloons.

4

Photography from the Air

In good flying conditions it is not difficult to take oblique views with a hand-held camera aimed from the cabin window of a light aircraft. The results may be disappointing, however, and there is a gulf between the standard usually reached by a beginner in the air and that required for a good record of an archaeological site. In this chapter I describe methods which should enable the necessary high standard to be attained. The information given here may be supplemented by referring to a paper by Wilson (1975), which is illustrated by well-chosen examples.

Nearly all the photographs taken by archaeologists are oblique views. This method is usually chosen because of its simplicity and the advantages of using aircraft and cameras of types which are widely available and relatively inexpensive to operate. The photographs provide good records of the small areas of land usually covered by ancient sites and provide data for mapping them, provided that the ground is reasonably flat. Because oblique photographs are so often taken, I will concentrate on this method here.

Alternatively, the ground may be recorded by a set of overlapping vertical photographs taken by a camera fixed in an aircraft and pointing vertically downwards through a suitable aperture. This method will record large areas much more systematically than oblique photography and will supply data for the accurate mapping of uneven or hilly ground, but it is more difficult to arrange because of the need to use specially modified aircraft. Figs 1, 4-7, 15, 39, 49, 52, 83-5 and 92-4 are vertical views; the other photographs reproduced in this book are obliques.

Taking photographs

The oblique view

Having become accustomed to the rather cramped working space of a light aircraft, the photographer can give his mind to making a good record of the archaeological sites below. One of the first aims must be to eliminate the common faults that crop up in most people's early efforts, including my own. These include a tendency to take photographs at too flat an angle, or from too far away, or with part of the site cut off, or without the landmarks necessary when mapping it. These faults can be minimised by taking pains in the assessment of the picture through the camera viewfinder, and in positioning the aircraft in the right place. Shots should be repeated if necessary, for film is cheaper than the expense of a second flight to re-photograph the site.

General views may be taken at shallow angles of about 30° to 45° from the horizontal, but to obtain the best records of patches of ground, the camera should normally be aimed steeply downwards at an angle of 50° or more to the horizontal, in order to reduce perspective distortion. This is quite straightforward in a high-wing aeroplane, moderately banked and with the window open, in which circumstances it is not difficult to take almost vertical pictures. It is better to work through an open window, in order to minimise reflections from the perspex and distortion of the image, but if there is no convenient aperture, photographs can be taken through perspex. If the cabin door is removed before the flight, the downwards view is unobstructed, but this method is inconvenient, draughty and only suitable for short flights. The camera must not be rested on any part of the airframe, because if this is done vibration will be

32 and 33. Gaimersheim, Bavaria, West Germany. Two photographs, taken from different directions, of the rather faint negative crop marks on a Roman villa site, which are visible from one direction (*above*) but invisible from another (*below*). Photographs by the author, 9 June 1981.

48

transmitted from the engine.

The constantly moving point of view necessitates quick decisions about the best moment to take the photograph; if this is missed, the aircraft has to circle back to where it was, thus losing one or two minutes. It helps to have everything ready, for example by taping the lens focus setting at infinity, so that it cannot be accidentally moved from the correct position, and by using a motor drive, which eliminates the need to wind the film on manually.

The direction of view must often be chosen with care. Faint crop and soil marks, and earthworks emphasised by shadow, generally show best from a certain direction, which has to be found by circling the site (Figs 32 and 33). Crop marks cause the most difficulty; indistinct marks are usually seen best when looking with the sun, but marks appearing only as height differences show best when the observer is looking towards the sun (Fig. 21). This direction is also best for marks shown by 'shine' in crops of barley, rye and certain wheats, i.e. by light reflected from the long shiny 'beards' of the plants at a certain stage of growth. Soil marks are usually simpler to record, but in winter, when the sun is low, Agache (1982, 29) has noted that large damp marks such as those on Fig. 101 show better looking towards the sun, and marks due to differences in soil composition (Fig. 102) show best seen with the sun. Earthworks emphasised by shadow appear with much more contrast when looking towards the sun, i.e. with their shadowed sides in full view. Unfortunately, in Great Britain there is often a haze in the cloudless weather needed for shadow photography. Haze reduces visibility much more when looking towards the sun than in the opposite direction, so the direction of view with most contrast is spoiled by reduced visibility. In these circumstances, it may be best to compromise by taking shadow photographs with the camera aimed at about 90° to the direction of the sunlight. Alternatively, visibility in hazy conditions can be improved by flying lower and thus reducing the thickness of haze through which the ground is seen, but there are limits to this, since the area covered by the photograph may become too small. Pairs of photographs taken from the same viewpoint, but at different times of day at intervals of a few months, emphasise different features on shadow sites, because of differences in the sun's direction (Figs 34 and 35).

Methods may need to be adapted to the local conditions in countries with climate and terrain very different from that of Northern Europe, on which the foregoing remarks are based. However, to judge from his published photographs, Poidebard appears to have worked in Syria on lines similar to those described here. Only one of his methods, i.e. taking photographs looking towards the sun when high in the sky (Poidebard, 1934, 11), is different; he appears to have flown at a very low level and recorded features shown by light reflected from the desert surface.

Stereo pairs of oblique photographs may be taken when circling a site. A convenient rule in the usual conditions of oblique photography is to allow about five seconds between successive exposures. A camera with motor drive should be used if possible.

The vertical view

A series of overlapping vertical photographs gives an accurate record of a large area of land. There is only one point at which each photograph should be taken, i.e. directly above the subject, and no question arises of searching for the angle from which sites show best. This can be a disadvantage, because faint crop marks do not show as well from directly above as from the best oblique view, but the loss of contrast is often compensated for by the good coverage of the whole site, parts of which may be obscure if only seen in the background of an oblique photograph.

The time interval between the overlapping photographs is controlled by an intervalometer, which must be set so that each exposure covers 60 per cent of the area covered by the previous one (Fig. 36A). This is termed the fore and aft overlap. The tracks of the aircraft should be planned so that the sides of the strips of photographs also overlap by about 25 per cent. These overlaps will only be correct if the effects of drift are taken into account. The adjustment to the aircraft's heading which is made to compensate for drift (Fig. 36B) will cause a strip of photographs to be produced which do not overlap correctly, as in Fig.

34 and 35. Ragnall, Nottinghamshire. Two views of the site of the deserted medieval village of Whimpton seen by shadows thrown by the sun low in the south (*above*) and low in the west (*below*). Each photograph shows details not visible on the other. In the background is the ridge and furrow of the medieval open fields. Photographs by the author, 11.30 a.m. on 4 January 1984 and 5.40 p.m. on 25 April 1984.

36. A: the fore and aft overlap of four photographs in a strip, and the side overlap of two strips of photographs. B: adjustment of the heading of an aircraft to compensate for the drift caused by a side wind. C: incorrect overlap of a strip of photographs taken by a camera which has not been rotated to allow for an adjustment in the heading of the aircraft.

36C. To remove this error, which is called 'crab', the body of the camera must be rotated slightly, so that successive photographs are in line, as in Fig. 36A. The photographer makes this adjustment with the aid of the camera viewfinder, on which an image of the ground is seen; he rotates the camera until points on the ground appear to be moving across the screen of the viewfinder parallel to its centre line.

The duties of the photographer, in the words of Wilson (1975, 31), 'require considerable concentration and coordination, as well as a good understanding between the photographer and pilot'. They include the control of the intervalometer, the elimination of crab, the levelling of the camera by centring a bubble, and all purely photographic matters, such as the shutter speed and the changing of film magazines. If there is a navigator, he will assist the pilot to line up the aircraft on the correct track *before* the actual photographic runs begin, but if not, the issuing of corrections about the exact heading is also the responsibility of the photographer. Many general descriptions of the procedures involved have been published (e.g. Kilford, 1979, 91-106).

It may be added that oblique photographs are sometimes taken with a vertical camera in a steeply banked aeroplane, something which must be more enjoyable for the pilot than the photographer.

Haze and cloud

A basic difference between photography from the air and on the ground is the lighting of the subjects. The lighting of aerial views is generally much more uniform than that of most out-of-doors subjects on the ground, except distant landscapes. Air photographs therefore tend to lack contrast, which is often further reduced by the effects of the atmospheric haze, caused by particles of moisture in the atmosphere between the ground and the camera. It is not possible to prevent the effects of haze from showing; they can be reduced, but not eliminated, by filters. As the flying height increases, so does the amount of haze through which the light has to travel. It is best to restrict photography to days when the visibility is at least 5-6 miles (8-10 km) at ground level.

The amount and height of cloud is very important. Successful vertical recording of large areas requires almost cloud-free and fairly calm weather, though small amounts of cloud may perhaps be avoided when photographing small areas. The conditions are less exacting when taking obliques, which may be done under cloud, provided that it is not too thick to allow adequate lighting of the ground below and that its base is not too low to leave space for the aircraft to manoeuvre safely: 3000 ft (900 m) or more is preferable. Under partial cloud cover there may be plenty of spaces with good sunlight, but as the amount of cloud increases, dark shadows may spoil pictures; clouds drifting across the sky have an unfortunate tendency to arrive over the place to be photographed at the same time as the aeroplane. It may be necessary to circle round, waiting for the right moment, and then it is often quite easy to misjudge the turn, so that by the time the aircraft is in position again, another cloud has arrived.

The most successful photographs are those taken in sunlight on days when the visibility is 20 miles (about 30 km) or more. The improved contrast of photographs taken under these conditions is noticeable. They may also be sharper, since the good light should make it easy to use fast shutter speeds consistently.

Cameras

Suitable cameras may be divided into three groups, the basic designs of which have remained little changed for some time, though they have been greatly improved in detail. They are 35 mm, medium-format and large-format cameras. The brief outline given here describes some of the main features of each group but does not cover details of particular models, which frequently alter with the introduction of new designs.

General notes on 35 mm and medium-format cameras

The cameras in this size range are those normally used for oblique photography. The high cost of the best-equipped models may be a problem when only a limited amount of flying is planned, but allowing for this constraint, it should be possible to select a camera that will give good results, given the high standard of design which has now been reached by many manufacturers. The first decision to be made is the film size, which determines the camera group. The important factors which then have to be considered are the type of lens and shutter, the number of exposures per film, the exposure meter and the ease of handling of the camera in the air.

Medium-format cameras, which take 220 type or 70 mm perforated-edge film, have many advantages and are a good choice for oblique photography. Cameras taking 35 mm film are also excellent for this purpose, but as the negative is smaller, it requires more enlargement to produce a given size of print, and definition must suffer, if only slightly. Both sizes of film may be subject to negative damage if badly handled, but the effects are more severe on the smaller size.

The focal length of the lens governs its angle of view and hence the area covered by the photographs, shorter focal lengths giving a wider angle. It is often necessary to record both small areas on which the details of archaeological features can be seen and large areas which include the land around sites; i.e.

both narrow and wide-angle views. Changing lenses to prepare the camera for these different views is inconvenient in the air and wastes flying time. It is therefore advisable either to take two cameras fitted with longer and shorter focal length lenses, or to take one with a zoom lens. The latter may give a marginally less accurate image.

Exposure times should be as short as possible in order to reduce image movement and thus improve the sharpness of photographs (see p.57). The shutter speed should range up to 1/1000 second if possible. Most cameras have focal plane shutters, which give this speed, but cause a slight image distortion (see p.56). Some cameras fit leaf shutters, which avoid the distortion but will not give a faster speed than 1/500 second.

The number of exposures per film varies. Cameras designed for general use take up to 40 exposures, but special backs may be fitted to hold much longer lengths of film, provided that suitable developing facilities are available.

Automatic exposure control is now standard on most cameras. This is a great advantage, since the light may change quickly, for example when the aircraft passes under a cloud. The control may be the aperture priority type, in which the aperture of the lens is set and the shutter speed varies, or the shutter priority type, in which the speed is set and the aperture varies. The latter type has the advantage that, by enabling a fast speed to be used consistently, it improves the sharpness of photographs.

For ease of handling when taking oblique photographs, the camera should be light and conveniently shaped. Cameras fitted with special handgrips and a motor drive are advantageous. The handgrips, which can be bought for most cameras, may be specially helpful when using telephoto or zoom lenses, which impair the balance of cameras and make it difficult to hold them steady. A battery-operated motor drive removes the need for the photographer to take his eye from the viewfinder when the film is wound on, so that it is easier to concentrate on the exact moment to take the picture as the scene passes by. It also enables stereo pairs to be taken easily.

The film is not held absolutely flat in most cameras designed for general purposes, though manufacturers have tried to improve the standard. Such cameras are described as non-metric, as opposed to metric cameras, which have special provisions to overcome

this and other sources of error. For specially accurate work, such as photogrammetric surveys, it is essential to use a metric camera.

35 mm cameras

The compactness, lightness and ease of operation of 35 mm cameras make them very suitable for use in the restricted space of a two-seater light aircraft, particularly when using separate cameras for different lenses or films. The weight of a modern 35 mm camera is under 1 kg, or up to 1.5 kg when fitted with motor drive and zoom lens. A camera fitted with a standard lens of 50 mm will record detail well on photographs taken from a height of 1000-2000 ft (300-600 m). If pictures of a larger scale are required, a telephoto lens with focal length of 100 or 135 mm should be used. Lenses should be of the high standard fitted to Canon, Leitz, Nikon, Minolta or similar cameras, which cause little or no measurable distortion of the image.

The standard film cassette holds enough for 36 exposures, which I find convenient for many flights. On longer flights up to three films may be used and some time must therefore be spent reloading, but this is not a serious problem. If a longer length is required, there are camera backs to take film for about 250 exposures.

With reasonable care, a standard can be reached with 35 mm cameras that is entirely satisfactory for almost all archaeological recording. All the photographs in this book taken by the author are from 35 mm negatives except Fig. 88.

Medium-format cameras

These cameras, which take 120 or 220 type film (62 mm wide) or 70 mm wide perforated-edge film have the advantage of a larger negative size. They weigh up to 2 kg, or up to about 3 kg when fitted with prismatic viewfinder, motor drive and handgrips. There are several different types of single lens reflex cameras which may be used successfully in the air. The more widely used are listed in Table 2.

It is worth mentioning also the 'press' cameras with eye-level direct vision viewfinders, made by Mamiya and Plaubel, but these apparently have no users among air photographers at present. All the above cameras have good quality lenses, the final quality of the image depending in general on the price.

The negative sizes vary according to the camera model, the most common sizes being 60 mm square and 60 by 45 mm. The number of exposures varies from 12 for 60 mm square negatives on 120 film, to 30 for 60 by 45 mm negatives on the longer 220 film, and 70 for the 60 mm square negatives on the 70 mm perforated-edge film which is loaded into the special Hasselblad magazine. 120 film is the least suitable because of its short length and the time that is consequently lost while changing films in the air.

Metric cameras of similar general design are available from Hasselblad, though at considerable extra cost.

Cameras specially designed for aerial use are manufactured by Vinten and Linhoff, though at a price that few archaeological photographers are likely to be able to afford. The Vinten F 95 camera, for example, which was designed for low altitude oblique photography from Royal Air Force aircraft, has a magazine for enough 70 mm film to take 500 exposures, motor drive, a vacuum system to hold the film flat and a focal plane shutter with a fastest speed of 1/2000 second. It weighs 7 kg and requires the extra space of a four-seater aeroplane.

Large-format cameras

The importance of photogrammetry in the production of maps has led to the development of special

Table 2. Medium-format cameras

Description	*Makers*
Cameras with waist-level viewfinders, which are adapted by fitting eye-level viewfinders	Zenza Bronica, Hasselblad, Mamiya, Rolleiflex
Camera with eye-level viewfinder, similar in general design to 35 mm reflex models	Pentax

large-format metric cameras to take the necessary vertical photographs, which are of superb definition and sharpness. They are very large and expensive instruments, for which the standard film width is 240 mm. The lens is generally of wide-angle type and the film is kept flat by a vacuum apparatus, which holds it against a plate. The Wild RC8 camera used in the Cambridge University aircraft weighs 103 kg with its film magazine. Extra magazines weigh 17 kg. This load necessitates the use of a twin-engined aircraft. The camera is mounted above a hole cut in the fuselage.

Finally, the old Williamson F 24 camera must be mentioned. It was formerly used by the Royal Air Force, took 140 mm wide film, and was fitted with two hand grips to take obliques, or motorised and mounted in the aircraft to take verticals. This camera is now out of date, but was much used in the past. Most of the earlier photographs in the Cambridge collection were taken with F 24 cameras.

Modifications to light aircraft for vertical photography

Vertical photography of a standard satisfactory for many purposes can be done with a medium-format camera mounted in a light aircraft which has been suitably modified, provided that the engineering design and installation are correct and that the appropriate Civil Aviation Authority approval has been obtained. Installations have also been made for 35 mm cameras. A considerable number of organisations in various parts of the world are using equipment of this type, though the expense of owning and modifying an aircraft have so far ruled out their regular use by archaeologists.

The method of installation depends on the type of aeroplane. If a hole is cut through the floor of the cabin, it must avoid control cables and not weaken the airframe unacceptably. If a blister or pod is fitted to the side of the fuselage, it must not affect the flying characteristics unduly.

Various installations have been described. The Hasselblad 70 mm camera mounted over a hole in the cabin floor of a Cessna 182 aircraft by Aerial Survey Inc. of Miles City, Montana, USA (Woodcock, 1976) appears to be one of the best. The aircraft is operated by a two-man crew, pilot and photographer. The installation allows the ground to be watched with the aid of a prism, which replaces the usual Hasselblad viewfinder hood. Access to the camera is easy, and it is convenient to make adjustments.

Film

Black-and-white panchromatic film provides excellent records, but for some purposes monochrome is not enough and the extra information given by colour is an advantage. Most archaeological photographers find the best solution is to make their basic record in black-and-white, supplementing it with a smaller number of colour pictures. Infra-red film also has applications, but only the false colour variety is important.

Panchromatic black-and-white film

A good choice of films is available, ranging from slow-speed and fine-grained to high-speed and rather coarse-grained material. The best film for a given set of circumstances depends on the range of lighting conditions expected and the degree of enlargement that is to be made when printing. Films such as Kodak Panatomic X and Ilford Pan F, the rated speeds of which are 32 and 50 ASA respectively, will permit very big enlargements to be made without trouble from 'grain', but it needs a good light to allow the fast exposures of 1/500 or 1/1000 second that are preferable. Ilford FP4 and similar films rated at 125 ASA are slightly less contrasty, but they may be exposed with successful results in rather worse lighting conditions, e.g. when the sun is low; I almost always use them. Ilford HP5 and other films rated at 400 ASA or thereabouts still give quite fine grain and allow fast exposure speeds in poor light.

It is usually advisable to take steps to increase the contrast of negatives by slight under-exposure and over-development. With a good light, the exposure may be halved and development time increased by about 25 per cent. Assuming that an exposure meter is used, the necessary adjustment to the exposure time will be made by setting the meter to twice the rated film speed (thus Ilford FP4 is metered at 250 ASA instead of 125 ASA). This helps to emphasise faint marks on the ground. A similar meter setting should be used for snow scenes, but when the light is less satisfactory, as on earthworks emphasised by shadow and most winter subjects, the rated film speed should

be set.

Buildings seen in bright sunlight may, on the other hand, have too much contrast, and some photographers recommend slight over-exposure, setting the meter at less than the rated film speed, followed by slight under-development. Whatever the conditions may be, the individual photographer can find the best answers for his own conditions of work by experimenting with short lengths of film, exposing several frames under similar lighting but with different exposures, and trying different conditions of development. One of the advantages of black-and-white film is that development is such a simple matter that test strips can be processed soon after a flight.

A yellow filter slightly improves the contrast of black-and-white negatives exposed under hazy conditions. Since haze is common and not always predictable, it is best always to fit this filter.

At the enlarging and printing stage, the appearance of pictures can be greatly improved by selection of the correct grade of paper. A contrasty grade is usually needed for photographs of crop marks and a normal grade for those showing 'shadow sites' or buildings.

The ease of processing black-and-white material is its main advantage. With simple laboratory equipment, the films can be developed and printed cheaply and the quality of the prints improved by selecting the correct grade of paper to allow for differences in the negatives. For those who develop and print their own photographs, it is the cheapest medium, but the charges for commercial processing of black-and-white film are similar to those for colour film.

Colour film

Colour photographs seldom record the shapes of features on archaeological sites any better than photographs in black-and-white, but they give more information about the country in general and are easier to understand. It is helpful, for example, to know the colour of crops in which marks are seen. Colour photographs are considered less suitable as archive material than black-and-white because of the possibility that their colours will fade in the long term.

The camera may be loaded with either reversal film, which produces colour transparencies, or negative film, from which prints are made. Kodak films with speeds of 200 ASA will give good records in the summer, but in winter, when the light is worse, it may be best to choose faster film, at the expense of slightly coarser grain. The exposure meter should be set at up to twice the rated film speed for a good light and at the nominal film speed at other times. A skylight filter should always be used to eliminate unwanted ultra-violet light and improve the colour balance by cutting out some blue light.

Development and printing is normally done in a commercial laboratory. There are no different grades of printing paper, so no compensation can be made during printing to reduce the effect of problems such as the pale and 'washed out' appearance of films exposed on hazy days.

If necessary, transparencies can be made from colour negatives, or prints from transparencies, so the choice between the two types of film is not final. Black-and-white prints can be made from colour negatives using panchromatic paper, and from transparencies by making intermediate black-and-white negatives and printing them; the second alternative involves slight loss of sharpness.

Infra-red film

Two types of infra-red film are available: false colour reversal film and black-and-white film. Both must be used with the recommended filters to exclude blue light. Only the false colour film is suitable for 35 mm and medium-format cameras. It has some useful applications, though some archaeologists may use it more for the striking colours of the pictures than for its advantages in recording sites.

It is not difficult to obtain good results with false colour film, provided that it is only exposed in sunlight or under thin cloud. The transparencies show the colours on the ground with a false rendering, for example, healthy green vegetation appears red, bare soil or rock are green if dry and dark if wet. Water and shadowed areas are black. The most common archaeological use is to emphasise crop marks; in a green field, better growth is shown as darker red, while stunted growth is paler. Other important applications are the location of the lines of old walls, partly overgrown by vegetation, and the detection of wet areas, which show as darker bands in the summer when the rest of the soil is dry.

Black-and-white infra-red film has reactions similar to false colour film. On prints, green vegetation

56

appears light-toned, while water and shadows are black. The available Kodak film has the disadvantage of very large grain size, which spoils the sharpness of pictures except for those taken with large-format cameras.

Exposure meters should be set at 100 ASA for Kodak Ektachrome false colour films, though it should be remembered that the meters are designed for visible light, not infra-red radiation, and it may be advisable to bracket exposures, i.e. take extra exposures, allowing one stop more and less. A deep yellow filter must be used.

All infra-red films penetrate haze to a limited degree, because the light reflected from the atmospheric particles is largely from the blue end of the spectrum, which the filter does not allow to reach the film.

A special focus mark for infra-red is found on

For reasons of cost, it is not used in routine archaeological photography, though an array of 35 mm cameras could be mounted for use in a light aircraft. Experimental photography of crop marks in Southern England has been done by a commercial firm on behalf of the Air Photographs Unit of the National Monuments Record, using panchromatic black-and-white film with various different filters, colour film and false colour infra-red film in an array of four medium-format cameras. It was found that the panchromatic film with yellow or orange filters gave the best results on some occasions and the false colour infra-red film on others (Hampton, 1974).

Filters

Table 3 shows which filters should normally be used with which films.

Table 3. Filters

Film type	Filter	Wratten no.
Panchromatic black-and-white	Light yellow	3 or 5
Colour	'Skylight' (faint pink)	1A or 1B
Infra-red false colour	Deep yellow	12 or 15
Infra-red black-and-white	Red	25
	or opaque	89B

cameras, but in the air, when the focus is set at infinity, this may be disregarded except at very wide apertures.

Multiband photography

The information obtained from different wavelengths of light is not identical. It is possible to take advantage of this to solve problems which may be difficult to explain by other means. The subject may be photographed by several cameras simultaneously, each loaded with a different type of film, or with the same film but different filters. This technique is known as multiband photography (Curran, 1985, 72). The cameras are mounted in a frame, so that their shutters can be operated simultaneously.

The applications of multiband photography are mainly in environmental studies; in forestry, for example, areas of diseased trees may be identified.

Effects of aircraft movement

The movement of the aircraft has two effects on the image of the ground recorded by a photograph. Some degree of blurring or lack of sharpness is caused, and on pictures taken by cameras with focal plane shutters the image is slightly distorted.

To consider the blurring of the image, we may take as an example an aircraft flying at 100 mph (160 kph) and at a height of 2000 ft (610 m), from which photographs are taken by a 35 mm camera with a 50 mm lens. Assuming an exposure time of 1/1000 second, it may be calculated that on a print enlarged five times to 180 by 120 mm (7 by 4.7 inch) the image movement will be 0.015 mm (0.0006 inch), which is not noticeable. As the exposure time is lengthened, the amount of image movement increases in proportion, and at 1/100 second the movement

recorded by a similar enlarged print will be 0.15 mm (0.006 inch), which will cause appreciable lack of sharpness. It is clearly essential to keep the exposure at as fast a speed as possible. The amount of movement, which varies with the ground speed and altitude of the aircraft, and the focal length of the lens, can be read on the time-motion dial of the Kodak Aerial Exposure Computer card.

The image distortion caused by focal plane shutters arises from the admission of light to the film by a slit which travels across it. Assuming that the slit passes across the film in 1/60 second, an average figure, and that the aircraft has a ground speed of 100 mph (160 kph), the camera will be carried 0.8 m through the air while the shutter is in motion. It is therefore possible for a point on one edge of a photograph to be represented as 0.8 m further from a point on the other edge than is actually the case. The distortion will increase progressively across the photograph. In practice, the actual amount and direction of the distortion depends on the way in which the shutter moves in relation to the movement of the aircraft. The error arising from this effect is serious in a photogrammetric survey made for cartographic purposes, but may be ignored in the normal archaeological survey, in which the features recorded by the photographs are plotted on an accurate base map, independently prepared.

The distortions due to the focal plane shutter are not present on photographs taken by a camera fitted with a leaf shutter, which is mounted between the units of the lens.

Scale of photographs

For useful information to be obtained from an air photograph, the size of the image of the earth's surface must be large enough to show the necessary level of detail. In most cases the working range of scales of the prints used by interpreters is between 1/10,000 and 1/1000, but larger and smaller scales also have applications.

1/50,000 to 1/20,000: useful in the study of the natural features of the landscape, its geology and vegetation, and for very large man-made features, such as canals.

1/10,000: the smallest scale likely to yield consistent information about the shape and size of early constructions. The units of the early countryside were

often small: prehistoric fields, for example, may be only 30 m across, which would form an image only 3 mm across at this scale.

1/5000: large sites such as hill forts may be illustrated well at this scale, which is also suitable for an area of ancient fields or large crop mark sites.

1/2500 to 1/1000: most smaller or very detailed sites are best studied with the aid of photographs enlarged to this scale.

1/250: used for detailed close-up shots of excavations taken with a long focus lens.

The method of calculating the scale of a photograph taken at a certain height by a camera of a certain focal length is given on p.65.

Remote sensing

The term remote sensing is used to describe the various methods of recording and processing information about the earth's surface obtained from distant sources. Air photography is a form of remote sensing, but the term is generally used for newer methods. These have so far had few archaeological applications, either because of expense or because of low spatial resolution, but they should be kept under review: progress is fast and the present disadvantages may be overcome.

Multispectral linescan

Radiation from the ultra-violet, visible light and infra-red wavebands are used in this method to produce images with similar properties to photographs, though the means of recording are completely different and there are more possibilities of manipulating the results (Curran, 1985, 101). Unfortunately, surveys by multispectral linescan are expensive in comparison with photography and are unlikely to give results sufficiently better than photography to justify the increased cost, though multispectral surveys made for other purposes might with advantage be scrutinised by archaeologists.

Thermal infra-red linescan

Thermal radiation can be recorded either on special apparatus originally developed for military use, or as one of the wavelengths handled by recent designs of

multispectral linescanners (Curran, 1985, 109). The differential heating of areas in full sun and in shadow will record earthworks in a way similar to that seen on photographs of shadow sites (Baker, 1975). This method can be used at night to record residual temperature differences. Again, it is much more expensive than photography.

Sideways-looking airborne radar (SLAR)

Microwaves transmitted from and recorded in an aircraft will produce an image of a strip of land at the side of its flight path (Curran, 1985, 115). The method can penetrate cloud and can be used by day or night. An interesting archaeological application has been in the recording of Maya canals in Belize, although they are now silted up and covered by tropical vegetation (Adams, 1980), which hampers normal air photography. The radar imagery was at the small scale of 1/250,000, but it covered 80,000 sq. km. and a great deal of information was recorded.

Spacecraft

Most spacecraft are unmanned satellites. Some carry sensors which scan the earth's surface and transmit signals that can be displayed on the ground as picture elements or pixels. These combine to give an image of the area recorded, which may be compared with a very fine mosaic: it gives the general impression well, but is limited in the resolution of detail. Pictures from sensors aboard the first Landsat satellites, which provide an enormous amount of useful information, have a ground resolution of about 80 m. They are intended for the delineation of large features, though the presence of smaller features can be detected. It was possible to trace irrigation canals 20 to 25 m wide made by Hohokam people in Arizona, USA, by means of pictures from sensors on the Landsat, and higher spatial resolution images from the Skylab satellites (Ebert and Lyons, 1980). Similarly, the lines of ancient canals in Iraq have been traced on Landsat imagery (Adams, 1981, 33). The size of pixels has been reduced recently and ground resolution is now 10 m, but there is no sign that this imagery will have a spatial resolution equal to that of low-level air photographs. Archaeologists will, no doubt, find many uses for satellite sensor data about environmental, geological and geographical subjects, but such applications fall outside the scope of this book.

Manned satellites, such as the Space Shuttle, are much better adapted for forms of conventional photography since the results can be brought back to earth as photographic films, without the need for electronic transmission. As a result of the great height at which they operate, the photographic images of ground features are extremely small even when taken with very long focus lenses, but the existence of such platforms in space suggests exciting prospects for the future.

5

Interpretation and Mapping

Most of the vast number of air photographs in existence in various parts of the world are verticals. As sources of information for cartography they are excellent, but the archaeological data they contain is incidental and may be 'hard to find. In contrast, the specialised archaeological collections consist mainly of oblique views, which usually show archaeological information prominently, but have disadvantages when used in making maps. Whichever type is under examination, the data contained must be assembled and drawn on maps if the photographs are to be more than just interesting pictures of ancient remains. This essential task of mapping requires much thought and preparation (Hampton and Palmer, 1977).

Since oblique photographs record so much, the methods used in mapping them are very important and form the main subject of this chapter. Less attention is given to verticals, since methods of mapping from them are described in many books on photogrammetry (e.g. Wolf, 1974; Kilford, 1979).

Interpretation

Before maps can be drawn, the information recorded on the photographs must be interpreted. The photographic image gives the shapes of everything visible when the film was exposed – the buildings, roads, fields, woods and all the other features of the modern landscape, together with any ancient remains. Everything is shown from an unusual angle of view, but it is not difficult to get used to this. The modern features must be identified, a process which is fairly easy if the photographs show land which is well known to the interpreter, but more difficult when they cover an unfamiliar type of country. Where ancient remains are to be seen, they should be identifiable as anomalies, different from the modern pattern of land use. The shapes of these anomalies may be of great

significance to the archaeological interpreter, who may quickly recognise ancient remains of certain types.

When looking at a photograph, the archaeologist usually requires three different kinds of information about a site: first, its geographical location, secondly, everything which can be deduced about the ancient remains traceable on it, and thirdly, the nature of the country and of modern land use. This must be extracted by recognition of numerous details in ways that are also used by interpreters of air photographs in other disciplines, such as military intelligence, or the study of geology, soils or vegetation. The principal characteristics of photographic images are generally grouped under a few headings, of which colour, shape, size, pattern, texture and shadow are the most important.

Colour differences, or, on black-and-white photographs, differences of tone, are the means by which all information is conveyed. A colour photograph can tell more than one in black-and-white, but for most purposes the rendering of the landscape by the latter is satisfactory as a record of archaeological sites. There are, however, circumstances in which the evidence can be misleading, for example in early spring, when black-and-white pictures tend to show much the same shades of grey for both the brown earth in ploughed fields and the green of the young plants of winter crops. In this case it may not be certain whether a black-and-white photograph shows soil or crop marks.

The shape of an image is the most important clue to the identification of the feature which it represents. The rectangular outline of a building, the long line of a road, bordered by the darker lines of the hedges on each side, the variously shaped plans of fields and their hedges, and many other shapes are easily recognised. The aerial view is very important in the

appreciation of shapes which are not easily understood by a person standing on the ground, e.g. the Roman camp seen in Fig. 96.

The size of an object, if known, supplements the knowledge gained from its shape. In the first examination of a photograph of unfamiliar country, it might be impossible to decide whether a rectangular image represented a small house or a large factory, but the question will easily be settled once the scale of the photograph is known. Alternatively, in a well known region, the sizes of houses could be estimated and would give the interpreter an idea of the dimensions of a nearby archaeological site.

Pattern is the orderly arrangement of related shapes. A town can be recognised by the arrangement of its roads and buildings; on a larger scale, geological formations are indicated by the lines of hills where hard rocks outcrop. To the archaeologist, the identification of a pattern can be very important, e.g. the remains of Roman centuriation in Fig. 84.

Texture is the effect caused by the repetition of many small features close together, such as the trees in a wood, or the plants in a meadow. In Fig. 1 the wood appears dark-toned and 'knobbly' and the meadow light-toned and fine-grained. Woods are frequently very important clues when trying to match a photograph with the corresponding position on a map in order to fix the location of a newly found site.

Shadows are very useful indicators on photographs taken when the sun was shining. They give the relief of archaeological features seen under a low sun and also suggest the relief of the landscape in general, though this is better studied with the aid of a series of overlapping photographs and a stereoscope. Provided that the time when the photograph was taken is known, shadows supply a means of finding north, which is another important clue when trying to identify the position of a site on a map.

Bias

When examining single oblique photographs taken during reconnaissance flights, it must be remembered that they show places chosen by the photographer, whose decisions about what to record may not always have been entirely correct. It is always possible that important sites have been missed. In contrast, overlapping verticals show everything visible at the time they were taken. The bias in the choice of subjects recorded by obliques must be taken into account.

The interpreter, similarly, may not be consistent in making decisions about differences of tone on photographs and the meaning of the images they show. There are techniques for image enhancement, which may be used to maximise the value of the recorded information (Curran, 1985, 176), but it has not yet been demonstrated that the cost of the equipment necessary is justified by the archaeological results. A technique commonly used is density slicing, which isolates the areas of specified ranges of tone on the image.

Misleading marks

The success of an aviator on a reconnaissance flight or an interpreter examining photographs depends on a good knowledge of the natural and man-made features of the landscape and an ability to identify the traces of earlier human work.

Ancient features may form part of the modern landscape, such as the Roman boundaries seen on Fig. 84, which have been incorporated into modern field walls, or they may have no relation to it, such as the earthworks on Fig. 54, which are caused by long-forgotten ancient features unrelated to anything modern. Once seen, features such as these are easily recognised the next time they appear, but there are many others which are less well defined and much more difficult to classify. Some of the mounds and ditches seen on shadow photographs could belong to any period, though recent earthworks may be distinguished by their sharper outlines. Crop marks are particular sources of difficulty, and experience is needed before it is possible to separate those of probable ancient human origin from others due to natural causes, current farm work or civil engineering work. Because crop marks are so seldom visible to an observer on the ground, this experience can only be gained while actually flying or looking at photographs.

Modern farm work causes more marks in crops than anything else. Lines parallel to field boundaries are very common and are generally due to the uneven application of fertiliser, or some similar cause. The 'envelope pattern' is often prominent as diagonal lines extending from the corners of fields where the tractor turns (Figs 72 and 76). There are many other recent agricultural marks, but all are easily identifiable

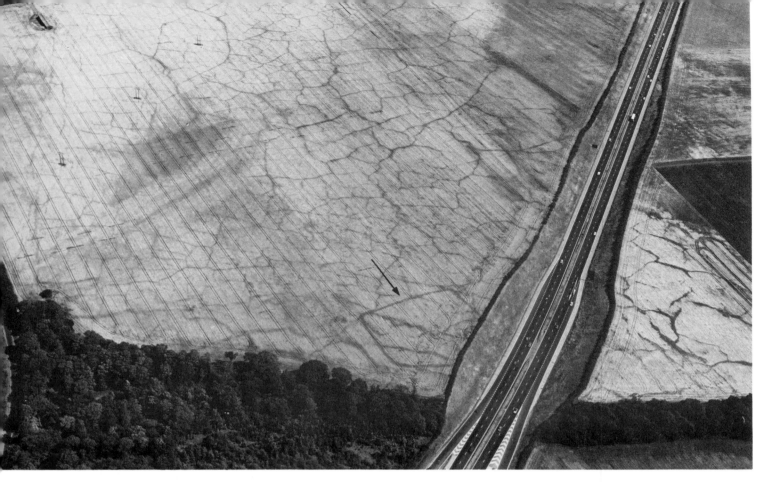

37. Brodsworth, South Yorkshire. An intricate network of crop marks caused by fissures in limestone rock underlying the soil. An arrow marks the crop mark of a rectilinear enclosure. Photograph by the author, 29 July 1979.

when the photographs of two or more years are compared, because they are different every year, while marks of ancient origin stay the same.

Ditches and pits of ancient origin tend to cause more distinct crop marks than those dug recently. The former are usually caused by accumulations of soil and vegetable matter in depressions which were open for long periods of time and only gradually filled. In this they differ from most modern holes and trenches, which are seldom left open for long and do not silt up slowly like those on ancient sites. Modern trenches may indeed cause negative marks, and the disturbance caused by a pipeline trench shows as a straight line which in some places might be taken for a Roman road (Fig. 100). On the other hand, there are distinct positive marks on modern systems of land drains (Fig. 80) and often, but not always, on the ditches of former land boundaries, which have been removed to enlarge fields. Such boundaries look ancient, but their relatively recent date can often be established by

reference to large-scale maps.

Various characteristic soil patterns sometimes occur (Evans, 1972), e.g. that seen on the base of Fig. 69, and soil depth variations cause the uneven dark and light tones of the background of most soil and crop mark photographs (Figs 3 and 13). Patches of soil may be so deep that crop marks do not develop even though they show nearby; this is probably the cause of the uneven results shown in Fig. 25. Former stream and river beds are often visible: in the Cambridgeshire and Lincolnshire Fens there are everywhere the meandering courses of streams shown by soil and crop marks, and in some river valleys in hilly country, crop marks show the positions once occupied by torrential streams, which often shifted their beds. Crop marks formed above the fillings of quaternary ice wedges are prominent on many gravel areas, where they can be mistaken for the boundaries of fields of very irregular plan. Fissures in the surface of limestone rock form a characteristic reticulated crop pattern (Fig. 37), and the outcrops of strata in various formations may produce bands of better and worse growth (Fig. 76).

This account of non-archaeological features which the interpreter must recognise could be continued at

length, but a good illustrated account is already available (Wilson, 1982a, 141-82). Practice in looking at sites shown on air photographs and common sense are the main qualifications needed to understand the varied problems. It must be admitted that most of those working on the subject have had to own up to mistakes, sometimes of an amusing nature, such as

38. (*below*) The Haven, Winteringham, South Humberside. When first found, the marks of a square inner enclosure, surrounded by a rounded outer enclosure, were compared with the plan of a Roman military post. Suspicions were aroused when it was realised that this was a field of mown hay, in which crop marks are unlikely to appear. It later transpired that they had been caused by trampling of the grass at a gymkhana held in the field a few weeks before! Photograph by the author, 28 June 1978.

the supposed Roman post seen in Fig. 38.

Finally, the danger of drawing conclusions from negative evidence, i.e. from the absence of crop marks, must be stressed. To do so may be very misleading, for the effects of wet weather or unsuitable soils may inhibit the development of marks on sites where extensive ancient remains exist.

Stereoscopes

Two overlapping air photographs, either oblique or vertical, give a three-dimensional impression of the ground surface when viewed through a stereoscope. There can be surprising differences between the appearance of a single photograph seen with the

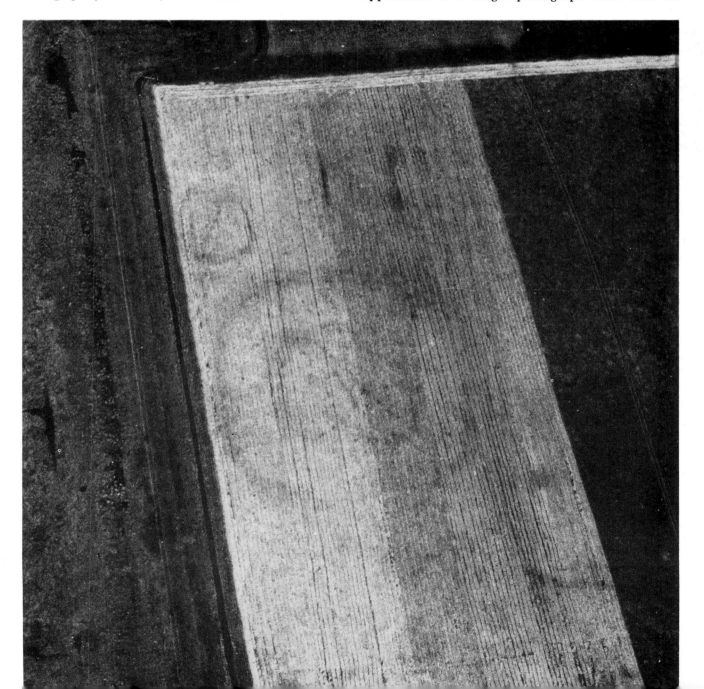

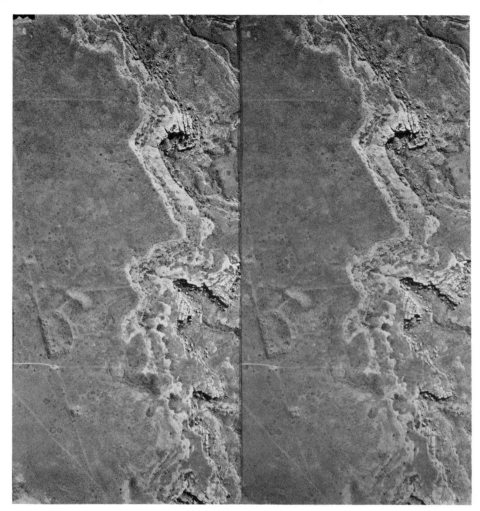

39. Chaco Canyon, New Mexico, USA. Strips from two overlapping vertical photographs, positioned for viewing through a pocket stereoscope. They show the ruins of Pueblo Alto, one of the more important sites in the Chaco Canyon National Monument, and the adjacent cliffs at the edge of the canyon. This is one of the pueblos built by Anasazi people between the tenth and twelfth centuries AD.

naked eye, and the same photograph, along with one that overlaps it, seen through a stereoscope. The former gives only a plan view in two dimensions; but the latter show height variations, which are usually exaggerated when seen in this way; steep slopes, for example, appear precipitous. Photographs viewed through a stereoscope may provide an interpreter with a great deal of extra information.

Both pocket stereoscopes and mirror stereoscopes are commonly used (Kilford, 1979, 135). Fig. 39 shows two strips cut from overlapping vertical photographs,

arranged for examination through a pocket stereoscope. This simple type of instrument has the disadvantage that its field is too small to allow more than parts of a pair of large photographs to be examined at one time, though it is not necessary to cut them in strips; a little ingenuity in turning up the edge of one of the photographs enables a lot more to be seen. The mirror stereoscope overcomes this difficulty by the extra width between the mirrors under which the photographs are placed, and the whole overlap of the pair can be examined conveniently. It may be fitted with a binocular magnifier to enable details to be seen more clearly.

Geometric properties of air photographs

An air photograph is a record on a flat film of the uneven surface of the ground. The geometry of the

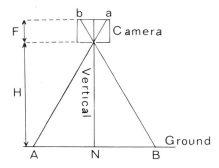

40. The scale of a vertical photograph equals the focal length (F) of the lens divided by the height above the ground (H).

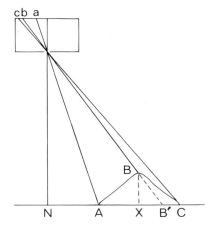

41. Diagram illustrating the displacement of the image b of a high point B. The photograph makes it appear to be at B′, whereas its map position would be at X.

relationship between the two surfaces is complex (see Kilford, 1979, 66-90) and need not be explained here, but it is necessary to mention a few particularly important points.

Scale

The ratio between the aircraft's height above the ground and the focal length of the lens of the camera determines the scale of a vertical photograph. On Fig. 40, H is the height and F the focal length, AB is a line on the ground and ba the corresponding image on the photograph. From similar triangles it will be seen that

ab/AB = F/H

But ab/AB is the ratio of the size of the image and its corresponding shape on the ground, i.e. the scale of the photograph. The scale is therefore equal to the focal length of the lens divided by the height above the ground.

As an example, in a camera with a 50 mm lens at a height of 500 m (1640 ft) above the ground the scale of the image on the negatives would be 1 in 10,000. If the ground were perfectly flat and the camera exactly vertical this scale would hold good for all parts of the photograph, but in practice there are distortions caused by the unevenness of the ground surface and tilt of the camera.

This account assumes a vertical view and does not apply to oblique photographs, in which the scale varies between the foreground and the distance.

Ground height variations

Although the wall XY in Fig. 54 runs across country in a straight line, the unevenness of the ground makes it seem to bend. Similar effects are demonstrated by Fig. 41, a diagram representing a camera taking a photograph of a hill rising from level ground. Points A and C at the base of the hill are equidistant from its highest point B, but on the photograph plane the distances ab and bc are not the same. This is because the camera records B as if it were at B′, whereas a map would show it at X, a point vertically under B. Point b on the photograph is therefore considerably displaced in comparison with the map position X.

This displacement is reduced as the distance NX decreases, i.e. as the camera moves towards the hill. If it were vertically above B, the photograph would show distances ab and bc as equal. The result of these effects is that only in the centre of a vertical photograph is the representation of uneven ground without distortion, and towards the edges of the photograph the distortion becomes progressively greater. When using vertical photographs for guidance about the positions of objects on the ground, it is necessary to remember these distortions; such photographs are not equivalent to maps, as is often assumed.

Technical terms

A few terms must now be defined. They have been slightly simplified, and for more precise statements reference should be made to books on photogrammetry (e.g. Kilford, 1979, 88-90).

A small cross is seen at the centre of a photograph

42. Collimating marks at edges of photographs and principal point P. The principal line is obtained by joining the principal point and the nadir point. Plate parallels are at right angles to the principal line.

taken with some metric cameras. Alternatively, there may be small marks, known as collimating marks, at the edge of the photograph, which can be joined to give the same point at the centre (Fig. 42). This is the *principal point* of the photograph, a point immediately behind the centre of the lens.

The spot on the ground vertically beneath the camera at the moment the negative was exposed is the ground nadir or plumb point (N on Fig. 40). This point is outside the area covered by most oblique photographs, but it will certainly be within the field of all vertical photographs, on which the *nadir point* of the photograph (the image of the ground nadir point) will be very near the principal point, and would coincide with it if the camera were exactly level at the moment of the exposure.

On an oblique photograph the line joining the principal point to the image of the nadir point is

termed the *principal line* (Fig. 42). Lines drawn at right angles to it are called *plate parallels*, and they have the useful property of being lines of constant scale. The scale of each plate parallel is, however, different; it diminishes from the foreground to the background of the picture, as common sense would suggest.

Mapping oblique photographs

Preparations

Many archaeological sites have been recorded by a succession of photographs taken over a number of years. Before the map is begun, all available photographs should be systematically examined. Some of the information they contain may be very clear, but in other cases it may be less easy to interpret, and it is often necessary to combine the evidence from a number of photographs. A common problem with obliques is that many of them do not cover large enough areas to include the landmarks

PHOTOGRAPH

M
250

X Y Z

MAP

43. A polygonal network used to rectify the image on an oblique photograph. *Above,* the tracing of the photograph; *below,* map with rectified drawing of crop marks. Ten points at hedge junctions are joined to make the network. An eleventh point Z is provided by producing the line of the hedge XY until it meets the hedge at the right of the photograph. The photograph showed ancient field boundaries at Tickhill, South Yorkshire.

necessary to fix their positions accurately, but a key photograph is usually to be found which includes the points needed. It is helpful to keep records of doubtful questions and about the photographs that have been consulted.

A sheet of clear film should be fixed on the photograph which is to be used. As the archaeological features are identified, their outlines should be traced exactly over their positions on the photograph. The control points, such as corners of fields or angles of buildings, should also be accurately traced on to the clear sheet, which then becomes a record of the interpretation of the photograph. Comments about doubtful items may also be written on the sheet. By action of this kind, interpretation can be made a separate stage from mapping, on the mechanical details of which it is then possible to concentrate without distraction. When the final version of the map is drawn, the photographs should be referred to again to ensure that details are correctly represented.

A visit to the site is advisable during work on a map. The main purpose is to get to know the topography of the area, and thus to appreciate its possible use in early times, so that interpretation and mapping may be done in an informed manner. At the same time, detailed points may be investigated, such as the verification of landmarks used as control points, and the degree of unevenness of the surface.

Preliminary mapping by freehand sketching is helpful in the initial investigation of a collection of air photographs, or in summarising the results of one's own flying. After this has been done, more accurate work should follow.

The methods of mapping oblique photographs described below may be divided into two groups, graphical procedures and computer-based procedures. The latter are far more satisfactory, but if suitable computer equipment is not available, the graphical methods, though more laborious, will produce good results. It should be remembered that all the methods, except the three-dimensional computer programs, treat the ground as plane, i.e. reasonably level or on a uniform slope.

The polygonal network method

This is the simplest of the three graphical methods given here. It is based on the fact that where the ground is plane, a straight line on a photograph is also straight on the map. If five or more points, such as the corners of fields, can be identified on both the photograph and a map of the area, and lines are drawn to join these points, they will form a network which will act as a guide when sketching shapes from the photograph on to the map. An example is given in Fig. 43.

The four-point or paper-strip method

Only four fixed points, such as the corners of a field, are needed in this method, which can be used to find the position of a spot located anywhere in the area they enclose. A series of points thus located will provide accurate guidance when plotting on a map.

Suppose a point x on a photograph is in a field with four corners at a, b, c and d (Fig. 44). The same four corners on the map are at A, B, C and D. Draw the rays ab, ac and ad on the tracing of the photograph, and AB, AC and AD on the map, and produce them. Add the ray ax. Fold a strip of paper to make a straight edge, place it on the tracing, and mark it where it cuts ab, ac, ad and ax. Then place the paper strip on the map and adjust it so that the marks for the rays ab, ac and ad coincide with the rays AB, AC and AD. Put a mark on the map opposite the mark on the strip where it cuts ax. Join this point to A. This will give the ray AX, on which the precise position of X is still to be found.

Repeat the procedure, drawing rays ba, bc, bd and bx, and constructing the ray BX. The intersection of AX and BX will give the position of X, the point on the map corresponding to x on the photograph. For improved accuracy, the construction may be repeated again to draw the ray CX, which will form a very small triangle with AX and BX. The best position of X is at its centre.

Though slow and tedious, this method is useful. It has stood the test of time, for it was used during the First World War.

Plate parallels

By joining the nadir point to the principal point, the principal line of a photograph is constructed. Plate parallels may then be drawn at right angles to it (Fig.

FIRST STAGE

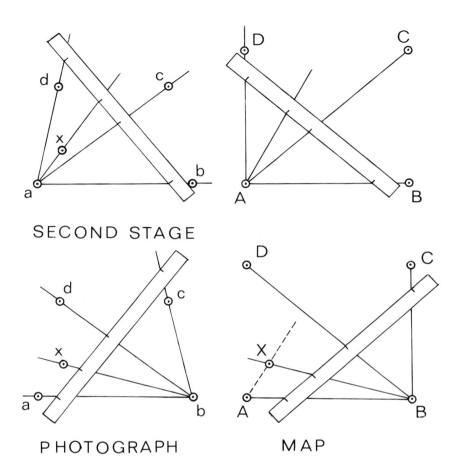

SECOND STAGE

PHOTOGRAPH MAP

44. The four point or 'paper strip' method of finding the position of point x.

42). These are lines of constant scale and therefore, if the map positions of two points on a plate parallel are known, other points may be scaled off between them, which can facilitate plotting. The plate parallels may be drawn to intersect two points on the map, but if this is not possible a missing point may be supplied by the paper strip method.

The weakness of this method is the difficulty of finding the nadir point. The usual procedure is by convergent vertical lines, such as the corners of tall buildings or electricity supply masts. If these are produced, it will be seen that they converge (Fig. 45) on the nadir, though due to inaccuracies several lines seldom meet in a point. Unfortunately, few photographs show the requisite vertical structures, because most photographs are of sites in open country. A further problem is the absence of collimating marks on many photographs. Without them the principal point can only be found approximately by joining the corners of negatives. Plate parallels are therefore seldom used for accurate mapping, but a knowledge of this property of air photographs may assist in the estimation of distances during sketch mapping.

Two-dimensional computer mapping

The transformation of the image on a photograph to plan view on a map can be done more quickly and accurately with the aid of a computer than by any

45. (*above*) Dunston's Clump, Babworth, Nottinghamshire. Crop marks of enclosures of Romano-British date and field boundaries seen in ripening barley (the light-toned crop at the centre) and sugar beet. Arrows show control points used in Fig. 46. The vertical lines of the electricity supply poles along the upper hedge have been produced to demonstrate the approximate position of the nadir point, on which they converge some distance below the base of the photograph. Photograph by the author, 17 July 1979.

B

46. A (*opposite, below*): interpretive tracing of the crop marks in the light-toned field shown on Fig. 45. Control points are marked by crosses. B (*above*): computer plot made from the interpretive tracing. The original was at a scale of 1/2500. C (*below*): fair drawing of the crop marks shown on the computer plot made with the aid of the photograph (Fig. 45) and several other photographs.

One Hectare

C

N

M 200

graphical means. This method has been brought within the reach of many archaeologists in recent years by the widespread availability of microcomputers and by developments in software. The programs that are being used in many places now are two-dimensional, i.e. they assume the site under investigation to be plane; the same assumption as was made with the graphical methods just described. A series of control points spaced round the edge of the site must be identifiable on both the photograph and the map of the area, and their relationship, which is worked out by the computer, enables the shapes recorded on the photograph to be rectified.

The computer must be connected to ancillary equipment which will encode the data and produce the rectified drawing. A relatively inexpensive solution to these needs is provided by a small digitiser and a small plotter. Equipment that takes A3 paper (420 x 300 mm) is adequate for most archaeological work, but this size of digitiser is expensive at present: if funds are limited, it may be necessary to compromise on an A4 digitiser and A3 plotter. A floppy disk drive unit is also required to record the output for future reference.

The first program to be widely used was based on four control points (Palmer, 1977). It has the advantage of simplicity and is suitable for the large proportion of archaeological sites which are on fairly level ground. Various modifications have since been devised, and there are now improved programs which take into account more than four control points in order to improve accuracy. They also incorporate facilities designed to make them easier to use (Burnside et al., 1983; Haigh, 1983).

The digitising procedure may be divided into two stages, the first of which concerns the control points and the second the shape of the feature to be rectified. In the first stage, the sensing device of the digitiser, or cursor, is placed accurately on each of the control points on the map and then in the same order on the same points on the tracing of the photograph. In the second, the cursor is moved over the outline of the archaeological features on the tracing of the photograph. The progress of the work may be checked on the display screen of the computer, which shows the outline drawn by the cursor as it gradually builds up. The computer calculates the rectified positions of the coordinates fed into it by the digitiser. This information enables the plotter to produce the

rectified drawing of the site, on which the map control points are also included. An example is given by Figs 45 and 46A-C, which show the original photograph of a site, the interpretive tracing, the computer plot and the final fair drawing. With slight amendments to the program, the plotter will make drawings at any desired scale.

The drawing produced by the plotter incorporates a very large number of corrected points, and it is therefore much more accurate than drawings produced by graphical methods, on which only a few points are determined and the rest is done by sketching. This improved accuracy cannot, however, overcome errors in the data fed into the computer. Provided that the ground is not excessively uneven, the main source of error is in the determination of the positions of control points on photographs. It is difficult, for example, to assess the correct point to choose at the junction of two hedges, which may be up to 2 m thick. A ground visit to the site is always helpful. The site shown on Fig. 45, for example, was visited before the interpretive drawing, Fig. 46A, was made. Measurements were taken of the position of the electricity supply line post which was used as one of the control points. If a ground visit cannot be arranged, it is useful to view two photographs stereoscopically if a stereo pair is available. The best method, which unfortunately is seldom practicable, is to put down ground markers in measured positions before taking the photographs. This enables the position of a feature in a large field to be plotted to within ± 1 m or better. Where such special aids were not available, the accuracy reached was in the order of ± 2 m within a feature and ± 4 m for the position of a feature in a field when plotting sites in Wessex on 1/10,000 and 1/2500 maps (Palmer, 1984, 5).

Three-dimensional computer mapping

A more advanced type of program, developed by Dr I. Scollar, makes allowance for differences in the height of the ground, though it takes much more computer time (Scollar, 1978, 82). The basis is two or more photographs of a site taken from different angles, on which three or more control points are identifiable. An iterative technique is employed, i.e. initial assumptions are made and the variables are repeatedly balanced against each other until a solution is reached. To obtain good results, the positions of

control points must be measured as accurately as possible on a contact film positive on polyester base, taken from a large-format negative. The use of paper prints or small-format negatives introduces undesirable errors. Scollar has obtained accurate results with this procedure, but it has the disadvantage of complexity.

Mapping vertical photographs

The methods of mapping used for oblique photographs can also be used for verticals, which have the advantage of much less perspective distortion, but there are other methods, suitable for verticals only, which can give much more accurate results. The simplest is the radial line method, which does not require special equipment, and which can overcome most of the effects of height distortion. The more specialised methods involve the use of photogrammetric machines of various types, which must be operated by trained personnel and are therefore expensive; the results, however, should be very accurate, and since the procedure takes three dimensions into account, they provide good maps of sites in hilly country.

A range of optical equipment is also available to assist sketch mapping from verticals, or to fill in details on a map already drawn in outline by one of the accurate methods.

Very brief introductory descriptions of various methods are given below; full accounts can be found in textbooks on photogrammetry.

The sketchmaster and the stereo facet plotter

Of the optical methods, the simplest is the sketchmaster, a device in which a semi-transparent mirror enables the images of both the photograph and the map of the area to be seen through an eyepiece as if they were superimposed (Kilford, 1979, 201). The images are adjusted until the best fit is given, after which the details can be drawn on the map as they appear on the composite picture. Distortions due to ground height variations cannot be removed, so the map and photograph can only be made to coincide over small areas, and a fresh adjustment must be made every time a new area is looked at. The sketchmaster will not deal with photographs taken at more than 10° from the vertical and it should not be

used to map hilly country.

Various additional facilities are incorporated in the Bausch and Lomb stereo zoom transferscope and the OMI stereo facet plotter, in which two photographs are viewed stereoscopically. Details are drawn on the map as before. Oblique photographs taken at steep angles (not more than 30° from the vertical) can be used with the OMI plotter.

Optical rectification when printing photographs

The relatively small distortion of vertical photographs caused by tilt can be largely removed by making adjustments during projection. For the most accurate work, specially made projectors are available, in which both the negative holder and the easel for the printing paper can be adjusted together by means of a link mechanism designed to maintain precise control. For less precise work, an ordinary photographic enlarger can be used. A map of the site is put on the easel, which is tilted slightly until the projected image of the negative makes the best fit with the map details. A piece of printing paper is then substituted for the map, while the easel is kept in the same position and the print exposed and processed. It is interesting to note that this was one of the principal methods of making maps from air photographs of the trenches during the First World War.

The radial line method

The graphical procedure for mapping points recorded by overlapping vertical photographs, known as the radial line method, gives good results on uneven land, provided that ground height variations do not exceed 10 per cent of flying height and camera tilt does not exceed 3°. Accurate flying is needed to achieve the latter requirement. The map positions of points on the photographs may be found if suitable control points are identifiable on both the base map and each photograph (see Kilford, 1979, 206-24 for details). The method is based on the fact that height distortion is radial from the nadir point (Fig. 45). Since the nadir and principal points almost coincide on vertical photographs, it may be assumed that distortion is radial from the principal point. Fig. 47 shows in principle how the intersection of rays drawn from the principal points can be used to find the position of a spot which is required to be fixed.

This procedure was formerly important in cartography, but has been superseded by plotting machines. When these are not available, or are too expensive to use, the radial line method can be used with advantage to map archaeological sites on ground too hilly to allow the use of the two-dimensional methods described on pp.68-72. Once a framework of fixed points has been constructed, the details between them can be filled in with the aid of a sketchmaster or similar optical device.

Plotting machines

Where sites on hilly or mountainous ground are to be mapped, or where contoured maps are required, photogrammetric plotting machines will give accurate

47. (*above*) The radial line method of finding the position of point x, using overlapping vertical air photographs, the principal points of which are w and y. The same spots are shown on adjacent photographs as w' and y'. W and Y are the map position of w and y. V and Z are the corresponding positions for other photographs in the series. X is the map position of x.

48. (*below*) Contoured survey of part of a Hidatsa Indian village in the Knife River National Historic Site, near Stanton, North Dakota, USA. Heights are given in feet. After plan made for the S.W. Cultural Resources Center, US Department of the Interior.

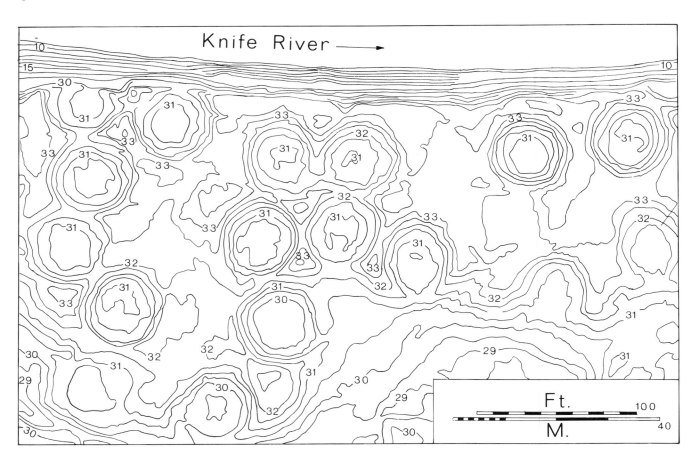

results. Large analogue stereo-plotters have been standard equipment in cartographic organisations for many years. Two overlapping verticals are viewed stereoscopically in the machine, which re-creates an analogue of the three-dimensional scene they depict. Looking through the eyepiece, the operator sees a spot of light, the 'floating mark' and, by manipulating the controls of the machine, can move it round features or along certain height levels on the photographs. At the same time the machine draws a map, which will be without the distortions present in the photographs and can include height contours. Surveyed points on the ground are needed as controls to supplement the photographic evidence (see Kilford, 1979, 174-90 and 240-9 for details).

Photogrammetric mapping has evolved to a highly developed state since aerial survey began 70 years ago. The operation of the large plotting machines is a highly skilled process. Maps made by this method may be expensive, but they are likely to be cheaper than maps of similar accuracy made by surveying on the surface. Fig. 48, part of a survey with contours at 6 inch (about 150 mm) intervals, showing the site of an Indian village in North Dakota, USA, demonstrates how much detail can be given and the precision which is possible.

Many developments are taking place in machine plotting as computers are used to re-create the three-dimensional image. The equipment to be used in the future will be different, but the basic problems will be the same.

Map design

It is essential that the purpose for which a map is to be made should be clear before it is started. The purpose will determine the amount and accuracy of the archaeological information to be given and the extent of the territory to be shown. These factors will decide the scale of the map and, together with a survey of the photographs available and the geography of the region concerned, will establish which method of mapping will best be used.

Table 4 summarises the three main purposes for which maps are regularly produced.

Most maps are likely to be drawn for inclusion in sites and monuments records, or for planning constraints. For these and similar purposes the size of a map is not unduly important, but it becomes a problem in cases where the map is to be published in a book or journal and must therefore fit a page size. It is often difficult to decide on the scale at which to draw a map for publication, because a large area may have to be represented on a small page; if the scale is too small, details may be lost.

Fully representational drawings can be made of crop marks at small sites (e.g. Fig. 65), but for the large areas which usually have to be mapped they are not practicable. At scales of 1/10,000 and smaller it is usual to represent most archaeological features by lines, either solid or stippled; at 1/2500 and larger, maps may still be largely composed of lines, but they may also be more representational, for example showing details of earthworks by hachuring, and

Table 4. Map scales		
Purpose	*Typical scale*	*Typical method of mapping*
General appreciation of sites in a large area	1/25,000 or 1/10,000	Sketching aided by network
Accurate information about particular sites or small areas	1/10,000 1/2500 or larger	Computer rectification
Guidance about present knowledge for use in the air	1/50,000	Sketching

perhaps crop marks by stippling, which allows their variations of density to be depicted as well as their shapes. Maps are designed to convey messages; to do this they must be clear and pleasant to look at. Some detailed choices must be made about mapping conventions. When only black ink can be used there are not enough conventions to permit standardised representation of all types of site. A fair degree of uniformity is, however, possible, and the symbols and conventions given below will meet many requirements. Where different colours can be used, a far wider choice of conventions is available, though in the case of maps for publication, colour greatly increases printing costs.

When making a fair drawing from the working drawings, such as those produced by the plotter which draws the output of a computer, it must be remembered that the line drawn by one of the commonly used pens with a point 0.3 mm wide represents a line 3 m wide on a 1/10,000 scale map, and even at 1/2500 the equivalent width is 0.8 m. This makes it difficult to represent small and complex features, which have to be simplified or omitted on maps of 1/10,000 scale or smaller. The information conveyed by large-scale and small-scale maps is therefore not the same.

Information about crop and soil marks accumulates gradually over a period of years; the maps made in the earlier stages of the investigation of cultivated land are therefore interim statements, and even after many years of flying new details may come to light. Drawings made for record purposes, such as sites and monuments records, often have to be added to and amended. Base maps may become untidy in this process, and there is much to be said for making archaeological records on transparent overlays mounted above the topographical maps.

On printed maps, published in books and journals, it is very often necessary to represent natural and modern man-made features in order to show the settings of archaeological sites. Natural features, such as height contours and the courses of streams, help to explain the landscape known to early man, and modern features, such as buildings, roads and field boundaries, help to show the exact positions of archaeological sites and also explain the reasons for gaps and blank areas. Unfortunately, the lines on the map showing present-day features are easily confused with those representing ancient remains, so that the archaeological message may not be well conveyed. This can be countered in various ways. The drawing may omit modern features which distract the eye (Fig.

Symbols for maps at scales of 1/10,000 and 1/2500

Positive crop mark or dark soil mark; ditch of earthwork

Negative crop mark or light coloured soil mark; bank of earthwork

Pits

Pit alignment

Large area of ground with positive crop mark or dark soil mark

Narrow line of negative crop mark showing foundation of building

Woodland

Built up or quarried areas in which archaeological features have been lost

Stream, showing direction of flow

Modern boundary

76

90), or by careful use of different line thicknesses and symbols may distinguish ancient and modern (Fig. 87). Alternatively, the printing may be different, giving ancient in red and modern in black (see maps in Benson and Miles, 1974), or ancient in black and modern in faint grey (e.g. several of the maps produced by the Royal Commission on Historical Monuments (England) given in Riley et al., 1985).

The symbols given on p.76 should be suitable for most of the common types of archaeological features shown by soil and crop marks and other important features of the landscape, when mapped at 1/10,000 or 1/2500 using black ink. The symbols given for banks and ditches may also be used for earthworks on maps of areas with soil and crop marks and earthworks in proximity to each other. For sites where only earthworks occur, however, it is best to depict them by the traditional hachuring method. A useful sheet of symbols for both earthworks and soil and crop marks has recently been prepared under the supervision of J.N. Hampton (Riley et al., 1985, 4).

6
Geology and Land Use

The methods and the results of archaeological air survey depend much more on the type of country being examined than on the nature of its early sites. The conditions under which the sites must be photographed and the number of flights necessary are very different for land with standing earthworks and for land under cultivation. On both, the soil and the underlying geology have important effects, though their precise nature depends on local circumstances.

The influence of these factors will be seen in the examples given below. The landscape is little different from its original state in the first two, but in the others there have been great changes which have concealed, but not entirely destroyed, the antiquities.

Uplands in North-Western Colorado, USA

This example is concerned with the use made of a series of overlapping vertical photographs of wooded country in the Piceance Creek Basin. They were taken to record vegetation for an investigation by Dr J. Grady into the relationship between the positions of early occupation sites and their environment (Grady, 1980). The sites were known from artefact scatters, found during previous field work in the area. The photographs give no specific information about any ancient features, but they allow the different vegetation zones to be mapped by comparison with observations made on the ground. The photograph and interpretive drawing illustrated here (Fig. 49), which cover only a small part of the land investigated, show three of the vegetation zones and the positions of a number of the occupation sites. Other vegetation zones are found elsewhere in the region.

Grady's analysis of the locations of sites and their environments showed differences between the vegetation zones in which sites occurred on the lower ground and in the more mountainous country. The

relationship between site location and geographical position and water supply was also examined. There was a contrast between the lower ground, where the occupation sites were near areas in which the food supplied by the vegetation was generally suitable for human consumption, and the higher ground, where they were near zones providing food mainly for deer. It was concluded that the early peoples had a way of life similar to that of the Indians found in the region by the first white settlers; i.e. they gathered vegetable foods on the lower ground in the spring and autumn, and moved to the higher ground in summer to hunt deer.

The use of air photographs to study the environment of early sites in this way is important in regions where much of the original vegetation survives, such as parts of the Americas, but is not possible in many countries of the Old World because, during their long histories of human occupation, the vegetation has been so greatly modified by man.

The desert of Eastern Jordan, near the oasis of Azraq

In this part of the desert zone of Jordan, the surface mainly consists of either bare basalt rock, limestone gravel or mud flats. The basalt is generally broken into rounded boulders. The area shown on the maps (Figs 50 and 51) has the advantage of being near the oasis of Azraq, in which there are pools of water fed by copious springs. Near these pools there is much vegetation, but elsewhere in the region it is very sparse.

The mapping of both natural and archaeological features on arid land such as this is easily done from air photographs. The vegetation is much too thin to hide the frequent remains of stone-walled structures, some of which are of types known to be of great

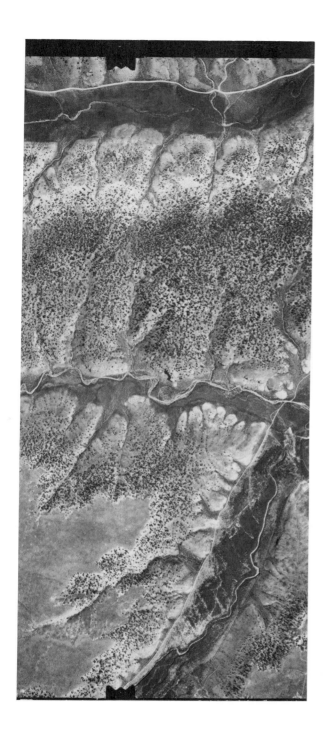

49. Duck Creek, Rio Blanco County, Colorado, USA. Strip from vertical photograph and interpretive drawing. On the upper and lower edges of the photograph may be seen two of the four collimating marks on the original. On the drawing, rings mark occupation sites recorded by survey in the field and symbols mark the land covered by three vegetation zones: (1) valley bottom big sagebrush shrubland, typical of the valley floors, (2) mid-elevation big sagebrush shrubland, which occurs on rolling uplands, and (3) pinon pine and juniper woodland, which covers the higher ground. Photograph by R.H. Hardwick, 21 July 1976; drawing after Grady, 1980.

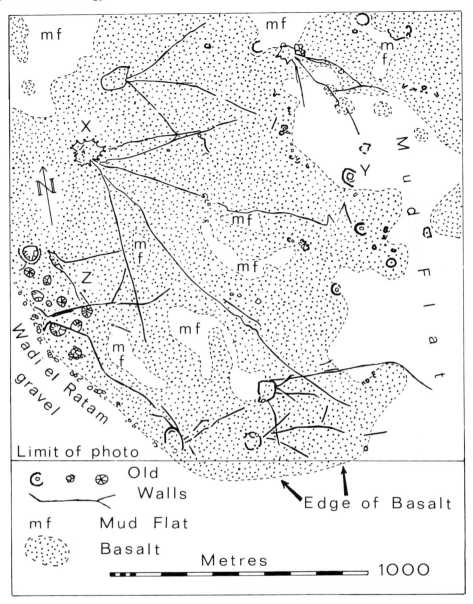

50. Azraq, Jordan. An area of the basalt desert on which are the walls of many ruined structures, typical examples of which are marked: X – a 'desert kite', consisting of long approach walls leading to an enclosure, which is surrounded by small hides; Y – a double-walled enclosure; Z – group of 'jellyfish' enclosures.

antiquity, providing evidence of human occupation over a long period. Differences of colour or tone show such structures clearly in many places on photographs. Similarly the geology is easily seen by the colour or tone of the rocks. Runs of vertical photographs, interpreted with the aid of experience of conditions on the ground, can give a great deal of

information. The drawing shown in Fig. 50, which was made from photographs at a scale of approximately 1/10,000, shows the surface geology and many ruined walls. Both this drawing and the map given in Fig. 51 are based on photographs taken by the Royal Air Force when stationed in the region (Riley, 1982). The lower part of Fig. 51, which was drawn from the same 1/10,000 scale photographs, is more satisfactory than its upper part, for which the source was a set of photographs at about 1/50,000 scale. Some of the walled sites showed up at this small scale, but others no doubt remain to be detected.

The black basalt rocks show as dark areas on the

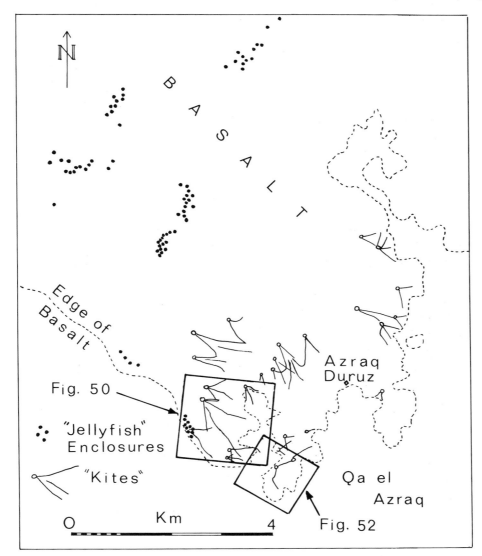

51. The desert near Azraq, Jordan, showing the distribution of 'desert kites' and 'jelly fish' enclosures.

photographs, contrasting with light-toned gravelly areas and mud flats (Fig. 52). Surface colour has a great effect on the ease with which ancient structures can be seen. Walls made of black rocks are usually distinct where they cross mud flats, but they may be difficult to see on the dark areas of basalt. On closer examination, however, it is found that on some parts of the basalt they are made more visible by narrow light-toned bands beside them. Strips of the light-coloured silt which had accumulated below the surface boulders were exposed when they were removed to build walls. Nearly all the archaeological features are found on the basalt because of the durability of walls built of this rock. In this region, therefore, the nature of the land surface greatly affects the survival of ancient remains as well as their visibility.

The most prominent ancient features are the 'kites' and 'jellyfish', names invented by Royal Air Force pilots and archaeologists respectively. The kites, an example of which is shown in Fig. 52, consist of pairs of long converging walls leading to walled corrals, which were probably used to trap herds of gazelle. Some may date from as early as the seventh millennium BC (Betts, 1983, 10). The jellyfish enclosures are a specialised form of walled structure with internal compartments, which may also be very

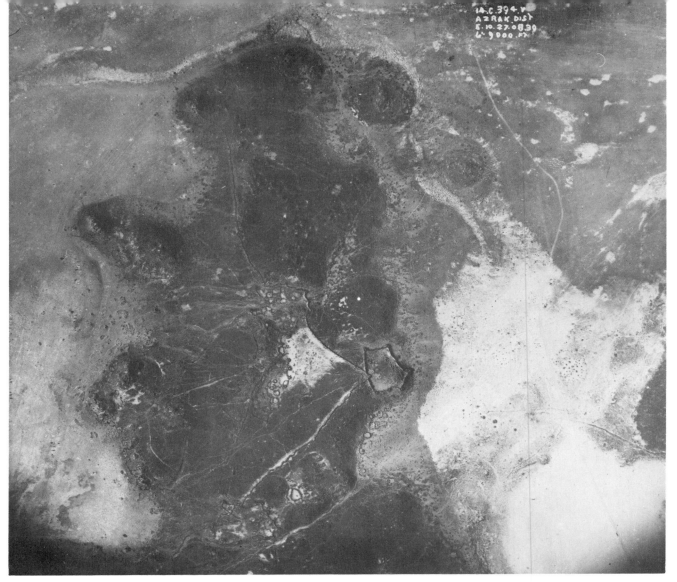

52. Azraq, Jordan. Old vertical photograph, on which the darker areas are low hills of bare basalt rock and the lighter areas are mud flats. Ruined basalt walls are shown by differences of tone and by shadow. The main feature is a 'desert kite', the two long approach walls of which converge on a five-sided enclosure. Small circular hides are spaced round its sides. On the basalt can also be seen many other small enclosures and traces of two earlier kites. Photograph by the Royal Air Force, 8.30 a.m. on 5 October 1927.

early in date. Other walled structures and many small cairns are scattered throughout the area, often occurring beside the mud flats, which may become pools of water during the winter rains. These probably range from ancient to quite modern, but the antiquities of this desert region have been very incompletely explored.

The guidance given by photographs is of great assistance during field visits. Although the ruined walls can usually be followed quite readily on the ground after they have been located, progress on foot is often very slow and tedious because of the masses of tumbled boulders on the basalt desert. Air photographs greatly reduce the problems of work on the surface by giving advance notice of the positions of structures and suggesting ways of reaching them by paths used by herdsmen.

Grassland in two Yorkshire dales

Most of the land is under grass in the upper parts of two North Yorkshire valleys, Wharfedale and Nidderdale, which are similar in some respects but different in others. On the eastern side of Upper Wharfedale, north of Grassington, there is a zone about 8 km long in which well-preserved earthworks are very noticeable from the air under the right conditions. In contrast, ancient earthworks are not easily found when flying over Nidderdale, although

82

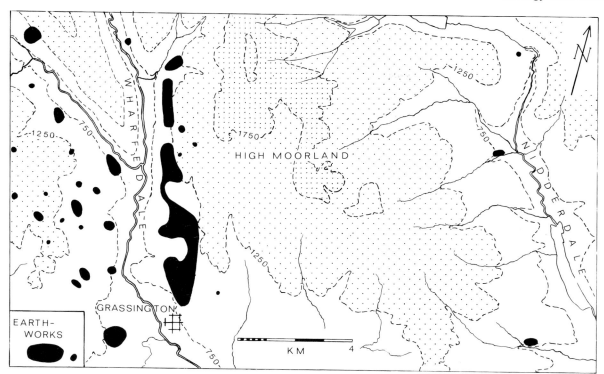

53. Upper Wharfedale and Nidderdale, North Yorkshire, showing the distribution of earthworks of ancient types photographed by the author. Earthworks thought to be of medieval or later date are not shown. Heights are given in feet.

that valley provides a rather similar environment. Between the valleys is a belt of high moorland on which can be seen no signs of ancient occupation and very little of modern. The areas of land on which ancient earthworks are common in this region are shown in Fig. 53.

The walls and banks of fields and enclosures of probable prehistoric or Romano-British date are exceptionally well preserved on the land north of Grassington (Figs 11 and 54). These ancient earthworks were no doubt originally much more extensive, and it may be assumed that in many places they were levelled by the ploughing of medieval and modern farmers. Medieval strip lynchets now cover many parts of the lower slopes of the valley (Fig. 55), and flat modern fields occupy much of the valley floor.

I expected, when I first examined Upper Nidderdale, that there would be many ancient earthworks similar to those in Upper Wharfedale. In fact, earthworks of this kind are difficult to find from the air in Upper Nidderdale, though they may be seen in a

few places, something which has not been fully explained. The different soils formed on the sandstone of Upper Nidderdale and the limestone of Upper Wharfedale must have caused differences in the early agriculture of the two valleys. Their recent agricultural history may also have been different. It may be assumed that much more will be revealed in the future in Upper Nidderdale when the results of aerial reconnaissance come to be supplemented by field work on the ground.

My oblique photographs, on which this account is based, have not proved an entirely satisfactory method of recording such a large area of early remains as that north of Grassington. The best method would be a vertical survey at a scale of about 1/5000 of the whole of that part of Wharfedale, taken when the sun was low, supplemented by oblique photographs where needed.

Arable land in the Upper Thames valley

The lowland country of the Upper Thames region is mainly under arable cultivation and earthworks are few, almost all having been levelled by ploughing. Without air photographs of crop marks, the majority of archaeological sites would be known only from

83

54. Nook, Conistone, North Yorkshire. Ancient fields, shown mainly by highlights, on the higher slopes of Upper Wharfedale. The wall between X and Y is straight, but the uneven ground causes it to appear to bend. Photograph by the author, 8.30 p.m. on 26 May 1977.

chance discoveries in gravel pits or civil engineering projects. The distribution of crop marks as known in 1979 in a part of the region is shown by Fig. 56, which demonstrates their occurrence in a large number of scattered patches. In most cases these are areas of thin soil above gravel, which provide ideal conditions for the formation of crop marks. This subject has already been discussed (above, p.38) in connection with the large-scale soil and crop mark map of an area south of Abingdon, Oxfordshire (Fig. 27), the position of which is shown on the lower right corner of Fig. 56.

Not all the crop marks are above gravel. Some are also found on the limestone hills to the north of the Thames valley and on soils above sand and limestone near the little river Ock, which flows into the Thames at Abingdon. Elsewhere, there are blank areas, parts of which are wooded or have clay soils unfavourable to crop marks. More could be written about various aspects of the distribution of crop marks on Fig. 56, but enough has been said to emphasise the need to appreciate the effects of geology.

The time-scale of the investigation of country such as this, with extensive and complicated crop marks, is very much longer than that of the regions previously described, in which almost all features of importance are visible as standing earthworks or stone structures.

55. Conistone, North Yorkshire. The plan of the medieval North Field of the village of Conistone is shown by shadows and highlights of the boundaries of strips on the broad band of land running from the upper left to the lower right. The strips are flat and were not ploughed in the way which produced the ridge and furrow very often seen elsewhere. The present-day field walls follow the boundaries of blocks of strips. On the left centre are the grass-covered ruins of a settlement and on higher land in the lower left corner are the remains of old field walls; the dates of these features are uncertain. Photograph by the author, 12.30 p.m. on 6 December 1983.

Changes of land use have had important consequences in this region for the air photographer. When I first knew it in the 1940s, there were many crop marks to record on land rather higher than the level of the Thames, but few on the flood plain near the river.

As a result of improved drainage and the ploughing up of former grassland near the river, many crop marks have been found in recent years on this land also; for example, from A to B on Fig. 56, where almost all the sites are recent discoveries.

The Upper Thames valley is the classic area in Great Britain for the study of crop marks, the scene of most of Allen's work in the 1930s. The relatively soft gravels form subsoils into which the early inhabitants were able to dig without much difficulty, and as a result the crop marks are very common and often very distinct. There are remains of all periods from Neolithic to Saxon, and some of the sites are very complex, e.g. that shown in Fig. 57.

Arable land in South Yorkshire

The results of aerial examination of the arable areas of South Yorkshire differ considerably from those of the Upper Thames valley, partly because of the differences in the geology of the two regions, and partly for archaeological reasons. The crop marks on a large area of South Yorkshire have already been mentioned in the discussion of the map given in Fig. 26, some of which is shown here in rather more detail in Fig. 58. This covers country with underlying rocks of the Magnesian Limestone and Coal Measures formations,

56. The Upper Thames and Ock valleys, showing the distribution of crop marks on archaeological sites. The crop marks on the land between A and B are almost all recent discoveries. The rectangle outlines the area covered by Fig. 27. After Hingley, 1979, 142.

on which comparison with Fig. 56 will demonstrate that crop marks are much less frequent than on the Upper Thames gravels. A similarly sparse distribution of crop mark sites is usually found when limestone country is examined elsewhere in England. As suggested above, this is very likely due to the difficulty of digging ditches and pits in the hard rock below the surface layer of soil.

Looking in more detail at the distribution of sites on the limestone belt, there are more on the northern part than the southern. Further to the south, in Nottinghamshire, there are also very few on this formation (Fig. 26). The hardness of the upper layers of the rock appears to be fairly uniform, as far as can be judged by visiting quarries, and the varying distribution of sites is probably caused by human rather than geological differences. On the Coal

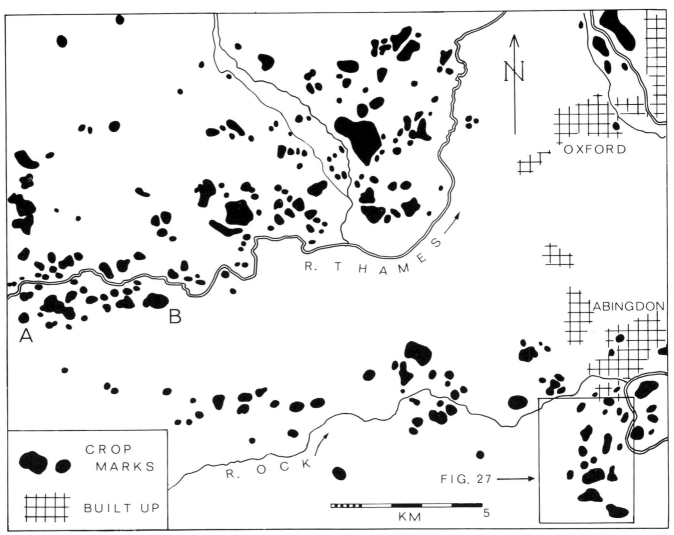

STANTON HARCOURT. 16.6.34 4.149

57. Linch Hill, Stanton Harcourt, Oxfordshire. Superimposed features shown by crop marks on a site which has now been destroyed by gravel working. The oldest remains are probably the six Bronze Age type ring ditches in the centre and background of the photograph. In the foreground are two clusters of dark spots, almost certainly caused by Iron Age type storage pits, and near them are two small rectilinear enclosures, perhaps of the same date. The extensive series of larger rectilinear enclosures and the two lanes, marked by their side ditches, are probably Romano-British. The large dark spots are unexplained. Photograph by Major G.W.G. Allen, 16 June 1934.

Measures, however, a geological explanation of the distribution is usually forthcoming, and many crop marks are on land where sandstone outcrops. There are also crop marks on clayey soils above the shales of the Coal Measures, but these appear to occur much less often. Allowing for the greater proportion of land occupied by industry and housing on the Coal Measures than on the limestone, the frequency of early sites on the two formations seems to have been not dissimilar.

The majority of the crop marks on the area of Fig. 58 are caused by the fillings of enclosure ditches (Figs 45 and 77 show similar enclosures). It may be noted that they are of simple shapes and that the complex sites of the Upper Thames valley, such as that seen in Fig. 57, do not occur here, presumably because of the difficulty of cutting many ditches in the hard rock. It is probable that the enclosures are of Iron Age or Roman date. Occasional ring ditches may be of Bronze Age date, though the survival of a long barrow in a wood on the area of Fig. 58 and the presence of a large henge (Figs 70 and 71) some distance beyond its northern edge suggest that there were originally more monuments of the Neolithic and Bronze Age than can now be found. It is probable that many early structures did not incorporate ditches cut into the rock, and have therefore left no traces. It may be concluded that the underlying rock of this region not only influences the frequency of ancient sites shown by crop marks, but also their types.

87

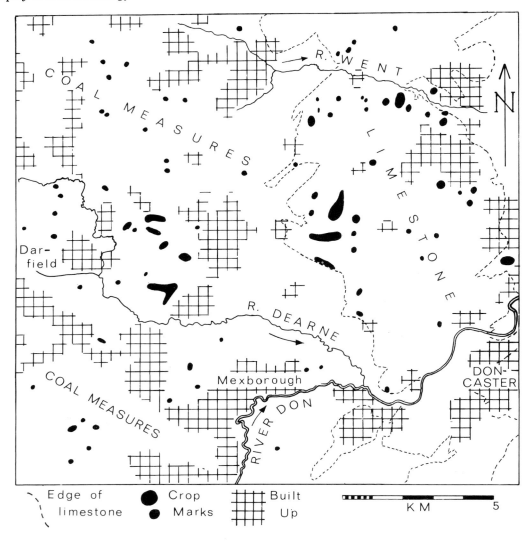

58. Part of South Yorkshire, showing the distribution of crop marks on archaeological sites.

The air photographs of the region consist mainly of obliques – the most economical means of recording scattered crop marks, which appear somewhat unpredictably. In my experience, a programme of flights during the summer months for up to ten years is likely to be necessary to record most of the crop marks in an area such as this. Changes of land use are unlikely to influence the results much because there is little grassland which could be ploughed up.

7
Detailed Analysis of Results

A description of the crop marks recorded at Aston on Trent, Derbyshire, is given at the beginning of this chapter in order to demonstrate how much information can be supplied by photographs of a small area. The wealth of information, however, provides only the shapes and locations of features on the ground, not their purposes or dates of construction. If their meaning is to be understood, the shapes shown by the photographs must be examined and compared, and supplemented where relevant by the results of excavation. The analysis of shapes, sometimes dignified by the term morphological study, is briefly discussed here. The shapes of various classes of sites are examined further in Chapter 8.

Although air photographs show the whole surface area of archaeological sites, they do not give many small but important details. Crop marks can be particularly misleading, because although they appear to show the complete plans of remains buried in the ground, they actually do not give a host of small features such as post holes, which are almost always revealed when the sites are excavated. This problem is the subject of the later part of this chapter, using as an example the results from part of the large crop mark site excavated at Mucking, Essex.

Crop marks at Aston on Trent

In this part of the central reaches of the Trent valley, the uneven distribution of crop marks (Fig. 59, upper part) resembles that in the Upper Thames valley (Fig. 56) and other similar valleys. As usual on soils above river gravels, the Trent valley crop marks are frequently very distinct and show much detail. The marks near the village of Aston on Trent have been plotted on two maps at scales of 1/10,000 and 1/2500, shown here at smaller scales (Figs 59 and 60). Some of the finer detail had to be omitted from the

1/10,000 map, and crop marks which appear to have been caused by the fillings of frost cracks and other periglacial features in the gravel have been omitted from both maps.

Aston on Trent is best known archaeologically for a very large crop mark feature, the pair of long parallel straight lines which run across the land east of the village and give the positions of the ditches of an elongated enclosure, the known part of which is 1750 m long. The square south-western end is clearly shown on photographs. On the evidence of similar enclosures elsewhere, there was probably a square north-eastern end, though it has not been located. This is a cursus, a type of structure that would be little known but for the results of aerial exploration. They have been found to date from the latter part of the Neolithic period.

The well-ordered plan of the cursus contrasts with the confusion of the plans of a large number of other features shown by crop marks, though the apparent muddle is caused by the superimposition of remains of different periods. Proceeding from north to south on Fig. 60, the most prominent features, apart from the cursus, are as follows:

A – six small squares, which may be the ditches of Iron Age square barrows (see p.107), though the excavation of one of them was inconclusive (May, 1970);

BB – several circles of the type usually termed ring ditches (see p.94); the large double ring surrounds the remains of a round barrow, now almost ploughed away, which was dated to the early Bronze Age by fragments of two beakers (Reaney, 1968);

C – a double line of small spots, which indicate pits or post holes, and may perhaps be compared with the similar double line of pits, dated by carbon-14 to

CROP MARKS

BUILT UP

59. Upper part: the Trent valley, south of Derby, giving the distribution of crop marks on archaeological sites. Lower part: detail of crop marks at Aston on Trent, which are in the area outlined by the rectangle on the upper part. Originals at scales of 1/50,000 (upper part) and 1/10,000 (lower part). After F.M. Mountford.

1900-1700 bc, in the complex of ritual sites at Milfield, Northumberland (Harding, 1981, 115);

D – an ovate shape with a semi-circular end, which is reminiscent of the larger ring ditches;

EF – parallel marks, probably showing the side ditches of a lane leading to the enclosures at F; it

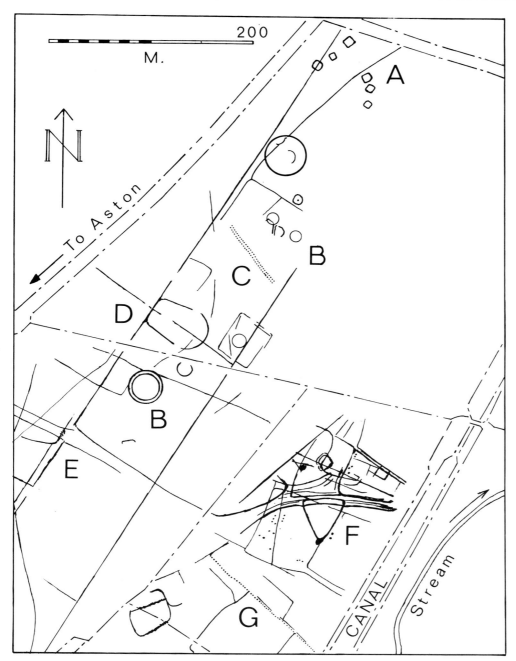

60. Aston on Trent, Derbyshire: larger scale map of the crop marks in the central part of the lower drawing on Fig. 59, showing additional details. Original at 1/2500. After F.M. Mountford.

appears to be later than the cursus, because there are breaks in its ditches where they cross the cursus ditch at E;

F – the complex marks of the ditches of a series of enclosures. These show signs of many changes and much recutting of ditches, and probably represent the site of an Iron Age or Romano-British settlement (see pp. 108-12);

G – a few small fields or paddocks, bounded partly by ditches and partly by a line of pits of a type found in many places, termed a pit alignment (see p.126).

On Fig. 59 there are also the following:

HJ – a long pit alignment and numerous enclosures, many of which adjoin or intersect each other;

K – two pit alignments which appear to be connected with an enclosure;

L – several small circles and arcs, which may show the positions of round houses.

This list covers all the important known features, but it is quite likely that more remains to be found. On some photographs the small curvilinear enclosure north east of J appeared to have gaps and to resemble a Neolithic causewayed enclosure (see Fig. 67), an interesting possibility. Further flying over the area is needed.

Apart from the double line of pits at C, for which there seem to be only a few parallels, all these features are very similar to many others elsewhere. The ring ditches and enclosures, and the pit alignments at G, HJ and K resemble others at many places in the Trent valley. A very large task lies ahead if the great body of information of this kind recorded by air photographs is to be reduced to a form convenient for future research.

Morphological study

General comments

Since the information supplied by air photographs consists only of shapes on the ground, its study is based on site plans. The procedure adopted is in essence to collect the data systematically, to classify the shapes by comparing similarities and differences and to consult the results of work on the ground which suggest the purposes and dates of the structures.

The very diverse shapes recorded in Great Britain may be divided broadly into three groups: first, the very common sites of prehistoric centres of activity, such as settlements, forts and burial mounds, and related sites of later date, such as Romano-British rural settlements; secondly, the sites of more highly developed centres, such as Roman towns and military stations; and thirdly, the widely dispersed remains of early fields and land boundaries. The shapes of all these types of early features are the means by which they are recognised on photographs. There are some types, such as Roman forts, which can usually be allocated to well understood groups, but the

prehistoric centres and related sites often present problems because of the difficulty of identifying enough distinctive attributes on many of the smaller sites. Some types of sites are not yet well understood, and their attributes need further examination if they are to be put into order.

Whatever the field of study, most classifications depend to a considerable extent on the hypotheses of preceding years. Sites which clearly belong to well established categories should be grouped together. Henges, for example, are familiar prehistoric structures, which, though they need further examination, belong to a category into which new examples (Figs 70 and 71) can be placed. A start can thus be made on the large number of sites that need to be classified by their shapes, but there still remain those which do not belong to established groups, which are in the majority in most regions.

In studying a certain range of sites, it is generally helpful to begin by arranging drawings of them in order, placing similar shapes together. This has been done on Fig. 61, which shows part of a large series of enclosures recorded in Wessex. By examining the complete series of drawings, groups of related enclosures were identified by similarities in their main attributes – outline, size, entrance plan, internal features, if any, and other points in common.

The relationships of individual sites to others in the same area may be important. Where similar shapes are close together, a connection may perhaps be inferred. The small squares at A on Fig. 60, for example, were presumably related to each other; the crop marks probably show the ditches of small square barrows, which were made at the same period. On the other hand, at sites B, C, D, E and F on Fig. 60 there are remains which probably belong to many different periods. The evidence of proximity must be used with caution.

The intersection or juxtaposition of different features is often a source of evidence. The cursus at Aston on Trent provides some interesting examples, some of which are extracted in Fig. 62. No. 1 shows a slight deviation in the cursus ditch where it meets a ring ditch, which suggests that the latter was already in existence when the cursus was made. No. 2 demonstrates that the cursus ditch touches, but is not deflected by an ovate ditch, which is probably the later feature. On No. 3 a probable Iron Age square barrow ditch appears to be superimposed on the

61. Drawings of ditched enclosures, taken from a large number recorded in Hampshire. After Palmer, 1984, 33.

cursus ditch, suggesting that it had been filled up and was not noticeable by the Iron Age. Similarly, as has already been mentioned, at E on Fig. 60 the lane seems to be later in date than the cursus, which it crosses.

Circular features

When the particulars of a series of features of similar shape have been collected, their attributes must be examined in detail in order to make the best use of the

62. Features intersecting or joining the ditch of the Aston on Trent cursus: (1) a ring ditch, (2) an ovate ditch, and (3) a group of probable square barrows.

information. As a simple example, the attributes of several groups of circular features are compared here. Standing earthworks preserve more information than sites levelled by agriculture, so they are considered before crop marks.

The shapes of the round barrows in the well-known early Bronze Age group on Oakley Down, Wimborne St Giles, Dorset (Fig. 63) are relatively simple – one or two mounds, generally surrounded by a circular ditch and in some cases also by a bank. The size of the mounds varies considerably in relation to that of the ditches. More complicated, though still relatively

63. Oakley Down, Wimborne St Giles, Dorset. This large group of early Bronze Age barrows includes all the standard Wessex types – bell, disc and bowl barrows. All except a very inconspicuous bowl barrow have encircling ditches. Photograph by Professor J.K. St Joseph, 2 May 1953.

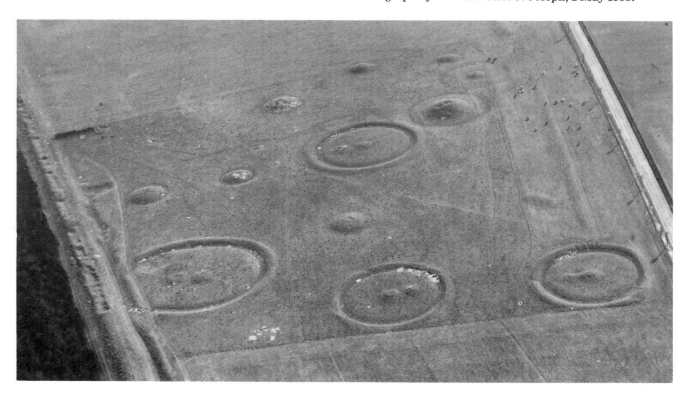

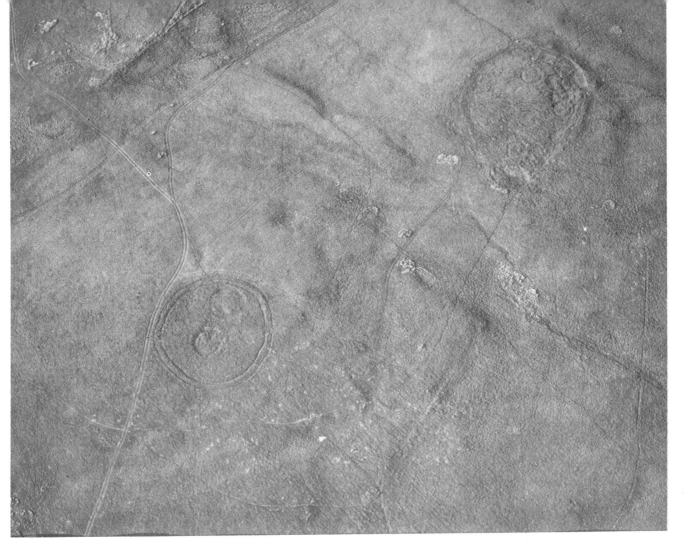

64. High Knowes, Alnham, Northumberland. Two settlement sites, both of which are within curvilinear palisaded enclosures, standing at about the 350 m level on the southern slopes of the Cheviot Hills. Photograph by T.J.W. Gates, June 1978.

simple earthworks are seen on Fig. 64, a photograph of two Iron Age homesteads at High Knowes, Alnham, Northumberland, parts of which have been excavated (Jobey, 1966). The nearer of the two enclosures on Fig. 64 is formed by two narrow trenches about 3 m apart, in which there were originally the bases of the posts of wooden palisades. The more distant enclosure was shown by a band of more verdant foliage, appearing here as a ring of slightly darker tone, under which palisade trenches were found by excavation. Inside both the large palisaded enclosures are small rings, which show the sites of round houses.

Table 5 summarises the attributes of three groups of features: the ditches of round barrows, the palisaded enclosures and the round house rings.

The structures at each of the three sites would be recognised immediately by most British archaeologists, who would not need to write down the attributes in order to classify them. The attributes are, however, better understood if they are summarised in writing; when tabulated, they are convenient for comparison with those of less well preserved sites, such as the large group of ring ditches at Foxley Farm, Eynsham, Oxfordshire (Figs 3 and 24), shown by crop marks.

The Eynsham ring ditches are very similar to the circular ditches surrounding the mounds in the Oakley Down barrow group. Indeed the central dark patch in one of the rings seen on Fig. 3 indicated the ploughed remains of a mound, which was still about 1 m high when rescue excavations took place in 1941 (Bradford and Morris, 1941). When the attributes of the ring ditch crop marks are compared with those of the barrow ditches, quite good agreement is obtained, as Table 6 demonstrates.

94

The agreement between the two sets of attributes makes it very probable that the Eynsham ring ditches mark the site of a large group of barrows, similar in type to those at Oakley Down. The ovate ditches at Eynsham were longer in proportion to their width than the one at Oakley Down, and it is probable that they surrounded larger mounds.

The relationship of crop marks to excavation results

The plans of sites recorded from the air show only the larger buried features, and excavation almost always uncovers far more than had been seen on any photograph. This is not surprising on earthworks, where much is clearly hidden below the turf, or soil mark sites, where only the colours of the surface soil are visible, but it can be unexpected on crop mark sites, photographs of which often show so much detail. When assessing the meaning of photographs of crop marks it is important to realise that the crops are normally not affected by the lesser buried features, such as small post holes and narrow ditches and gullies, which are numerous at most sites. The size below which buried features do not produce crop marks may be assumed to vary from one place to another, according to the type of soil, kind of crop and weather conditions. No systematic work has been done on the subject, a brief mention of which might with advantage be included in excavation reports to

Table 5. Circular features

Attribute	Oakley Down barrows	High Knowes palisades	High Knowes round houses
Shape of ditch or trench	Circular; one ovate	Two slightly irregular rings	Circular
Diameter	20-55 m	50-70 m	8-13 m
Internal features	Mounds	Round house rings	None
Grouping	Unenclosed group of 18	Two sites 110 m apart	All within palisade rings
Source of information	RCHME, 1975, 102	Jobey, 1966, 11 and 17	

Table 6. Ring ditches and barrows

Attribute	Eynsham ring ditches	Oakley Down barrows
Shape of ditch	Circular; two ovates	Circular; one ovate
Diameter	Approx. 10-47 m	20-55 m
Internal features	Remains of mound in one case	Mounds in all cases
Grouping	Unenclosed group of 32	Unenclosed group of 18
Source of information	Bradford and Morris, 1941	RCHME, 1975, 102

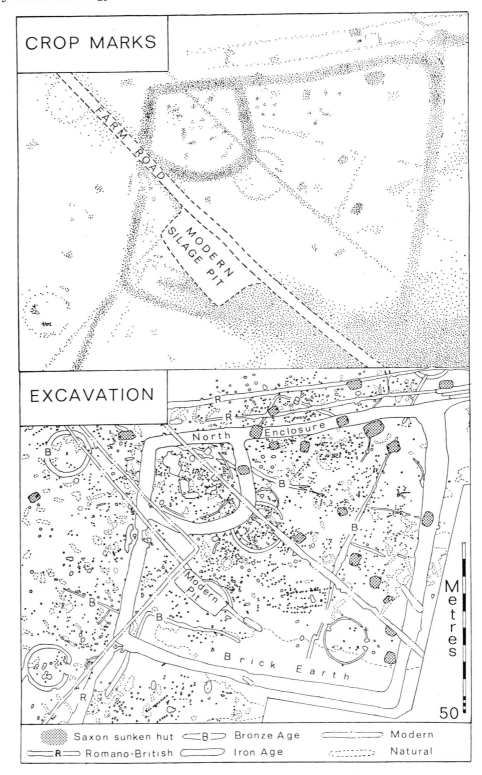

CROP MARKS

EXCAVATION

North Enclosure

Brick Earth

Metres

50

Saxon sunken hut ⊂B⊃ Bronze Age ⎯⎯⎯ Modern
⊂R⊃ Romano-British ⊂⊃ Iron Age ⋯⋯⋯ Natural

65. The North Enclosure at Mucking, Essex, plotted from photographs of crop marks and from the results of excavation. Excavation plan after M.U. Jones.

66. (*right*) The North Enclosure at Mucking showing degrees of distinctness of crop marks.

build up knowledge about the interpretation of the crop marks on the many sites that are unlikely ever to be dug.

In order to obtain information about the relationship between the plans given by photographs of crop marks and by excavation (Fig. 65), the results from the site known as the North Enclosure at Mucking, Essex (Jones, 1979, plates 64 and 65) have been investigated. Well defined crop marks were recorded in barley growing on thin (0.2 to 0.25 m) soil above gravel, though at one corner of the site there was clay or 'brickearth' below the surface, on which the ancient features did not form marks. The features which caused the marks were mainly the fillings of ditches of various dates, from the Bronze Age to recent times, and of Saxon sunken floor huts. The marks may be divided into three groups, according to their distinctness (Fig. 66), which may be correlated

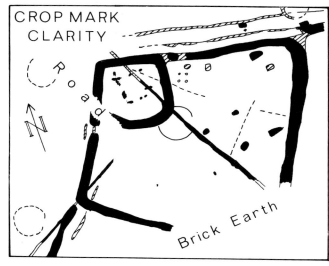

CROP MARK CLARITY

━━ Very clear ⎫
⎯ Clear ⎬ Crop Marks
----- Faint ⎭

Table 7. Excavated crop marks of ditches and post holes

0 Metres 100

Description Crop marks very distinct	Width (metres)	Depth (metres)
Ditch filled with sandy loam	3.2/4.5	1.4/2.0
Ditch filled with dark sandy loam	0.9/4.1	0.35
Crop marks distinct		
Two ditches filled with sandy loam	0.7/1.5	0.2/0.4
Two round house trenches filled with sandy loam	0.7/1.5	0.35/0.65
Crop marks faint		
Two ditches with gravelly filling	0.4/2.4	0.2/0.45
Two round house trenches filled with sandy loam	0.7/1.5	0.2/0.5
Four post holes with gravelly filling	0.7/1.0	0.5/0.75
Features without crop marks Large number of post holes 0.5 m and less in diameter Various ditches less than about 0.5 m in width Anything on the brickearth		

approximately with the descriptions of the fillings of the excavations in the gravel. The data are summarised in Table 7, giving dimensions taken at the gravel surface. The table demonstrates that the larger excavations make more distinct marks and that sandy loam filling makes more distinct marks than gravelly filling in a ditch of similar size.

There were many Saxon sunken floor huts (Grubenhäuser) at Mucking, identifiable on photographs by large dark spots of characteristic shape. Their fillings in many cases included a basal layer with much ash and charcoal, which was rather different from the material in the ditches. Table 8 summarises the information about these hut sites. On this table, it will be seen that the distinctness of the marks corresponds with the depths of the fillings. The depth of the huts tends to be less than that of the ditches and it may be concluded that the layer of ash and charcoal favoured the development of crop marks.

Table 8. Excavated crop marks of sunken floor huts

Crop mark description	No. of huts	Width (metres)	Depth (metres)	Layer with ash and charcoal
Very distinct	6	2.45/4.1	0.28/0.46	Present
Distinct	3	2.15/3.05	0.15/0.23	Present
Faint	1	3.30	0.13	Absent

8
Applications: Early
Sites and Monuments

The way in which the evidence from air photographs is used tends to differ according to the kind of site under investigation. In order to show the influence of such factors, a series of examples is considered here and in Chapters 9 and 10. The examples in this chapter are mainly taken from sites and monuments in England that can be described individually, though they should also be seen as part of a wider study of the ancient landscape. As so much of England is under cultivation, crop marks are mentioned very often; the

effects of geology and modern land use, mentioned in Chapter 6, should not be forgotten in interpreting them.

The additions to knowledge arising from crop marks tend to increase in inverse ratio to the size of the monuments. The more massive, such as large henges

67. Mavesyn Ridware, Staffordshire. Crop marks of a Neolithic causewayed enclosure with three ditches. In the foreground is a ring ditch. The site is on a low rise near the river Trent. Photograph by D.R. Wilson, 24 July 1981.

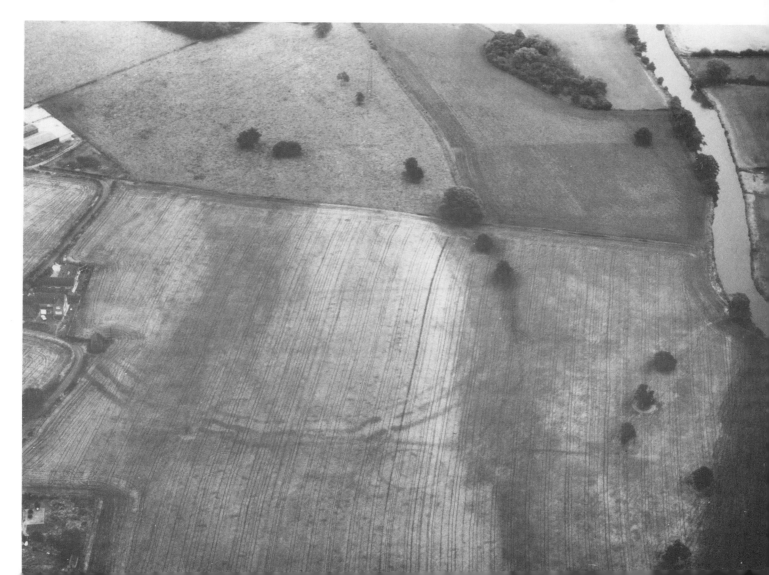

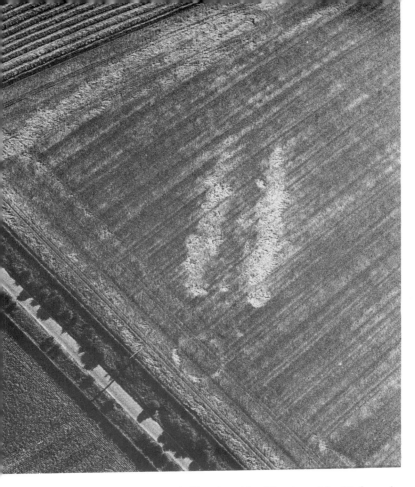

68. Kilham, North Humberside. The two side ditches of a long barrow shown by positive crop marks, where the plants have partly collapsed or been 'laid' because of their greater height. The pale tone of the marks was caused by reflected light. A ring ditch is shown by similar marks. Photograph by the author, 20 July 1982.

or forts, have frequently survived as standing earthworks, so that aerial discoveries are in a minority. There are many more opportunities for the aviator to find and record the sites of smaller and less conspicuous ancient features, most of which were easily destroyed by agriculture. The cumulative importance of large numbers of minor sites is great, provided that good use is made of photographic records.

Larger prehistoric monuments

Some of the more spectacular discoveries made from the air in England are new examples of major prehistoric monuments. The most notable are causewayed enclosures and long barrows of the earlier Neolithic period, and cursus and henges of the later Neolithic and earlier Bronze Age. Many of these monuments are large and have easily recognisable

attributes. The interrupted ditches of causewayed enclosures (Fig. 67), the wide side ditches of many long barrows (Fig. 68), the great length of many cursus (Figs 59 and 69) and the wide ditch and exterior bank, with one or two opposed entrances, of henges (Figs 70 and 71) are distinctive. In spite of their size, a good many of these large monuments have been levelled and are now only shown by crop marks, which are the usual source of new discoveries. Less often, enough of the original structure remains on the surface to form marks on bare soil (Figs 69 and 70). A combination of crop marks in the summer and soil marks in the winter (Figs 70 and 71) may be instructive.

Deep ditches may be shown very distinctly by positive crop marks, but this is not always the case. The ditches of some long barrows on chalky soils, for example, have little effect on crops growing over them in most years; the explanation may be that when the sites were levelled much chalk rubble was moved from the mounds to the upper part of the ditch fillings, where it now obstructs root penetration. Its exceptional size may partly account for the long delay in the recognition of the great ring of causewayed enclosure type at Duggleby, North Yorkshire (Fig. 72). When intact, it was one of the largest early prehistoric monuments in Britain, but though aerial exploration of the Yorkshire Wolds has been in progress since the late 1940s, the ring was not identified until 1979 (Riley, 1980b).

The additions made to the distribution map of causewayed enclosures are very important. At one time they were thought to occur in England only in the south of the country, generally on hilly ground. Crop marks have since shown that there were also enclosures in river valleys (Fig. 67) in other regions (Palmer, 1976). There has been a similar expansion in the distribution of Neolithic causewayed enclosures in France; a few have been found in the north-east (Fig. 16) and many in the west central region, where aerial discoveries now greatly outnumber the sites found by field work (Dassié, 1978, 129; Scarre, 1984, 17). Additions to the known distribution of henges in various parts of Great Britain are also important.

In general, the plans of the new causewayed enclosures in England are similar to those already known as earthworks, though there are unusual sites, of which the Duggleby ring is one, with the small number of gaps in its ditch and its great central

69. Burton Fleming, North Humberside. Soil marks of the north end of cursus D, one of the four cursus centred on Rudston village. A dark mark gives the line of the ditch, inside which is the faint light-toned mark of the bank. The zig-zag effect caused by ploughing (see also Fig. 13) is seen when the marks are examined closely. To the right of the end of the cursus is the soil mark of a round barrow and in the lower left corner is a pattern of soil stripes of a type formed in the last Ice Age. Photograph by the author, 21 October 1983.

70 and 71. Ferrybridge, West Yorkshire. Soil marks (*above*) and crop marks (*below*), showing the bank, ditch and two opposed entrances of a henge. The bank is shown very clearly by light-toned soil marks, but hardly makes a crop mark, except where its base is outlined by deeper soil at one of the entrances. The ditch makes a rather diffuse dark crop mark. Three ring ditches are also shown by crop marks. Photographs by the author, 24 March 1982 and 5 August 1981.

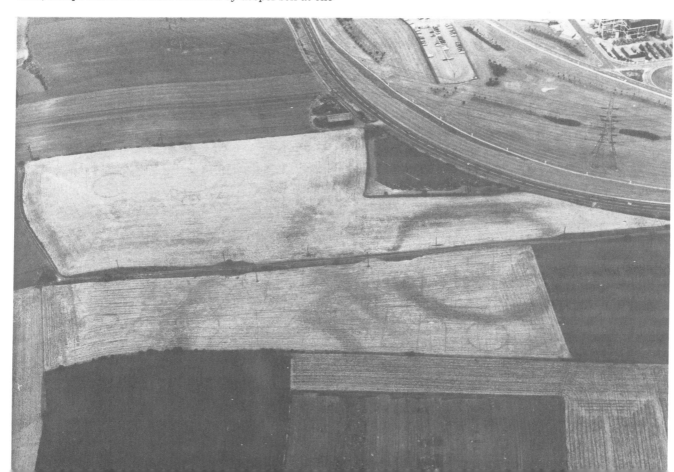

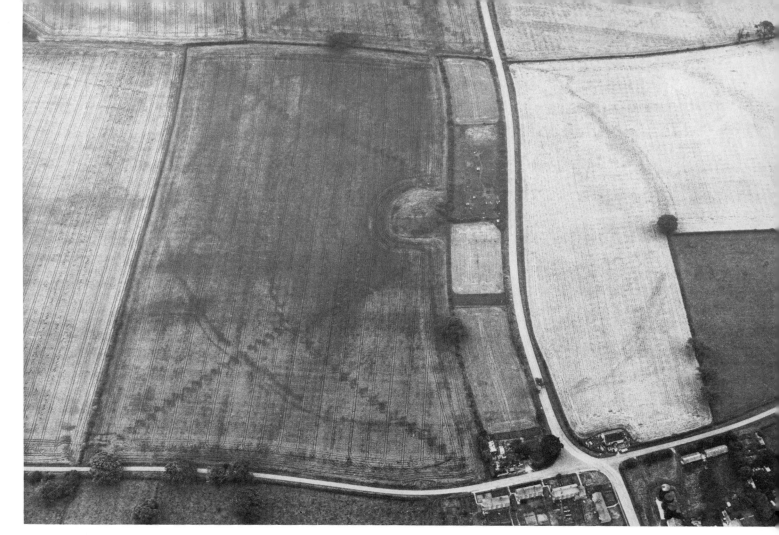

72. Duggleby Howe, Kirby Grindalythe, North Yorkshire. The huge Neolithic howe or barrow, which was excavated in 1905 by J.R. Mortimer, is at the centre of a crop mark ring, about 370 m in diameter, consisting of a wide inner ditch with interruptions and a narrow outer ditch. A small ring ditch is also seen to the left of the howe. Two fields have the 'envelope pattern', formed at the turning points of modern farm machinery. Photograph by the author, 8 August 1979.

barrow. Most of the new henges also resemble those surviving as earthworks, though some buried features which would not be visible on earthworks have been revealed by crop marks – the rings of post holes for large timbers found on certain sites, e.g. Woodhenge, Durrington, Wiltshire (RCHME, 1979, 18). The decay of these large timbers left voids in their post holes, which filled with plugs of soil large enough to cause distinct crop marks.

The monuments which have been most illuminated by aerial research are cursus; their banks and ditches have in almost all cases been levelled by ploughing (Fig. 69), so that out of the total of over 40 known cursus (Hedges and Buckley, 1981), those shown by soil or crop marks account for all but three. Several types of plan can be seen when drawings of cursus are assembled.

It is also interesting to notice major items in site plans which may *not* cause crop marks to form, even though they might be expected to do so. Unlike the holes made for rings of timber uprights, those made for the bases of standing stones do not appear to cause marks, no doubt because the stones do not decay and leave voids in the same way as timbers. There were, for example, no crop marks on the stone holes at the site of the Devil's Quoits henge at Stanton Harcourt, Oxfordshire (Grimes, 1943-4, 30). Similarly, the structures buried under long barrows very seldom form crop marks after the mounds have been ploughed away. T.G. Manby has pointed out that the remains of long mortuary enclosures found under some long barrows were made of timber uprights, which stood in foundation trenches large enough to

103

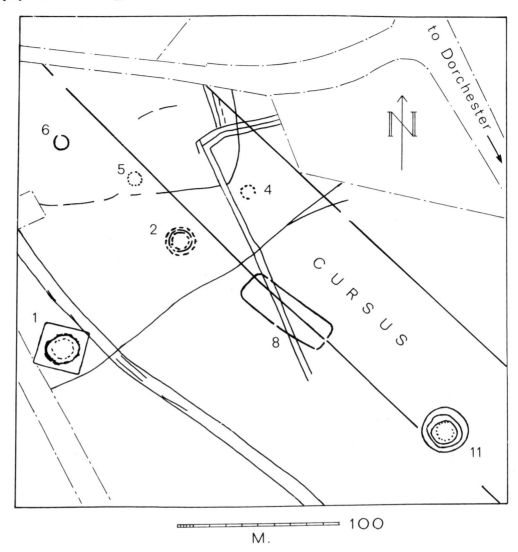

73. Dorchester, Oxfordshire. Drawing of crop marks which show various Neolithic features of unusual interest. The area is crossed by the ditches of a cursus, which intersect an oblong ditch (site 8) and are interrupted near a multiple ring ditch and pit ring (site 11). There are also three other pit rings (sites 2, 4 and 5), one of which is multiple, a combined ring ditch and pit ring (site 1) and a penannular ring ditch (site 6). The small rings have been termed hengiform monuments. After Atkinson, Piggott and Sandars, 1951, fig. 2.

cause crop marks to form. The rarity of such marks is probably because the trench fillings included much chalk rock or flint packed in to support the timbers, and because the voids left by the rotting of timbers would have been filled by chalk from the mound above, not by soil.

The study of henges has been biassed by the fact that few small-sized examples have escaped levelling by ploughing. Photographs of crop marks have, however, made important additions to the small henges with diameters of less than 30 m, usually termed hengiform monuments. Several sites which have been placed in this class are shown on Fig. 73, and more may be included in the crop mark sites termed ring ditches. There are also small cursus monuments, which appear to merge with the ovate and oblong ditches discussed below.

Smaller prehistoric monuments in England

Simple features, round, ovate, square or oblong in shape and relatively small in size, far outnumber the larger monuments just described. Air photographs of sites of this nature, which are generally seen as crop

74. Ovate and oblong ditches. Crop marks: 1 – Charlecote, Warwickshire (after W. Ford), 2 – Dorchester, Oxfordshire (see Fig. 73), 3 – Caldecotte, Bow Brickhill, Buckinghamshire (after Loveday and Petchey, 1982), 4 – Radley, Oxfordshire (after Bradley, 1984). Barrow ditches: 5 – Giants' Hills, Skendleby, Lincolnshire (after Phillips, 1935b), 6 – West Rudham, Norfolk (after Hogg, 1938), 7 – Royston, Hertfordshire (after Phillips, 1935a). Mortuary enclosure ditch: 8 – Normanton Down, Wiltshire (after Vatcher, 1961).

marks, make an important contribution to records of early sites and monuments, though it is often difficult to draw firm conclusions about their original form since they seldom have sufficiently distinctive attributes. Many crop marks show the sites of monuments of known types familiar as earthworks, but others may indicate the remains of small structures of little-known types, now almost all levelled by agriculture.

Round barrows, hut circles and ring ditches

Among the photographs of circular monuments, the most striking are probably those of upstanding barrows of certain Wessex types, such as those shown in Fig. 63. Here, air photography fulfils a useful illustrative role. Such monuments are not likely to be newly discovered from the air, since they are easily seen from the ground, and field workers have searched for them thoroughly; but probable small barrows in

remote places may be recorded on photographs, which then provide a good guide for the field visits which are necessary to examine them. Photographs of earthworks, however, have proved much less important sources of information than those of circular crop marks which may give the sites of ploughed-out round barrows (Figs 3, 24, 57, 60, 71). On soils above gravel and chalk, ring ditches of from 10 to 50 m diameter may be very frequent.

Many circular crop marks have been excavated and have often, but by no means always, been found to be the ditches of former round barrows of Bronze Age date, or of Iron Age round houses. The process of levelling a round barrow and converting it into a site shown only by a crop mark on the filling of the encircling ditch can unfortunately be watched at many places. Where there is no ditch, the site of a barrow on cultivated land is lost.

The problems of understanding the reason for a circular crop mark arise from its few attributes and the many purposes for which a small circular ditch might have been dug. These include hengiform monuments, Roman signal stations and windmill mounds (Wilson, 1982a, 90), as well as round barrows and round houses. Only when they occur in groups, such as that at Foxley Farm, Eynsham (see p.94 and Fig. 3), or have some distinctive attribute, such as the remains of a central mound in the case of a probable barrow, or occur in a settlement enclosure in the case of a probable round house (Figs 64 and 80), is the choice narrowed enough to leave no room for doubt.

Ovate and oblong ditches

In various parts of Great Britain photographers have noticed and recorded occasional crop marks of ovate and oblong ditched enclosures which appear to differ from the common settlement type enclosures (see pp.108-12), either because of unusual length in relation to width (Fig. 74, nos 1-3) or because they occur in groups of ring ditches of round barrow type (Figs 3, 24, and 74 no. 4). It is interesting to see how far these sites can be classified and explained. By analogy with ring ditches, they may be termed ovate and oblong ditches.

It is not difficult to understand the ovate or kidney-shaped marks sometimes found in groups of ring ditches of round barrow type. They are almost certainly the ditches dug to surround two or three

105

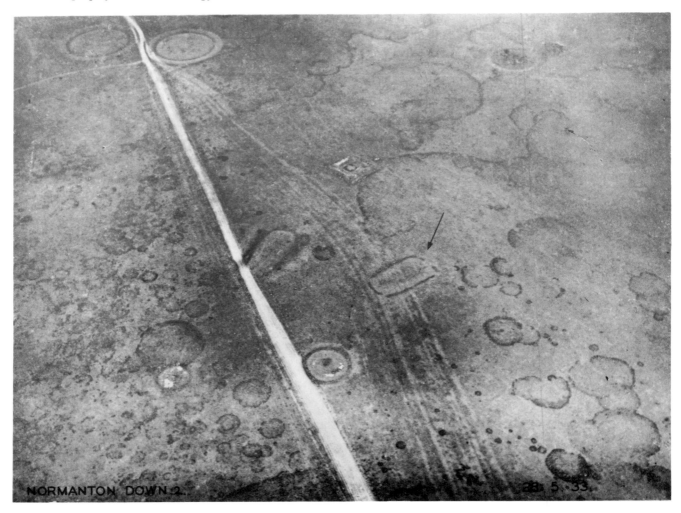

75. Normanton Down, Wilsford cum Lake, Wiltshire. A long
barrow, a mortuary enclosure (marked by an arrow) and
four round barrows are shown by marks in the grass – dark
marks in the ditches and light on the banks. The numerous
dark marks of various sizes and irregular shape are the
fungus rings, or 'fairy rings' which are found in old pastures.
Photograph by Major G.W.G. Allen, 28 May 1933.

adjacent round barrows (Grinsell, 1941, 80).

There is more doubt about the meaning of the
remainder (Fig. 74 nos 1-4), which have rather
different attributes. Important evidence comes from a
few sites which have been excavated. The first to be
investigated was a large oblong at Dorchester,
Oxfordshire (Figs 73 site 8 and 74 no. 2), which proved
to be Neolithic. Its ditch had apparently not
surrounded a mound (Atkinson, Piggot and Sanders,
1951, 60). The oblong ditch on Normanton Down, near
Stonehenge (Figs 74 no. 8 and 75), which had an
internal bank and flat central area, was also found to

be Neolithic (Vatcher, 1961). The two sites are classed
as long mortuary enclosures. Other ovate and oblong
ditches surrounded mounds. Three excavated long
barrows had oval ditches (Fig 74 nos 5, 6 and 7), and
two oblong crop marks were found, when excavated,
originally to have contained mounds (Fig. 74 nos 1
and 4); both were Neolithic (Ford, 1971; Bradley,
1984).

On the basis of this information, it might be
suggested that most of this class of ovate and oblong
ditches were the sites of Neolithic mortuary enclos-
ures or long barrows. However, to confuse matters, the
excavation of an oblong at Caldecotte, Buck-
inghamshire (Fig. 74 no. 3) showed that it was not
constructed until the first century BC (Loveday and
Petchey, 1982, 20; information from R. Loveday). As
with many ring ditches, it is seldom possible to be
certain about the identification of the original purpose

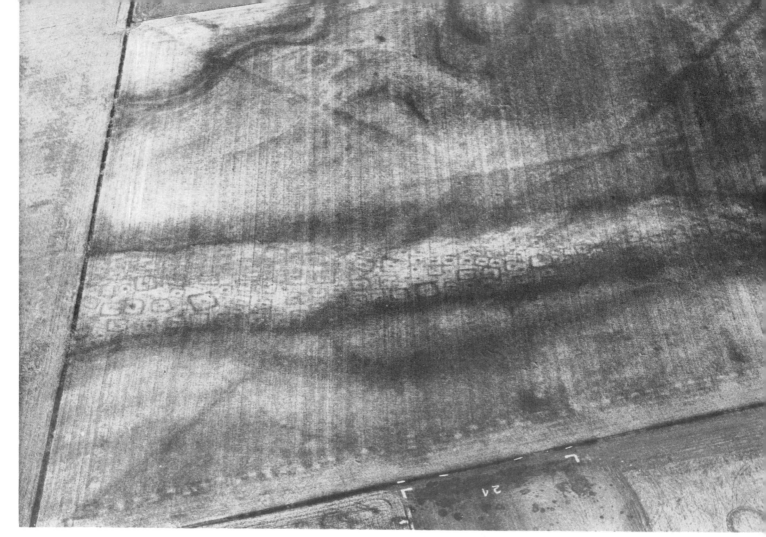

76. Grindale, North Humberside. Closely packed group of Iron Age barrows shown by the crop marks of their square ditches and burial pits. Other crop marks show the 'envelope pattern' caused by modern farm machinery and curving bands (upper left) caused by different strata in the underlying chalk. Photograph by the author, 29 July 1974.

and date of these sites. Their attributes are not distinctive and they seldom occur in groups.

There are similar problems in France, where a satisfactory explanation has not yet been agreed for the crop marks of elongated ditched enclosures photographed in the west of the country, inland from La Rochelle (Marsac, Riley and Scarre, 1982), and occasionally elsewhere. They may be termed long ovates. Surface inspection has established that there were originally mounds within at least some of these ditches. At present a date in the Neolithic period is assumed because of the resemblances of the long ovates to the Neolithic long mounds or *longs tumuli* of the region.

Square barrows

Small square crop marks and sometimes soil marks occur in their thousands in East Yorkshire. They are typically from 5 to 15 m across and may have a central spot. Those that have been excavated were found to be the sites of Iron Age square-ditched barrows, the spots marking graves (Stead, 1979, 29). They are often in groups, some of which are very large, like that seen in Fig. 76. A cluster of crop marks of this particular shape and size in close proximity may be identified with certainty as an Iron Age cemetery. This elementary application of morphology would be the immediate reaction to Fig. 76 of an archaeologist familiar with the barrow type. By an extension of the proximity argument, it may be assumed with a fair degree of confidence that the isolated small square marks found in many places in East Yorkshire are also the sites of similar barrows.

A few small squares of similar type are also known

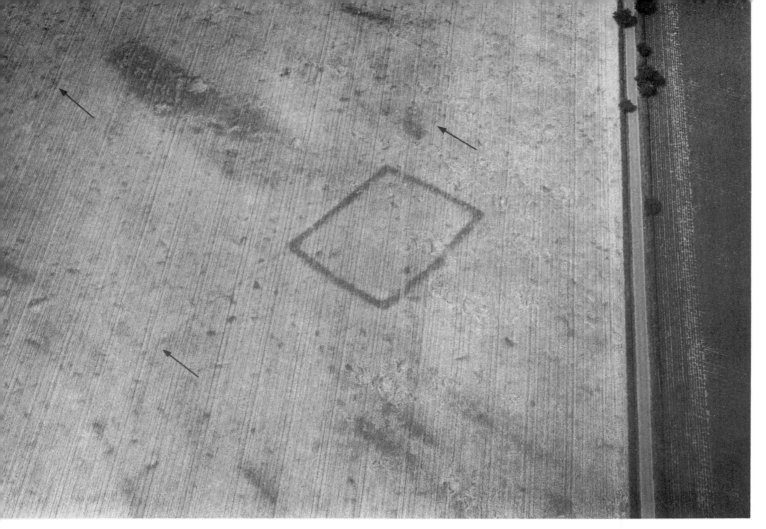

77. Morton Grange Farm, Babworth, Nottinghamshire. A field of barley with very distinct marks of a rectilinear enclosure and indistinct marks of parallel field boundaries (shown by arrows). Photograph by the author, 6 July 1984.

in the Trent valley (Fig. 60, site A), Lincolnshire and Cambridgeshire (Whimster, 1981, Figs 47 and 48), Wessex (Palmer, 1984, 106) and Eastern Scotland (Maxwell, 1978, 44), sometimes occurring in small groups. They have the common attributes of a square shape and a similar size range to those in East Yorkshire, but they are difficult to explain with certainty.

Enclosures and settlement sites

The most frequently found of all kinds of early sites in Britain are those usually called enclosures (Fig. 77). These are pieces of land marked off by ditches and banks, or by walls in upland country, usually for settlements or homesteads, and also perhaps for agricultural purposes, such as penning livestock.

Various examples in the crop marks at Aston on Trent, which have already been mentioned (Figs 59, sites J, K, H and 60, site F), demonstrate how much they vary in shape, size and complexity. When enclosures survive as earthworks, little damaged, as at the palisaded sites at High Knowes (Fig. 64), the remains of houses can often be seen within them; when they are shown by crop marks, traces of round houses (Fig. 80) or storage pits may be visible, but usually only the enclosure ditch was dug deep enough to affect the crops.

Where conditions for the survival of remains are good, the sites of unenclosed or 'open' settlements may be shown by round house rings, groups of pits and lengths of ditch, with no outer enclosure ditch or wall. These were undoubtedly much more numerous than the known sites suggest, for their slight traces were easily destroyed by ploughing and show as crop marks only where conditions are very favourable, as in the Upper Thames valley.

All periods from the Neolithic onwards are

78. Diagram of enclosure shapes. Simple enclosures: 1 to 4 – rectilinear (including 1 to 3, four sided, and 4, polygonal), 5 and 6 – curvilinear, 7 – D-shaped, 8 – rectilinear double ditched, 9 – joined to field boundaries, 10 – with internal feature. Complexes: 11 – dispersed, 12 – clustered, 13 – superimposed, 14 – linear.

represented by enclosures excavated in England, though most date from the later prehistoric or Roman periods. The excavated enclosures are in a very small minority, and little is known about the age of the great majority recorded only as shapes on air photographs. If these shapes could be classified into datable types, this would constitute a very useful tool for the study of early settlement patterns and land use. However, it is not easy to classify enclosures. Difficulties arise from the presence of many anomalies and the use of similar shapes at different periods. In the Wessex enclosures on Fig. 61, for example, although nos 1 to 3 and 5 to 7 form groups of definable shapes which may be classed together, no. 4 is not regular.

A set of terms that can be used to describe some of

the more important shapes can be taken from Palmer's work on settlement sites in Wessex (Palmer, 1983). Although these terms were chosen to describe sites shown by crop marks, they can also be used for earthworks provided that the differences in emphasis given by air photographs are remembered; on earthworks, banks and mounds are prominent, whereas crop marks show only features buried below the surface.

The numerous enclosures which occur in isolation may be termed simple enclosures. Those of definable shape, which are fortunately in the majority, may be divided further into:

(a) rectilinear, which have more or less straight sides (Figs 77 and 78 nos 1-4); the difference between the terms rectilinear (bounded by straight lines) and rectangular (shape with four right angles and four sides) should be remembered; strictly speaking, a polygon (Fig. 78 no. 4) is rectilinear;

(b) curvilinear, which includes all enclosures approaching a round shape, any corners being only slightly angled (Fig. 78 nos 5, 6);

(c) D-shaped, when one side is straight, or nearly so, and the remainder is curvilinear (Fig. 78 no. 7).

It will be noted that intermediate shapes occur. Fig. 78 no. 3, for example, though included in the rectilinear group, verges on curvilinear.

The irregular or anomalous shapes of some enclosures imply that formal planning was accorded little importance during their construction. The shapes may have been partly the result of conditions on the ground and the labour available. Rectilinear enclosures may have conformed to the boundaries of rectilinear field systems (Fig. 78 no. 9), whereas curvilinear ones may have been in open country. A given length of ditch or wall encloses more land in a circular shape than a rectangular, and it has been found in some regions that the largest enclosures, like the hill forts, are curvilinear. On the other hand, some groups of enclosures were probably made to traditional plans. It may well prove most satisfactory to classify British enclosures regionally, defining local types which take into account any attributes that can be isolated. The same approach should serve well in other countries, e.g. in France, where different types have been recorded (Agache, 1978, photos 64-5, 78 and

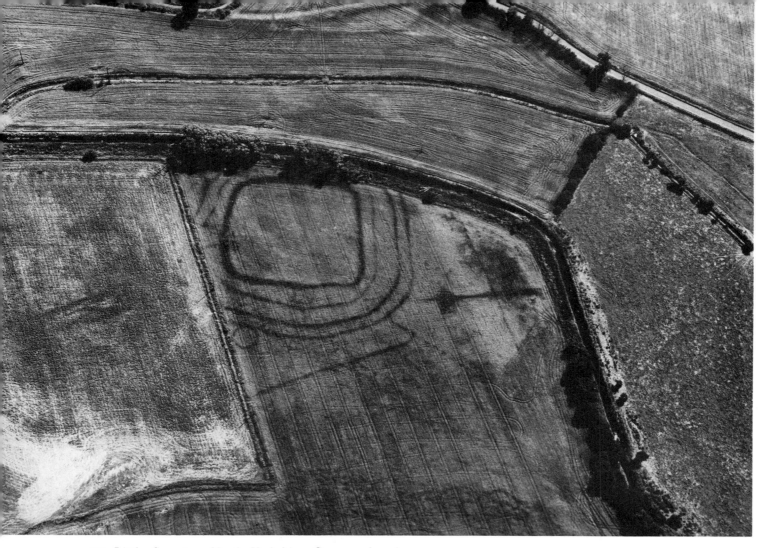

79. Little Smeaton, North Yorkshire. Crop marks of a multiple ditched enclosure beside the little River Went. A ring ditch is also visible. Photograph by the author, 29 July 1979.

80), and in the Middle East, where shapes unfamiliar to British eyes are seen (Fig. 50).

Among the attributes which should be considered are the following:

(a) size, which is very important;

(b) number of ditches – single, double or multiple (Figs 78 no. 8 and 79);

(c) ditch width – a broad ditch may indicate strong defences, while a very narrow one may have been a palisade trench;

(d) the entrance, which may be a simple gap in the ditch, or occasionally some specialised type, such as Fig. 61 nos 3 and 8;

(e) internal features, if visible, such as round house rings or subsidiary enclosures (Figs 61 no. 1, 78 no. 10 and 80);

(f) the proximity of other features, such as fields (Fig. 90) or other enclosures.

There are also groups of enclosures and associated features, which may be termed complexes and divided into:

(a) dispersed complexes, formed by several enclosures close to each other (Fig. 78 no. 11);

(b) cluster complexes, in which several enclosures are in contact, or are close together and aligned on each other, but do not overlap (Fig. 78 no. 12);

(c) linear complexes, which are very long and narrow, often consisting of enclosures bordering a lane (Fig. 78 no. 14) or boundary ditch;

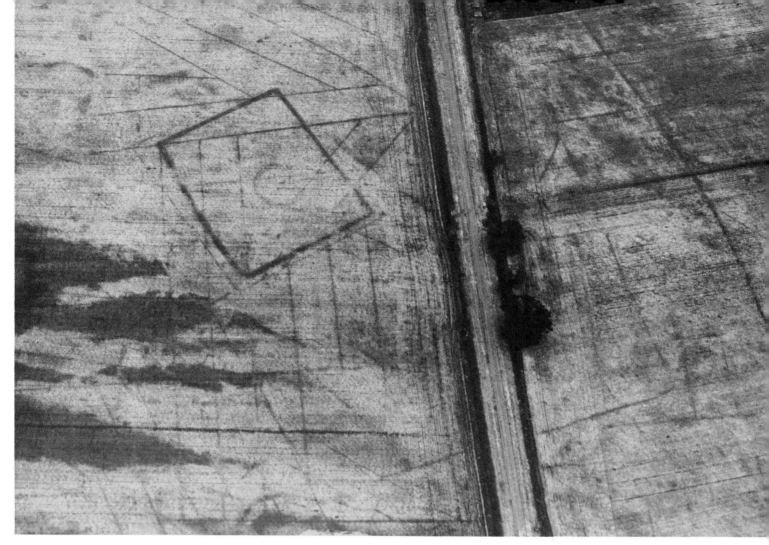

80. Bursea, Holme on Spalding Moor, North Humberside. A complicated series of crop marks. The archaeological features are the faint marks of a round house, with large entrance gap, situated in a rectilinear enclosure with two ditches. It appears to be connected to a much larger enclosure. Other marks are caused by modern land drains and by patches of wet soil. Photograph by the author, 4 July 1976.

(d) superimposed complexes, in which the component parts intersect, probably because of additions, changes of plan and recutting of ditches (Figs 57, 60 site F and 78 no. 13).

An interesting investigation of enclosures in Wessex, where more have been dated by excavation than elsewhere in England (Palmer, 1983, 50), found that the earliest were small and rectilinear, dating from the eighth century BC. Apart from that rare and specialised Neolithic type, the causewayed enclosure, the first curvilinear enclosures originated in the sixth and seventh centuries BC. In later centuries both curvilinear and rectilinear types were made. The complexes were distinctly later, first occurring during the third to first centuries BC. Many of the sites were used for long periods, continuing in use into Romano-British times. These Wessex results should not be taken as typical of England in general; insufficient excavation has been done to allow similar comparisons to be made in other regions.

Local characteristics are noticeable in the enclosures and settlement sites of all regions of Britain for which comparisons of shapes and plans have been made. Comparing statistics from areas in Wessex (information from Palmer) and areas in Nottinghamshire and South Yorkshire (Riley, 1980a), it is found that simple curvilinear enclosures are the commonest type in Wessex, but are unusual in Nottinghamshire and South Yorkshire where rectilinear enclosures preponderate. The Wessex enclosures tend to be larger, including many more over 0.5 hectares in area, whereas there were proportionately

more small examples of below 0.1 hectares in the Nottinghamshire area. In neither of these regions is there the high proportion of enclosures with double or multiple ditches that are found in the Upper Severn valley, presumably dug for defensive reasons. As a contrast, the frequency of open settlements on the second gravel terrace of the Upper Thames valley may be mentioned (Hingley and Miles, 1984, 57). On the Yorkshire Wolds, the very large linear enclosure complexes are a striking feature of the sites shown by crop marks. In Scotland, there are differences between the settlement sites in Angus and those in East Lothian and North Fife (Macinnes, 1982). It is probable that differences in society, farming practices and chronology are all reflected by variations in enclosure and settlement plans.

9
Applications: Early Agriculture

Aerial reconnaissance is of special importance in the examination of the vast areas of land over which the traces of early fields and land boundaries are dispersed. Early in the history of air photography, a foretaste of the results to be expected was given by Crawford's work on 'Celtic' fields in Wessex (Crawford, 1924). The size of the task of finding and recording these remains is suggested by the examples given in this chapter, which include brief accounts of work in England and a few other countries.

Fields tend to leave only slight traces after they have been abandoned, and these are soon levelled by later cultivation. The increase in the area of land under cultivation today therefore lends urgency to the need to extend the surveying and recording of those areas of ancient fields that remain in relief. All archaeologists are aware of the damage done to ancient features by modern ploughing, but they see much less of the actual process of destruction of the relics of the ancient landscape than does the air photographer.

Where ancient fields survive as earthworks, or where they are shown by soil marks, it may be possible to survey a large area at one time by vertical photography. It is preferable to have such vertical surveys made specially, at times when conditions are known to be good for archaeological purposes, but, as we shall see, good results have often been obtained from vertical surveys made for other purposes. The fields and land boundaries shown by crop marks usually only appear on scattered areas, for which oblique photography is generally more convenient.

Shadow sites and vegetation marks in Colombia

The aeroplane is proving useful in the study of the remains of early cultivation in various areas of Central and South America. Large areas of land with the surface thrown up into parallel ridges (Deuel, 1971, plate opposite p. 222), usually referred to as ridged fields, have been photographed in Campeche and Veracruz, Mexico, in Ecuador and in other countries (Siemens and Puleston, 1972; several papers in Darch, 1983). In an unusual programme in Guatemala and Belize, experimental airborne radar imagery was used to penetrate deep vegetation and record surface patterns believed to be Maya canals (Adams, 1980). Some of the results of the examination of sites in Colombia, organised by Dr W.M. Bray and others and still in progress, are given here.

The early sites in a small area of the El Dorado valley, about 70 km east of Buenaventura, Colombia, are sketched in Fig. 81, which gives part of the results of a field survey based on air photographs. Where datable, these features were found to belong to periods between the later first millennium BC and the Spanish conquest, after which most of the land was abandoned and reverted to forest. The clearing of trees in recent years, to enable the land to be used for cattle ranching, has exposed many traces of its formerly dense occupation.

The air photographs used to guide the field workers included a series of verticals at the scale of 1/10,000, taken as part of a coffee plant census. They recorded the ground well, but had been exposed in the middle of the day and therefore did not show the shadows needed to depict features in relief. Fortunately, they were supplemented by a few other photographs taken when the sun was low by a different photographer. The work on the ground was also done when the sun was low in the sky, i.e. in the evening and early morning, in order to make use of the shadows which showed up low earthworks. Further information was given by the greener grass growing on old ditch lines in dry weather. The results were marked on the 1/10,000

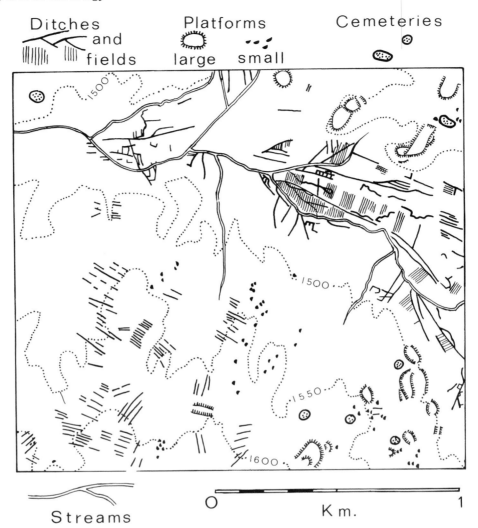

Ditches and fields

Platforms large small

Cemeteries

Streams

0 Km. 1

81. El Dorado Valley, Columbia. Map showing old drainage ditches, ridged fields, dwelling platforms, looted cemeteries and permanent streams (seasonal streams are omitted to simplify the drawing). Heights in metres. After Bray, Herrera and Schrimpff, 1983, 4.

photographs and later transferred to maps. The agricultural remains shown in Fig. 81 include many ditches on the hillsides, which probably served both as drainage channels and as property boundaries, and small blocks of ridged fields in the valley bottoms, probably made to provide drier soil on wet land (Bray, Herrera and Schrimpff, 1983).

Arid regions of the Middle East

Irrigation and settlement patterns in Iraq

A very extensive investigation of the abandoned watercourses and irrigation canals in Iraq and the sites of the ancient settlements which depended on them has been made by Professor R. McC. Adams (Adams, 1981). His work was based on vertical air photographs made for other purposes, access to which was only allowed for a limited period of time, and on field surveys. The principal evidence supplied by the photographs, which were at the small scale of 1/35,000, was the faint discolouration caused by the lines of ancient watercourses and by the remains of cities, towns and small settlements. In preparing maps from the photographs, problems were caused by the absence of ground controls on the desert land which covered much of the area surveyed. About 10,000 sq km was examined between the rivers Euphrates and Tigris and a similar area near the Lower Diyala river (Fig. 82).

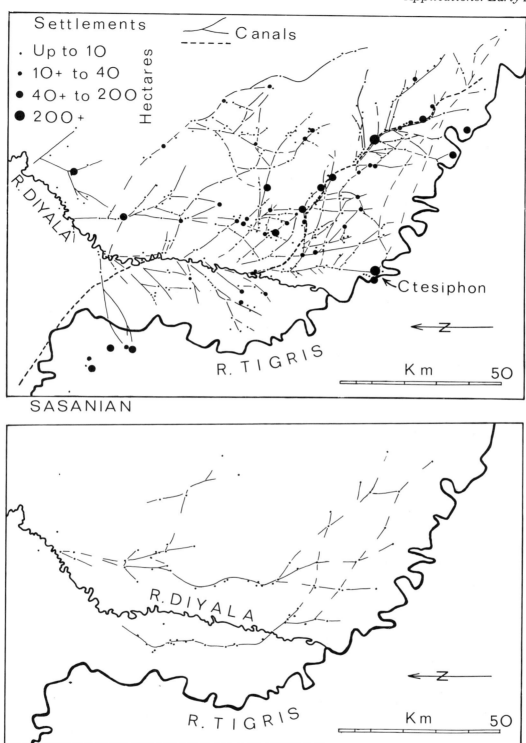

82. Lower Diyala Plain, Iraq. Maps showing watercourses and settlement sites. *Below*: Neo-Babylonian and Achaemenean periods, *c*. 700-300 BC. *Above*: Sasanian period, *c*. AD 200-600. After Adams, 1981, 193 and 212.

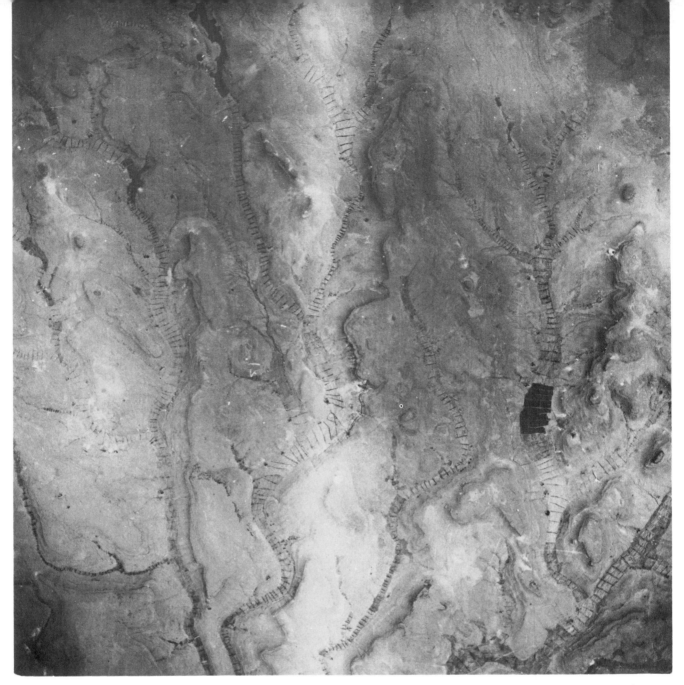

83. Wadi walls in the Negev, Israel. In a hilly desert area, wadis are crossed by many walls built by Nabataean and Roman farmers to retain soil and moisture. The walls are shown by vegetation growing round them. The dark patches are crops grown by modern bedouin farmers. After Evenari, Shanan and Tadmor, 1971, fig. 62. Reprinted by permission.

The settlement sites, which varied from occasional great cities to large numbers of small sites, showed on the photographs as lighter or darker patches, or as places where the texture was 'smoother', though many of the indications were false. The effects of wind erosion were troublesome; material had been eroded in some places and deposited in others, causing fields

of dunes. The information from photographs was checked and amplified by the ground survey, which was particularly important for the knowledge about the dates and sizes of settlements given by the systematic collection of pottery sherds. The sites dated from the fourth millennium BC onwards. Adams has published a series of period maps summarising the results, of which Fig. 82 gives two examples.

116

84. Zadar, Yugoslavia. Part of a Roman system of centuriation shown by present-day field walls, some of which preserve ancient boundaries. Photographed from a height of 27,500 ft by the Royal Air Force, 5 November 1943.

Water collection systems and fields in the Negev, Israel

Although the Northern Negev carries only a little sparse vegetation, there are widespread traces of former agriculture and the ruins of several towns, such as Shivta (Fig. 93), which were inhabited in the successive Nabataean, Roman and Byzantine periods. Maps of the ancient water collection systems and fields, which extend over about 3000 sq km, have been compiled by Y. Kedar with the aid of vertical air photographs (Kedar, 1967).

The collection and use of water by ancient farmers in this semi-desert region and their methods in

117

general have been investigated by Professor M. Evenari and his colleagues (Evenari, Shanan and Tadmor, 1971), who have provided a good example of the use of air photographs in locating scattered remains, which were then thoroughly examined on the ground. Their field work was assisted both by existing vertical photographs and by observations and oblique photographs from light aircraft and helicopters, which gave the positions of water channels, cross walls in wadis (Fig. 83), buildings and the large areas covered by banks and heaps of stones (Fig. 5). When possible, the flights were made early in the morning when the sun was low (information from Professor Evenari). The help afforded by this means varied according to the ground surface. Where it is mainly covered by limestone debris of uniform colour, shadows were very useful in the recognition of ancient features. Elsewhere, the quantity of dark coloured flint fragments in the composition of banks and mounds makes them darker than their surroundings (Fig. 5), and therefore easy to see from the air without the need for shadows to emphasise them.

Centuriation

The Roman system of land division by centuriation involved the marking out of territory in a grid of large squares or *centuriae*. Much has been published on the subject (e.g. Bradford, 1957, 145-216; Dilke, 1971, 82-97). The sides of the squares measured typically 20 *actus* in Roman units, or about 710 m, though variants are known.

In many countries round the Mediterranean traces of the Roman centuriated landscape have been recognised in the lines of modern field boundaries and roads, though the original schemes have usually been much altered. Two developments, it has been pointed out (Bradford, 1957, 155), have initiated periods of discovery and study of centuriation: the advent of large-scale mapping in the nineteenth century and of air photography in the twentieth. The large areas of land covered by Royal Air Force vertical photographs taken during the Second World War gave Bradford many opportunities, of which he took full advantage. Fig. 84, chosen from material he studied, shows centuriation on the Dalmatian coast, where some of the field walls preserve ancient boundaries.

The remains of centuriation have survived remarkably in Tunisia. A survey, based on air

photographs, has been made covering a region measuring about 250 km from north to south, on which approximately 6000 sq km of land appears to have been centuriated. It has been published at a scale of 1/50,000 (Caillemer and Chevallier, 1954). Photographs show the ancient boundaries both as stone walls, often retained as modern field boundaries (Bradford, 1957, plate 49), and as soil or crop marks, unrelated to the modern system (Stevens, 1958, plates 4 and 5).

Ancient field research in the Netherlands

The most thorough published survey of the remains of ancient fields yet produced is by Dr J.A. Brongers and covers various areas in the eastern part of the Netherlands (Brongers, 1976). His main source of information was the archives of the Topographical Service at Delft; the photographs were not taken specially for archaeological purposes, and come from a variety of sources.

The fields, which are more or less square and usually only about 35 to 40 m across, are divided by quite large banks which form a grid pattern. Fig. 85 shows the soil marks by which these banks are most often detected. In a few cases on heathland, where they survive as earthworks, they have been recorded by the shadows thrown by the low sun. Some exceptional photographs taken by the Royal Air Force early in 1945, when the land had been partly flooded for military purposes, showed the fields as dark coloured wet patches in the lighter coloured grid pattern of the drier soil of their banks (Brongers, 1976, plate 20).

Maps of the fields were prepared by making tracings of post-war vertical photographs, most of which were of 1/10,000 scale. The tracings were then matched with modern topographical maps. The investigation included the excavation of one of the heathland sites. Brongers suggests that this type of field generally came into use about 600 BC and lasted till about 200 AD. He also discusses the use probably made of the fields and the reconstruction of the ancient landscape.

85. Hijken, Drenthe, Netherlands. The grid pattern of soil marks shows the banks of a system of ancient fields. Air Photograph Archives, Topographie Service, Delft.

86. (*above*) Vag Hill, Widdecombe in the Moor, Devon. Steep oblique photograph of part of the Dartmeet system of ancient fields, dating from about 1600-1700 BC, and various later earthworks, which are shown partly by shadows, partly by differences in the vegetation. The ancient fields are bounded by parallel boundaries, locally known as 'reaves', which run from the top to the bottom of the photograph. On the left side of the figure, some of the reaves have been modified to form medieval or later boundaries. Hut circles are seen in various places. Photograph by the National Monuments Record (England), 17 May 1977.

87. (*right*) Grateley, Hampshire. Map showing relationship between linear ditches and ancient fields near the hill fort on Quarley Hill (lower right). Ditches are marked as black lines and banks are stippled, whether now existing as earthworks (e.g. the hill fort) or shown by soil and crop marks (e.g. the ancient fields and some of the ditches). The dotted areas are covered by modern buildings. In the upper right corner is a lane with side ditches and central rut, and in the lower left four barrows and a ring ditch. Heights are given in metres. After Palmer, 1984, 110. Crown copyright.

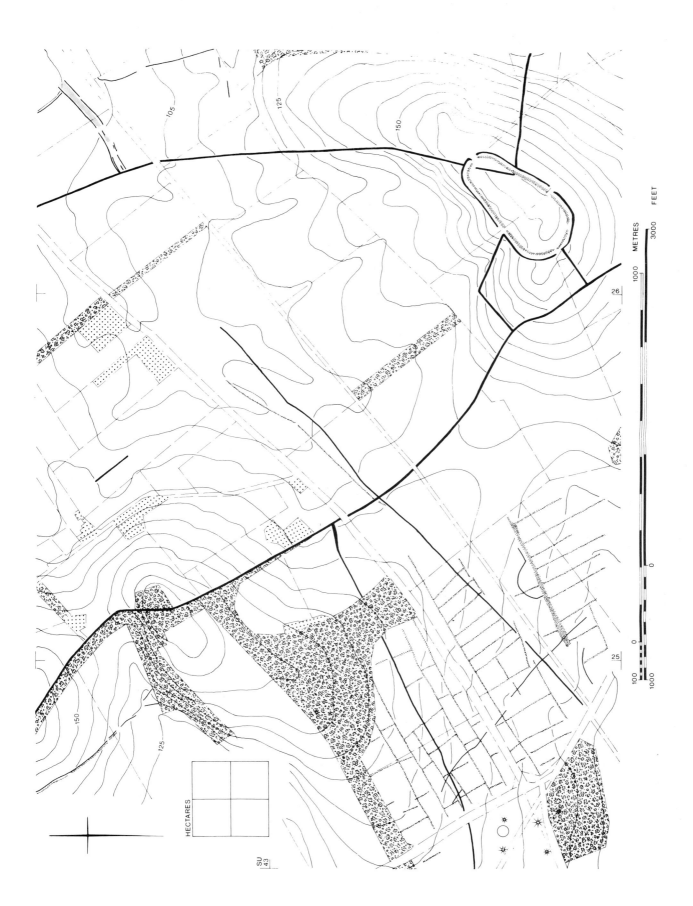

105

125

150

150

125

SU
43

26

25

METRES

FEET

3000

1000

0

0

1000

100

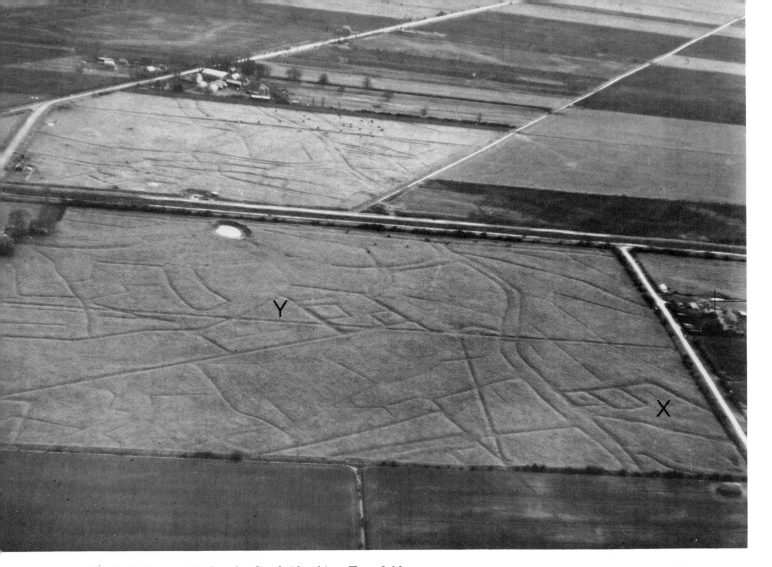

88. Shell Bridge, Holbeach, Cambridgeshire. Two fields under grass with many earthworks, shown mainly by the darker green grass in ditches. These are a long lane, fields and small enclosures. Excavations before the field was ploughed revealed evidence of Romano-British domestic occupation in the enclosures at X and of industrial activity at Y (Phillips, 1970, 309). Photograph by the author, 13 November 1945.

Early fields in England

Prehistoric and Romano-British fields

In many upland parts of England, low earthworks and ruined walls still preserve fields and land boundaries of very early origin. In the south-west, there are remains of special importance on Dartmoor and Bodmin Moor. On Dartmoor, planned systems of parallel boundary walls known as 'reaves' (Fig. 86) cover at least 160 sq km of land (Fleming, 1983, 220), and on Bodmin Moor there is about 90 sq km of moorland in an unimproved state, with many traces of

early activity. These are complete ancient landscapes, with upstanding earthworks and walls. Their great interest has given impetus to current programmes of mapping and recording. In the north, parts of North Yorkshire (Figs 11 and 54) and Northumberland also preserve impressive remains of ancient fields.

The Bodmin Moor survey at 1/2500 scale has had the advantage of good quality vertical photographic cover. The maps were made with a photogrammetric plotting machine, which largely eliminated inaccuracies due to height variations on the hilly ground. Control points were taken from Ordnance Survey maps where possible, but many had to be surveyed on the ground specially. The lack of control points is often a problem when mapping open country in upland areas. Supplementary obliques were taken to aid interpretation of the verticals. The maps were checked and amplified by field work, and the combination of air and ground work was found very

89. Green Mile Farm, Babworth, Nottinghamshire. Crop marks in a field of sugar beet caused by the boundary ditches of ancient fields of 'brickwork plan'. In one field there is a D-shaped enclosure. Photograph by the author, 5 August 1977.

effective (Johnson, 1983, 12).

Two surveys are in progress on Dartmoor: sketch mapping of the whole moor at 1/10,000, based on air photographs, by the National Monuments Record (England); and an accurate ground survey at 1/1000 of part of the moor by Sheffield University, using air photographs only to help find ancient features.

In the lowland zone, most information about ancient fields comes from soil and crop marks, which can only be surveyed from the air. The best known type, the so-called 'Celtic' fields, which formerly survived as earthworks (Figs 6 and 7) in many places on the chalklands of Southern England (Bowen, 1961, 14), have now generally been levelled by modern ploughing. The area of land they originally covered is not known, but the chalk belt which curves through several counties from Sussex to Dorset measures about 250 km from end to end. Their original extent was therefore probably very great. During the long period of use of 'Celtic' fields, which in some cases may have lasted from the second millennium BC to the end of the Roman period, the movement of soil downhill on sloping ground formed small terraces, generally called lynchets. The soil marks which now show them (Fig. 8) are caused by varying depths of soil where former lynchets are under plough in modern fields. At the higher parts of the lynchets the plough cuts into the underlying chalk, causing a whitish mark to appear, on one or both sides of which there may be dark bands indicating deeper soil. On chalkland many years are required before the soil becomes uniform and the marks disappear, but when this eventually happens, there is usually nothing left to show the positions of fields of this type, because they were seldom bounded by the ditches that would cause crop marks to develop today.

61

62

63

A 1 Road

Hodsock
Priory

N

85

Hodsock
Forest
Fm

84

River
Ryton

Cross-
ley
Hill

Fleecethorpe

B 6045 Rd.

83

1000

M

82

Built up
or wooded

A scale of 1/10,000 has generally been used for maps of this and other types of ancient fields shown by soil or crop marks, with selected areas plotted at 1/2500. Maps published include 'Celtic' fields in Dorset (e.g. RCHME, 1970, 318-46) and Berkshire (Bradley and Richards, 1978). Fields in relation to the whole pattern of the ancient landscape of Hampshire (Fig. 87) have been considered by Palmer (1984). The small 'Celtic' fields, which were normally from 0.1 to 0.5 ha in area, often formed part of large planned systems.

Although many other lowland regions must have been cultivated by ancient farmers, later ploughing has largely obliterated the remains of their fields. In the Upper Thames valley, for example, where it might have been expected that the numerous ancient settlement sites shown by crop marks would be accompanied by fields, they can very seldom be traced; only near a few of the settlements are there some small ditched fields or paddocks (e.g. Fig. 57). This is not surprising, for there are few slopes on the wide valley floor on which lynchets would have formed, and the rarity of fields shown by crop marks only implies that, like the 'Celtic' fields on the adjacent Berkshire Downs, the fields in the valley were not bounded by ditches. In some similar regions, however, such as the Trent valley, there are occasional places with field boundary ditches shown by crop marks.

Only in a few special lowland areas can extensive systems of field ditches dug by ancient farmers be traced. One is in the Silt Fens of Cambridgeshire and Lincolnshire, where the ground is very low lying and many ditches must be dug to drain the land. There are widespread remains of fields, lanes and enclosures, traceable by the Romano-British drainage ditches which show well from the air. At one time they could be seen in many places as low earthworks in grassland (Fig. 88), but almost all the land is now under plough. The humose fillings of the former ditches show in spring and summer as crop marks and in winter as soil or damp marks. Maps of fields and settlement sites covering about 200 sq km have been published (Phillips, 1970).

Another region is the North Nottinghamshire and South Yorkshire Bunter Sandstone belt, where crop

90. Hodsock, Nottinghamshire. Map of crop marks showing large system of 'brickwork plan' fields and various associated enclosures and lanes. The position of this map is shown on Fig. 26.

marks show the boundaries of fields on about 40 sq km of land (Riley, 1980a). A regular plan is often seen, with a series of long parallel boundary ditches, between which cross-ditches mark out large fields of from 0.5 to 2.8 hectares in area, producing a 'brickwork' plan (Figs 89 and 90). Enclosures are joined to the field boundaries in various places. The reason for this scheme of land division is not fully understood. The ditches cannot have been needed to drain the soil, which is sandy. It is not certain that the crop marks showed all the land divisions, and the large fields might have been divided into smaller plots by minor boundaries which have left no trace. Excavation of enclosures associated with the fields at the site shown on Fig. 45 has revealed that they were in use during the Roman period, so it is assumed that the fields were also in use then, though their origin was possibly earlier. Much remains to be elucidated. Aerial survey of the Bunter Sandstone country has provided a map of the former land boundaries, but only work on the ground will tell how the land was used.

Medieval fields

By far the most common remains of early cultivation seen in England are medieval. In many parts of the country it is very easy to recognise the strips into which the medieval open fields were divided. The method of ploughing then used often produced the characteristic earthworks known as ridge and furrow (Figs 3, 34 and 35). Sometimes the strips were ploughed in a way which left them flat, though their edges show as differences of height on sloping ground (Fig. 55).

When these earthworks have been levelled by modern cultivation, the ridges form light coloured soil marks (Fig. 14), which last for many years on chalky soils but disappear fairly soon on other soils. The furrows may cause crop marks, though only if they were deep enough to have cut into the subsoil. Figs 3 and 24 show a field in which ridge and furrow disappeared without trace between 1933 and 1982.

Air photography has assisted in the survey of medieval fields by recording isolated and inaccessible patches of earthworks and areas of soil and crop marks and by illustrating the general plan of large areas, but this work has not received much priority. Probably the most useful source of evidence available

is the vertical survey of the whole of the country made by the Royal Air Force after the Second World War, when much more remained of earthworks on grassland.

Early land boundaries

Linear earthworks

Many parts of Great Britain are crossed by the remains of ancient linear earthworks. Their banks and ditches may still be upstanding, so that they can be followed on the ground by field workers, but more often they are now difficult to trace without aerial observation of soil and crop marks. Fig. 13 shows a much ploughed example in East Yorkshire. Linear earthworks have been given most attention in Wessex (Bowen, 1978; Palmer, 1984, 65), where they cut through 'Celtic' fields in various places (Fig. 87), and they are also very well developed in East Yorkshire. In both Wessex and Yorkshire the beginnings of many linear earthworks appear to date from the end of the second millennium BC. Similar linear ditches in the Midlands have been recorded as crop marks.

The recovery of the lines of these earthworks is important in the study of the ancient landscape for two main reasons: they were major land boundaries and, like the long ditches of cursus, they provide evidence about features that they intersect or adjoin (compare Figs 62 and 87).

Pit alignments

Another form of land boundary, consisting of a row of large pits (Fig. 15), is of interest because nearly all have been found from the air as crop marks. These pit alignments occur mainly in the Midland river valleys, East Yorkshire and South-Eastern Scotland. Most of them probably date from the Iron Age. In a few places in Scotland and Yorkshire, pit alignments still remain intact as earthworks. The Yorkshire earthworks have long been known (Mortimer, 1895), but appear to have been forgotten until they were recently published again by Dr D.A. Spratt (1982, 182).

10
Applications: The Roman Empire

The military and civil works of Rome left traces which are still easily visible in many countries. Great contrasts may be seen between aspects such as the monumental buildings of cities in the East and the modest centres of British towns, but in roads and military defences there is much that is comparable across the whole Roman Empire. The methods best suited to the aerial exploration of these remains depend to a great extent on the climate of the region in which they occur. In the East, the desert encroached on abandoned structures, which often still stand as quite well preserved ruins. The damp climate of the West, however, caused uninhabited sites to be overgrown by vegetation and buried by accumulated soil, so that sites which have been robbed of building materials have now become cultivated fields in which ancient features show as crop marks.

The eastern frontier

The opportunities given by the good preservation of many ancient structures in the East are not easy to exploit. At present aerial reconnaissance is very seldom possible and even the vertical surveys made for official purposes in various countries are difficult to consult, except in Israel. Old photographs made by archaeologists and others in the 1920s and 1930s are very useful for the areas they happen to cover, and they show something of the results that should be obtained in the future, if present troubles ever cease.

The Roman frontier in the East ran for a great distance along the margins of the desert from the head of the Red Sea to Iraq. This is a vast area, much of which is difficult to reach. The aeroplane is essential for its examination. The work of Poidebard in Syria after the First World War has been of fundamental importance to all who have followed him in frontier studies, and it is fortunate that he was so well supported by the French authorities of his time. Fig. 2 gives the places of which photographs or maps were published in two important books (Poidebard, 1934; Mouterde and Poidebard, 1945). Many other photographs were taken but not included in the books. The map also gives the similar results of Stein's expedition. The lonely and desolate nature of some of the country they explored is shown in Fig. 91, Stein's photograph of Tell al Ghail in North-Western Iraq. He visited this place on the ground, but recorded no evidence of its date (Gregory and Kennedy, 1985, 48).

The general outline of the defended zone, or *limes*, was known in the 1920s, but it was not understood in any detail until Poidebard's work was published. His principal achievements appear to have been based on the reconnaissance of the lines of Roman roads, which were often clearly seen from the air though invisible on the ground. By wide ranging flights, he discovered numerous forts and signal stations, which it would have been difficult or impossible to find by a search on the ground, and at the same time he added to the detailed knowledge about sites which had already been recorded.

The ruins of many stone-built forts on the Syrian *limes* are found along the great road, the Strata Diocletiana, which ran from the fort at Azraq in Jordan to the Euphrates. These forts had high walls with projecting corner towers and often also interval towers; their areas are small, ranging from 0.15 to 0.7 ha. Fig. 92 gives the plan of the fort at Han al

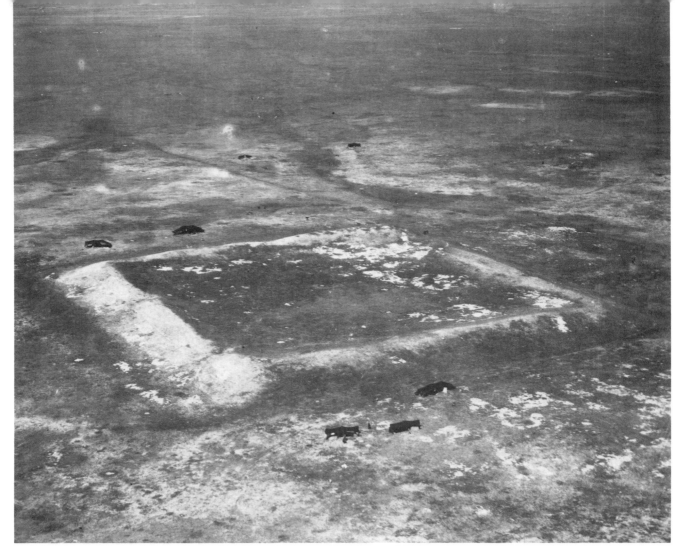

91. Tell al Ghail, North-Western Iraq. Fort remains, with vegetation marks on the remains of sun-dried brick walls and the surrounding ditch. A number of bedouin tents can also be seen. Photograph by Sir Aurel Stein, 22 March 1938.

Manqoura and part of its water supply arrangements. Similar forts also occur on the Arabian *limes* to the south. Many can probably be assigned to the late third or early fourth century AD, though the investigation of their dates and history has hardly been begun. It should be noted that scholars now doubt whether some of the forts recorded by Poidebard and Stein really belong to the Roman period.

To the west of the Euphrates, most of the ruins of forts were clearly visible on the firm surface of the desert margins when seen by Poidebard, but some sites were shown by banks and mounds rather than walls, because of stone robbing. East of the river, some of the forts were less easy to find. Sun-dried brick was much more often used in this region and

some sites were obscured by up to 0.3 m of wind-blown soil, so that the remains were only clearly visible when conditions were good. Shadows and vegetation marks were found helpful on occasions (Poidebard, 1934, plates 4A and 7).

The temporary camps built by the Roman army on campaign have rarely been recorded in the East, though there is a famous group at Masada, built to house troops during the siege of the Jewish fortress. They were known to archaeologists long before the time of the aeroplane. Photographs of these camps illustrate them well and demonstrate the clarity with which stone fortifications show on bare ground when seen from the air (Fig. 4). The main attributes of the large camp – straight sides, round corners and short curved defences (termed *claviculae*) inside the entrances – match those of temporary camps in Britain, providing a striking example of the standardisation of defence design at opposite ends of the Empire. Many ruins of low walls inside the camps are

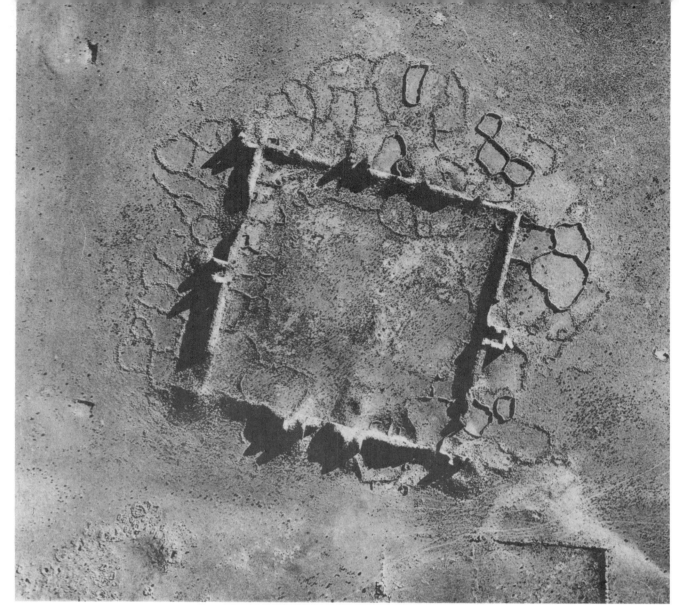

92. Han al Manqoura, Syria. The ruins of the Roman fort, round which are many walled enclosures built by bedouin herdsmen. At the lower right is a water tank. This place, the Roman Vallis Alba, is in the desert south west of Palmyra. From Poidebard, 1934, plate 20.

the remains of temporary structures (Richmond, 1962, 146). The defences of the larger camp shown in Fig. 4 enclose an area of 2 ha. It is surprising that there do not appear to have been any aerial discoveries in the East of temporary camps. Possibly Poidebard and Stein were too much occupied by the search for permanent forts and gave insufficient thought to the possibility that the less conspicuous defences of temporary camps might also await discovery.

Roads were no less important to Rome in the East than in other parts of the Empire. The ease with which they can be found depends on their construct-

ion. A few of the greatest were made with a surface of dressed stone blocks, as seen on the road from Antioch to Chalcis. Some major roads were metalled and had a foundation of large stones, which were originally covered by a layer of small stones, e.g. the Via Nova Traiana, running from Southern Syria to the head of the Red Sea. More often roads seem to have been unpaved, though perhaps marked by a border of stones on each side, leaving a space between about 12 m wide. Only on low ground or at the crossings of winter stream beds in wadis was the surface improved. Poidebard termed roads of this type *voies de terre amenagées* (1934, 167). He found that they were sometimes only identifiable from the air by marks on bare soil or vegetation marks, which were often invisible from the ground, though he remarked,

129

93. Shivta, Negev, Israel. The stone-built ruins of the Roman and Byzantine town. There were three churches, recognisable by the two rows of pillars inside them. The open space in the centre of the town, near one of the churches, is the site of two large water storage tanks. Photograph by the Survey of Israel, 3 December 1977.

with a touch of humour, that observation from the surface was easier from the 3.5 m elevation of the rider of a camel.

Town and harbour plans in the East and Mediterranean countries

Large-scale vertical photographs provide good records of the general plans of many deserted cities and towns. Fig. 93 shows the well-preserved ruins of the stone-built town of Shivta, which is on the margin of desert land in the Negev, 43 km south-west of Beersheva, Israel (Segal, 1983). The site has been

130

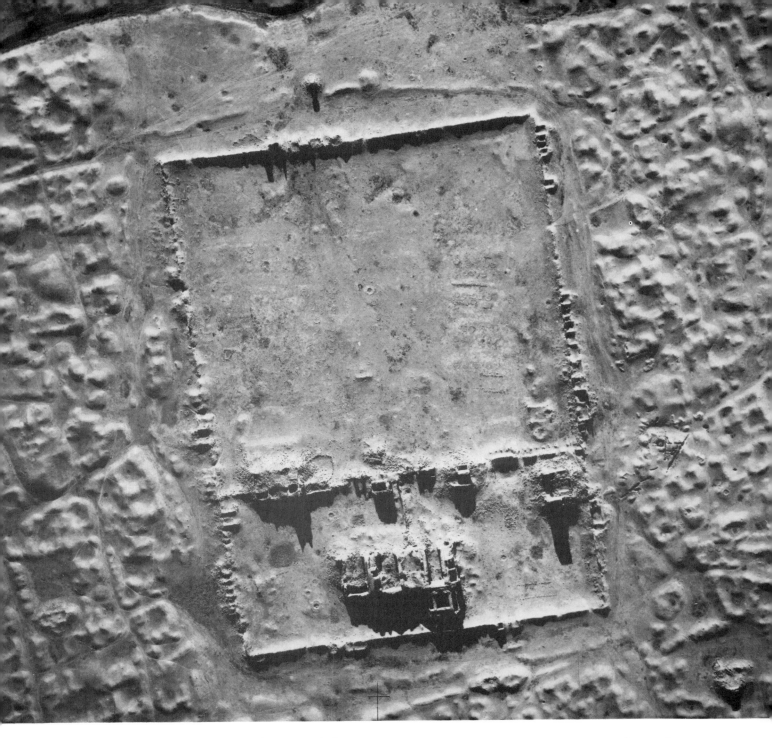

94. Al Hadr, Iraq. The central part of the ruins of the ancient city of Hatra, which was abandoned after its capture by the Sasanians in the mid-third century AD. The ruins of the great stone construction in the centre are surrounded by the remains of sun-dried brick buildings. Photograph by the Royal Air Force, 16 September 1936.

partially surveyed by various archaeologists, including T.E. Lawrence and C.L. Woolley before the First World War, but previous plans have been superseded by a new drawing based on the photograph reproduced here. The positions of a number of points were measured on the site to enable the exact scale of the photograph to be found and tilt to be rectified (Brimer, 1981). In other regions, where most buildings were made of sun-dried brick, the ruins of decayed houses are much less easy to understand on an air photograph. The contrast between the ruins of the stone-built complex in the centre of the ancient city of Hatra, Iraq, and the

confused heaps remaining from the surrounding mud-brick buildings emphasises this point (Fig. 94).

The sites of many of the former classical cities have continued in use, often retaining important elements of their plans. The lines of the original streets have in many cases left a permanent imprint on all later growth, e.g. at Lucca, Verona and various other Italian cities (Bradford, 1957, 256-63; Ward-Perkins, 1974). The grid plans of the ancient cities, surrounded by later developments, are visible on modern street maps, but they can be appreciated better on photographs.

The study of the submerged remains of ancient ports can be aided by aerial views looking down into the clear waters of the Mediterranean. The presence of underwater structures has been recorded in several places and there are evidently opportunities for exploration of the coastline. Photographs published recently include those of submerged remains of buildings and quays at Pozzuoli in the Bay of Naples (Schmiedt, 1970, plate 136), and at Corinth and the ancient Halieis in Greece (Schoder, 1974, 86 and 112).

Britain and France

In Western Europe, the formal planning of many Roman constructions, such as forts, larger towns and villas, provides a much better framework into which to fit discoveries recorded from the air than the rather loose systems of classification of most prehistoric sites. In consequence, Roman sites of these types tend to be studied on rather different lines from prehistoric sites and also from rural settlements of Roman times, which in many respects seem to have been very similar to those of earlier centuries. Only a few subjects can be reviewed here, military remains in Britain and villas in France being the most important.

Military stations: camps and forts

When the 1978 edition of the Ordnance Survey Map of Roman Britain is compared with the 1928 version, the increased number of military sites is very noticeable. The majority are aerial discoveries. The number now known is demonstrated by Fig. 95, a map which shows a region important in the history of Roman Scotland. Of the sites shown, only 13 were known in 1928, but by 1984 the number had risen to 58. The new discoveries have greatly increased knowledge about the con-

siderations which governed the choice of sites. The work of Professor J.K. St Joseph has been especially important in the exploration and explanation of military remains of this kind.

Aerial survey has been particularly successful in recovering the plans of temporary camps, the rather slight remains of which were easily levelled by ploughing when the land was later cultivated. In Britain in 1978 a total of 370 camps was known, of which 269, or 73 per cent, had been found from the air (Wilson, 1982b, 304); more have been recorded since. Nearly all the newly discovered camps were shown by crop marks, though a few were low earthworks which had escaped ploughing, such as one on an upland pasture at Malham, North Yorkshire (Fig. 96) and four in Redesdale, Northumberland, which were seen on Royal Air Force verticals (Richmond, 1940, 124).

The British camps probably date from a period between the conquest and the northern campaigns of Severus, i.e. from the mid-first century to the beginning of the third century AD. Their attributes, which are highly specific and have been known for many years, generally make it easy to recognise them. The very common playing-card outline, with single ditch, straight sides and rounded corners, is a shape which usually stands out from the numerous less regular rectilinear enclosures of other types, such as those mentioned on pp.108-12.

The most variable attribute of camps is their size, which differs according to the purpose for which they were made. The largest known, several camps of 67 ha, must have been made to accommodate a very large force; at the other extreme are some very small camps of as little as 0.1 ha, which are thought to have been dug during the training of troops. The very large camps extend over several present-day fields, and the crop marks which show them seldom develop over the whole site in a single year. The recovery of their plans has generally involved several years' work, because of the need to wait for the right crops to be grown and seen under suitable conditions on various parts of the site.

Distinctive groups of camps of similar size and design have been identified along presumed lines of march in parts of Scotland. It is assumed that the number of men in a certain force would have needed a camp of about the same size at each stopping point. One such series is formed by the sixteen camps of about 25 ha known in Strathearn and Strathmore

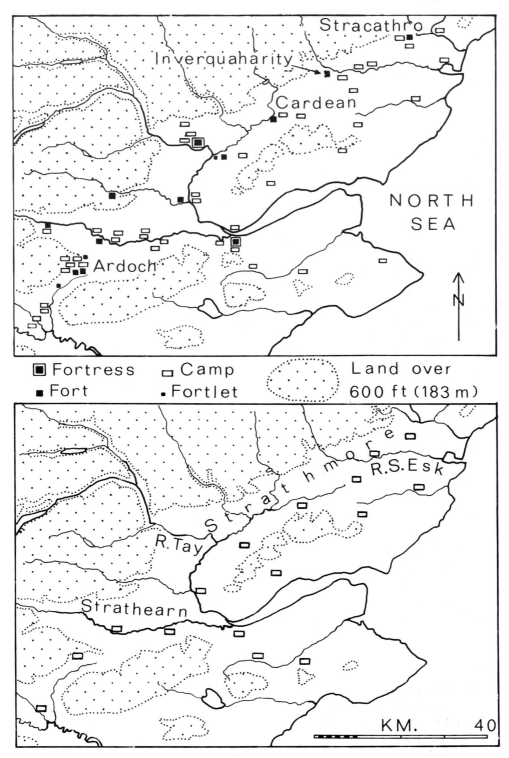

Fortress ▣ Camp ▢ Land over

Fort ■ Fortlet ▪ 600 ft (183 m)

KM. 40

95. Maps of part of Eastern Scotland, showing Roman
military stations. *Above*, all sites; *below*, 25 ha (63 acre)
camps. After St Joseph, 1973, 227 with some additions.

133

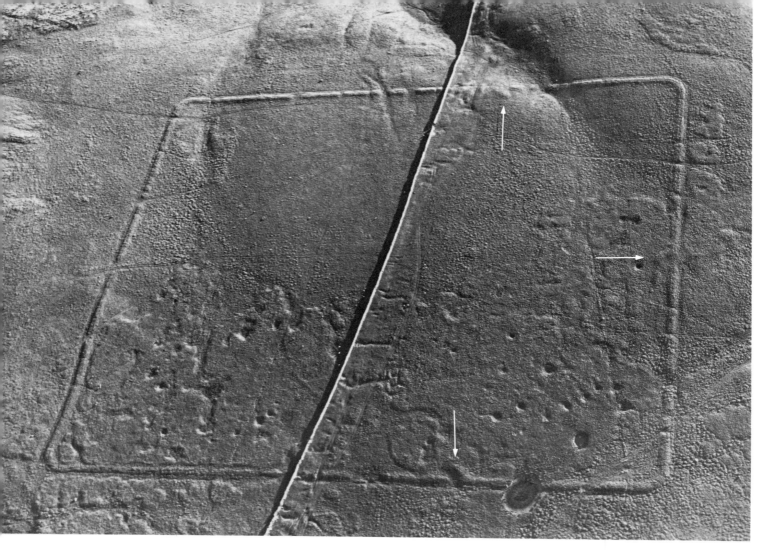

96. Malham, North Yorkshire. The earthworks of the Roman temporary camp shown by shadow. *Claviculae* (marked by arrows) can be seen at three of the entrances. The numerous depressions inside the camp all appear to be natural. Photograph by the author, 8.30 p.m. on 21 June 1977.

(Fig. 95). These appear to mark the outward and return routes of a large force, probably that which was deployed on one of the Severan campaigns during the years AD 208-11 (St Joseph, 1969, 116).

For a complete series of camps to be visible in this way, they must be situated on land favourable to crop mark formation and have had reasonably deep ditches. Where the line of march entered a region with soil unfavourable to crop marks, camps may cease to be traceable. A geological map may therefore be useful in assessing the significance of apparent gaps in a series of camps, though it may be noted that at Scone, Tayside, one of the 25 ha camps has been found by marks in crops growing on clay, which is

normally unfavourable to their formation.

The ditches of camps vary in depth considerably from one site to another. The filling may reach 2 m below the modern surface and form very distinct crop marks, or it may be much shallower, sometimes forming little more than a furrow in the subsoil which produces only a thin crop mark in dry years and none in wet. On land with hard rock below a thin layer of soil, crop marks of camps can hardly be expected, because their ditches are unlikely to have penetrated the rock.

The entrance defences of camps are important features, which may only partly be shown in the crops. A rush through the entrance by attackers was impeded by supplementary defences of types characteristic of Roman camps and occasionally also found at forts. These are known as the *titulum*, a transverse bank and ditch outside the entrance (Fig. 1), and the *clavicula*, a curved extension of the rampart, either inside (Fig. 4) or outside the entrance.

97. Newton Kyme, North Yorkshire. Positive crop marks show the defences of a fourth-century Roman fort. Inside the narrow mark of the outer ditch is a broad mark caused by two ditches, which overlapped as a result of re-cutting (information from H.G. Ramm). The narrow inner mark probably shows the robber trench from which the foundations of the wall have been removed. A negative mark gives the line of a road inside the fort. Other photographs show traces of a smaller first-century fort which originally occupied the site (Frere and St Joseph, 1983, 110). The broad dark crop marks are natural features, probably old river courses. Photograph by the author, 23 July 1979.

They are shown by crop marks if there was a ditch; *titula* almost always had ditches and can therefore be detected at sites on cultivated land. *Claviculae*, on the other hand, had ditches only when they were outside the entrance; internal *claviculae* are therefore unlikely to be found as crop marks. The subject has been well treated by Wilson (1982a, 99).

Traces of structures are very seldom found within camps because the soldiers were normally housed in leather tents during a campaign. There is nothing in Britain to compare with the ruined walls in the siege camps at Masada (Fig. 4). However, signs of an orderly plan are recognisable in the crop marks of lines of pits recorded in the large camp at Inchtuthil,

Perthshire, which probably give the positions of tents and of certain streets (St Joseph, 1965, 82; Maxwell, 1982). Marks round the periphery of a few camps, a little inside the ditch, are probably caused by the fillings of holes dug along the inside of the rampart for latrines or field ovens.

Almost all the temporary camps known in Britain are in Wales and its approaches, Northern England and Scotland. Very few are in South-East England. On the other side of the Channel, camps have not been found in France despite the frequent references to them in Caesar's *De Bello Gallico*. It was at one time said that insufficient aerial exploration had been done in France, but this explanation of the absence of camps of familiar types is now difficult to credit. Possibly the practices of Caesar's army were different from those of the armies operating a century later in Britain. Agache suggests that the irregular rectilinear enclosures near Gallic promontory forts at Liercourt-Erondelle, Somme, and La Chaussée-Tirancourt, Somme (Agache, 1978, 219 and 227) were perhaps made by Caesar's forces during their temporary reoccupation of the former Gallic defences. The contrast between the frequency of Roman temporary

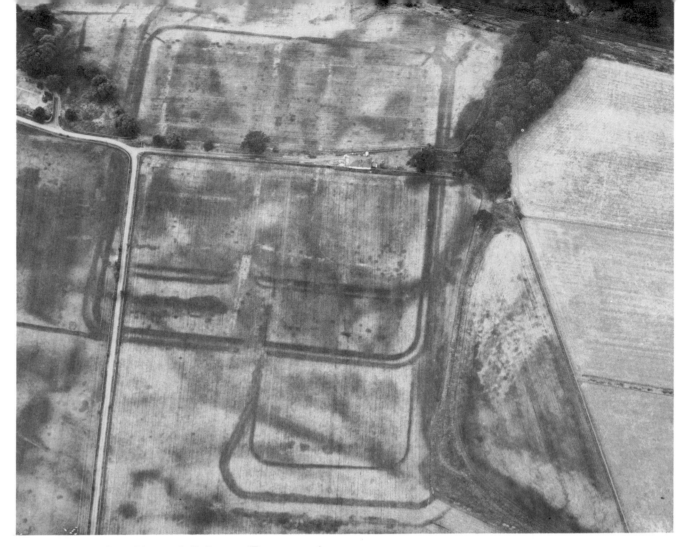

98. Dalswinton, Dumfries and Galloway. Two successive later first-century Roman forts on this site are shown by exceptionally distinct positive crop marks on the double ditches of their defences. The smaller fort was the earlier and the larger one later (Frere and St Joseph, 1983, 123). In the foreground of the photograph and to the left are the ditches of annexes of the forts. Negative crop marks indicate roads. Photograph by the Royal Commission on the Ancient and Historic Monuments of Scotland, 14 July 1977.

camps in Northern Britain, Wales and Scotland, and their rarity or absence in Southern Britain, France and the Middle East has yet to be satisfactorily explained.

Forts, the permanent stations of auxiliary units, most of which in Britain were built in the first and second centuries AD, were more strongly defended than camps. They therefore left more prominent remains, which have been more easily found on the ground by field workers. Wilson's enumeration of the 250 forts known in 1978 found that 58, or 23 per cent, had been identified from the air. Since then more have

been discovered, including a number in Scotland, but the proportion of aerial discoveries is still much smaller than that of camps, the less substantial remains of which were more easily levelled by ploughing.

The shape of the defences of first- and second-century forts is rather similar to that of small camps. They are normally rectangular with rounded corners, the playing-card shape being very common. The defences are stronger than those of camps; the ditch is wider, or there is more than one ditch. The entrances as shown by crop marks are usually only gaps in the ditch, sometimes with *titula* as an extra protection. The size range includes small sites of from 0.1 to 1 ha, termed fortlets, normal forts of from 1 to 2.5 ha and occasional larger forts, two of which are seen in Figs 97 and 98.

Crop marks on fort sites very often show no more than the position of the ditches as positive marks. Many years of ploughing have generally removed all traces of the rampart, though enough of it sometimes

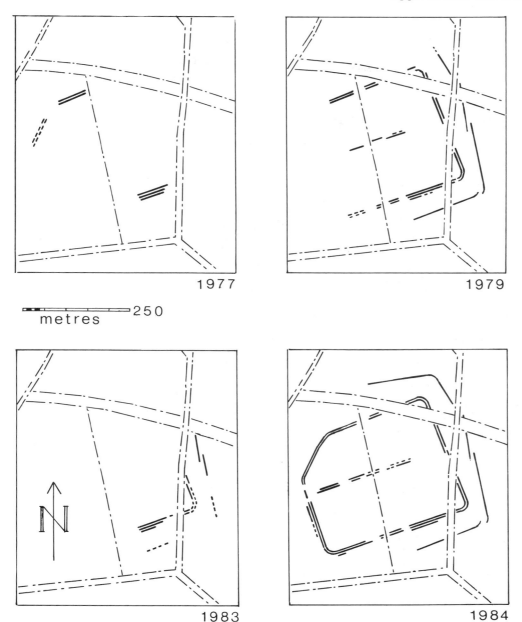

99. Osmanthorpe Manor Farm, Edingley, Nottinghamshire. The crop marks seen in successive years on the site of the vexillation fortress after its first discovery in 1977. Nothing was seen in other years.

remains to form soil marks or crop marks at the appropriate season. Where there are crop marks, a positive mark may be expected on a turf rampart and a negative mark on one made of clay. The internal arrangements of forts seldom show as crop marks, though on unploughed sites negative grass marks sometimes give a chequer pattern of roads very clearly. Crop marks of roads are seen faintly on Fig. 98. Traces of wooden or (more often) stone buildings are occasionally seen in crop marks.

Several successive forts were often built on the same site, causing crop marks to show a very complicated pattern. Fig. 98 shows the site at Dalswinton, Dumfriesshire, on which there are very clear traces of two forts, both of which had annexes. The marks of several camps are superimposed in the same way at various places.

The positions of forts were chosen systematically,

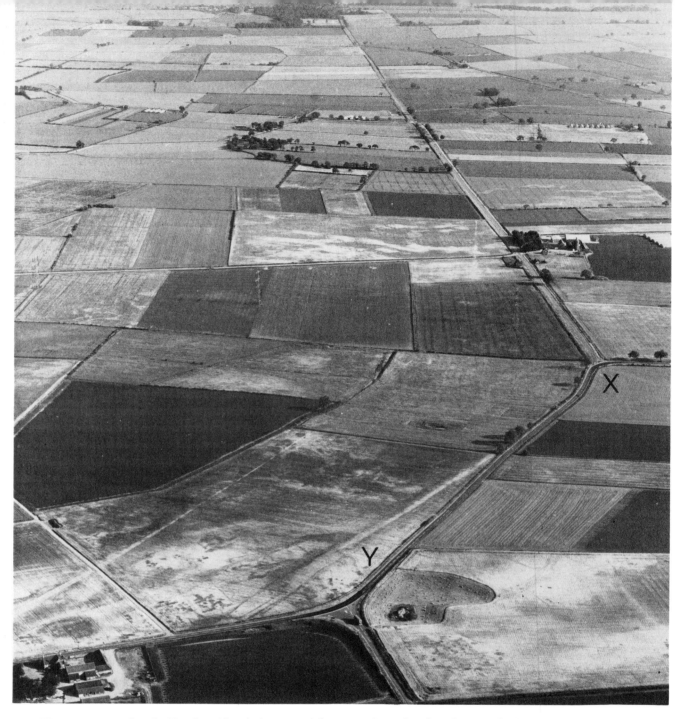

100. Winteringham, South Humberside. A long straight length of the Roman road, Ermine Street, ends at X. Beyond this point the course of the road was unknown until crop marks gave the line of the missing part. Between X and Y negative crop marks are caused by the metalling of the road and positive marks by its side ditches. The light-toned negative mark on the left is the track of a recent pipeline. Photograph by the author, 29 June 1976.

and tend to be about a day's march apart – say 15-25 km. A similar spacing was observed by Poidebard in Syria (1934, 40, 73). Where a number of forts have been found in a region, gaps often become apparent and air reconnaissance can be directed to specific locations. In the part of Scotland shown on Fig. 95, for example, no fort was formerly known near the river South Esk, leaving a long gap between the forts at Cardean and Stracathro, which suggested that another fort remained to be found. In the dry summer

101. Behen, Somme. Gallo-Roman villa shown by damp marks (*taches d'humidité*) early in the morning. The dark patches, which only showed well looking into the sun, are caused by soil remaining from the pisé walls of the ancient buildings. Photograph by R. Agache, Service des Fouilles.

weather of 1983, crop marks of a small fort were found at Inverquaharity, Angus. A missing element was thus supplied, though it is not yet certain that the gap has been filled since a larger fort was expected. Similarly, in places where there are very small distances between the forts on a certain route, it is likely that systems of forts of different dates are present, the first system having gone out of use before another was constructed, with a different choice of sites.

As discoveries of British forts accumulated, it was realised that some were very much larger than the rest. These large forts, which are generally from 8 to 12 ha in area, are now known as vexillation fortresses. It is assumed that the large area of ground was needed to accomodate the considerable number of troops in a *vexillatio*, or detachment, from a legion and perhaps also from auxiliary units (Frere and St Joseph, 1974, 6). A number of these fortresses, all but one of which are crop mark discoveries, are located in the north central part of England and the Welsh Borders. As

with the large camps, the plans of the vexillation fortresses have in most cases been recovered gradually, since their defences extend into several modern fields (Fig. 99).

At none of these vexillation fortresses have remains of buildings been seen from the air, though this need cause no surprise: during the excavation of the fortress at Longthorpe, Peterborough, Cambridgeshire, the positions of buildings were traceable only by wall trenches about 20-30 cm wide and 15-30 cm deep (Frere and St Joseph, 1974, 8). Such narrow trenches would be unlikely to cause crop marks.

In France, two large forts with areas of 15 or 16 ha, comparable with the British vexillation fortresses, have been recorded at Folleville, Somme, and Vendeuil-Caply, Oise (Agache, 1978, 232, 237). Soil and crop marks showed the double-ditched defences with *titula* outside the entrances.

Roads

Some dramatic illustrations of the way in which Roman roads cut across the landscape have been provided by photographs (Fig. 100), but in general the roads they show were already known. Aerial explor-

102. Warfusée-Abancourt, Somme. Gallo-Roman villa shown by white soil marks where deep ploughing had cut into the tops of buried walls. There are traces of two courtyards, the smaller of which, on the left of the photograph, is separated from the larger, on the right, by a small lodge. The principal residence was at the extreme left. The whole structure is 320 m long and outside it is the soil mark of an enclosing wall. Photograph by R. Agache, Service des Fouilles.

ation has played a part in the search for new lengths of roads, both in remote areas where the ancient road surface is little damaged and on cultivated land, but in general the discoveries have filled in gaps and recorded details, rather than making major changes to the map. Road metal may show as a light coloured soil mark, or may cause a negative crop mark, though these are less often seen than the positive marks formed on the ditches which were usually dug on both sides of the strip of land occupied by the road (Figs 17 and 100). Quarry pits dug to obtain road metal may also be found on both sides of a road, sometimes as earthworks, more often as positive crop marks.

Villas

The number of previously unknown villas which have been found from the air in England is not large in comparison with discoveries of other types of Roman sites. Useful information has, however, been obtained about the surroundings of villas, e.g. at Cromwell, Nottinghamshire, where there is a remarkable complex of crop marks (Fig. 25).

In France, on the other hand, the results are on a far greater scale and of a much more spectacular nature. In the north-eastern part of the country, the aerial exploration by R. Agache in Picardy has discovered hundreds of villas, which are well documented by his many publications. Many of the villas are of great size. Their sites show in three ways: by large dark patches, which are emphasised by damp marks (Fig. 101); by white soil marks where deep ploughing has brought to the surface parts of buried walls of chalk blocks or foundations of rammed chalk (Fig. 102); and by crop marks on the lines of similar walls or foundations. The dark patches appear to be caused by material from the disintegrated upper parts of buildings, which buried the lower parts and protected them from damage until the introduction of modern farm machinery.

Plans can often be made in considerable detail from the photographs, though Agache notes (1978, 259) that soil and crop marks are not formed by the remains of cob walls without chalk foundations, which have been found in some villa excavations. On villas shown by soil marks, the plans of the main building and various outbuildings were often obscured by spreads of chalky material from the floors of rooms

140

which were paved. Where the floor was made of rammed earth, as in many old-fashioned French rural buildings, the white soil marks of walls showed more clearly. Examples may be seen among the extensive buildings of the villa at Warfusée-Abancourt, Somme (Fig. 102).

There have been many other discoveries of villas, often also of great size, elsewhere in France, in West Germany (Scollar, 1965, pl. 26-35; Christlein and Braasch, 1982, pl. 47-52) and in Belgium (Léva, 1982, 251), and no doubt many more await discovery in Italy, Spain and other parts of Europe, provided that their remains have not been ploughed away.

Towns

When flying near the sites of Romano-British towns, the negative crop marks of their streets are sometimes so prominent that they can be seen from a considerable distance. The most notable examples include Silchester, Hampshire (Fig. 20), Caistor by Norwich, Norfolk, and Wroxeter, Shropshire. The streets at these sites were planned on a regular grid pattern, typical of the larger towns. In France similar crop marks occur, e.g. on the site of the Gallo-Roman town of Novioregnum at Barzan, Charente Maritime, on the shores of the Gironde (Dassié, 1978, 173).

The streets which make these noticeable marks were normally surfaced with gravel, and repeated repairs caused accumulations of road material, which, not surprisingly, now have an adverse effect on plants growing above, producing negative crop marks. At some towns, a positive mark down the centre of the roads indicates the soil filling of the central drains, as may be seen on Fig. 20. At Silchester, the marks of the streets 'in a sort of baulks that cross one another' were seen on the ground centuries ago, and were recorded in Gibson's edition of Camden's *Britannia*, published in 1695.

The negative marks seen on the Silchester photograph (Fig. 20) show much of the plan of the forum, which stands in an insula, or town block, bounded by roads. The walls of the rooms round three sides of an open square show well, but on the fourth side, where there was originally a basilica, or large hall, much less is visible. Excavation has found that the walls of the basilica were much robbed for building material (information from Dr M. Fulford). The few basilica walls which show are still present as footings below ground. Similar crop marks have provided remarkably detailed plans of buildings which cover much of the area of the town of Wroxeter (Wilson, 1984). At such sites most of the crop marks are negative, caused by stone-built foundations. Positive marks on the positions of former timber structures are much less often found, though Fig. 20 shows a rather indistinct dark mark in the courtyard of the Silchester forum, which may be the beam slot for one of the walls of an earlier building. It is therefore possible at that site to make a suggestion about an earlier phase, though in general little can be deduced from crop marks about the complicated building history of towns.

11
The Future

The aerial discoveries made in Britain and a few other countries have brought to light archaeological sites in numbers that would have amazed earlier archaeologists, but in many cases this great success in discovery and recording has not been accompanied by an equal emphasis on the study of the results.

Parts of a few countries in Western Europe have been examined quite thoroughly, but little has yet been done in the rest of the world. Even in Britain, where archaeological air photography began in the 1920s, there are still regions which have been given little attention. There is no doubt that aerial exploration would be very successful in many other countries if systematic flying and photography were begun, though time may be short in some regions because of the damage that is being done to early remains.

The equipment available for use by the air photographer is now very satisfactory in most respects, though progress will continue, and the simple methods with which this book has been mainly concerned will develop further. Unless much larger funds are made available for aerial research, it may be assumed that work will continue to be based on relatively inexpensive equipment, though in view of the advantages of vertical photography for the survey of large areas and hilly country, some extra spending is called for on apparatus for vertical surveys.

The advanced methods of remote sensing, which have only been mentioned very briefly, should be kept under review. At present they seem unlikely to supersede low-level photography, but developments in this field are rapid. The success of conventional methods of photography in the past should not prevent archaeologists from watching for signs that a change of tactics is necessary.

Flying offers great scope for individual initiative, and air photography owes much to a few dedicated people. They will surely have successors who will continue to give an impetus to aerial exploration, but because of the growing importance of team work and the need for more follow-up on the ground, the formation of small groups will be increasingly needed. The best work is likely to be done by well informed locally-based flying teams. Their survey areas should not be too large, because only small-scale maps and brief notes can be referred to in the air, and there are limits to the information which can be carried mentally.

The time spent in the air on reconnaissance and photography is only a small fraction of that required on the ground to work on the results. Important advances have taken place recently in the use of computers for mapping air photographs – both single obliques and runs of overlapping verticals. These better facilities should enable archaeologists trained in the use of air photographs to divert some of their time from routine mapping to the investigation of the sites that have been recorded.

The translation of the initial recording of sites as shapes drawn on maps to information in the sites and monuments records of archaeological organisations is beginning to receive more attention, and the potential of computers is being looked at in this area. Some difficult questions are involved here. The information must be stored in such a way that it can easily be tapped for further study, but most of the great numbers of complicated shapes recorded on maps are difficult to describe concisely by words or any other symbols. Some means may perhaps be found to store the information in graphical form and then interrogate the computer graphically.

The main purposes for which information is needed are the control of the progress of the aerial work itself, the study of individual sites and groups of sites in coordination with data from other sources, and the

study of the ancient landscape as a whole. Aided by systematic work of this kind, it should be possible to draw conclusions from many years of work both in the air and on the ground. Longer-term objectives must include the publication of more work that draws these results together, making them more easily available and better known both to scholars and to the informed public.

Bibliography

Adams, R.E.W., 1980. 'Swamps, canals and the location of ancient Maya cities', *Antiquity*, 54, 206-14.

Adams, R. McC., 1981. *Heartland of Cities*. University of Chicago Press.

Agache, R., 1963. 'Détection des fossés comblés sur terrains sans végétation grâce à l'humidité rémanente des remblais', *Bulletin de la Société Préhistorique Française*, 60, 642-7.

— 1970. *Détection aérienne de vestiges protohistoriques, gallo-romains et médiévaux*. Société de Préhistoire du Nord, Amiens.

— 1978. *La Somme pré-romaine et romaine*. Société des Antiquaires de Picardie, Amiens.

— 1982. 'Nouvelles orientations de recherches en archéologie aérienne dans le nord de la France', in Léva (ed.) *Photographie aérienne et prospection géophysique en archéologie*, 23-35. C.I.R.A., Brussels.

Agache, R. and Bréart, B., 1975. *Atlas d'archéologie aérienne de Picardie*. Société des Antiquaires de Picardie, Amiens.

Allen, G.W.G., 1984. 'Discovery from the air' (ed. J.S.P. Bradford and O.G.S. Crawford), *Aerial Archaeology*, 10.

Allen, J., 1980. 'Lift off', *Popular Archaeology*, Sept. 1980, 25-7.

Anderson, R.C., 1979. 'A kite-supported system for remote aerial photography', *Aerial Archaeology*, 4, 4-7.

Atkinson, R.J.C., Piggott, C.M. and Sandars, N.K., 1951. *Excavations at Dorchester, Oxon*. Ashmolean Museum, Oxford.

Baker, W.A., 1975. 'Infra-red techniques', in Wilson (ed.), *Aerial Reconnaissance for Archaeology*, 46-51. C.B.A. Research Report, 12.

Baradez, J., 1949. *Vue aérienne de l'organisation romaine dans le Sud-Algérien: fossatum Africae*. Editions Arts et Métiers Graphiques, Paris.

Beazeley, G.A., 1919, 'Air photography in archaeology', *Geog. Journ.*. 53, 330-5.

— 1920. 'Surveys in Mesopotamia during the war', *Geog. Journ.* 55, 109-27.

Benson, D. and Miles, D., 1974. *The Upper Thames Valley: an archaeological survey of the river gravels*. Oxfordshire Arch. Unit Survey 2.

Beresford, M.W. and St Joseph, J.K.S., 1979. *Medieval England: an aerial survey*. 2nd ed. Cambridge University Press.

Betts, A.V.G., 1983. 'Black desert survey, Jordan: first preliminary report', *Levant*, 15, 1-10.

Birch, N.H. and Bramson, A.E., 1984. *Flight Briefing for Pilots*, vol. 4. Pitman, London.

Bowen, H.C., 1961. *Ancient Fields*. British Association, London.

— 1978. 'Celtic fields and ranch boundaries in Wessex', in Limbrey and Evans (eds), *The Effect of Man on the Landscape – the Lowland Zone*, 115-23. C.B.A. Research Report 21.

Braasch, O., 1983. *Luftbildarchäologie in Süddeutschland*. Gesellschaft für Vor-und Frügeschichte in Württemberg und Hohenzollern.

Bradford, J., 1957. *Ancient Landscapes*. Bell, London.

Bradford, J. and Morris, J.M., 1941. 'Archaeological notes', *Oxoniensia*, 6, 84-9.

Bradley, R., 1984. 'Radley, Barrow Hills – the neolithic monuments', *South Midlands Archaeology*, 14, 113-17.

Bradley, R. and Richards, J., 1978. 'Prehistoric fields and boundaries on the Berkshire Downs', in Bowen and Fowler (eds), *Early Land Allotment*, 53-60. British Arch. Repts. 48.

Bray, W., Herrera, L. and Schrimpff, M.C., 1983. 'Report on the 1981 field season in Calima', *Pro Calima*, Basel, 3, 2-31.

Brimer, B., 1981. 'Shivta – an aerial photographic interpretation', *Israel Exploration Journal*, 31, 227-9.

Brongers, J.A., 1976. *Air Photography and Celtic Field Research in the Netherlands*. R.O.B., Amersfoort.

Burnside, C.D. et al., 1983. 'A digital single photograph technique for archaeological mapping and its application to map revision', *Photogrammetric Record*, 11, 59-68.

Caillemer, A. and Chevallier, R., 1954. *Atlas des centuriations romaines de Tunisie*. I.G.N., Paris.

Cătăniciu, I.B., 1981. *Evolution of the System of Defence Works in Roman Dacia*. British. Arch. Repts. International Series 116.

Christlein, R., and Braasch, O., 1982. *Das Unterirdische Bayern: 7000 Jahre Geschichte und Archäologie im Luftbild*. Konrad Theiss, Stuttgart.

Crawford, O.G.S., 1924. *Air Survey and Archaeology*. O.S. Professional Papers, New Series no. 7.

— 1934. 'The mile ditches at Royston', *Antiquity*, 8, 216-18.

— 1954. 'A century of air photography', *Antiquity*, 28, 206-10.

Crawford, O.G.S. and Keiller, A., 1928. *Wessex from the Air*. Oxford University Press.

Curran, P.J., 1985. *Principles of Remote Sensing*. Longman, London and New York.

Darch, J.P. (ed.), 1983. *Drained Field Agriculture in Central and South America*. British Arch. Repts. International Series 189.

Dassié, J., 1978. *Manuel d'archéologie aérienne*. Editions Technip, Paris.

Deuel, L., 1971. *Flights into Yesterday*. Macdonald, London.

Dilke, O.A.W., 1971. *The Roman Land Surveyors: an introduction to the Agrimensores*. David and Charles, Newton Abbott.

Downey, R.R., forthcoming. 'A history of archaeological air photography in Great Britain', *Aerial Archaeology*, 13.

Ebert, J.I. and Lyons, T.R., 1980. 'Prehistoric irrigation canals identified from Skylab III and Landsat imagery in Phoenix, Arizona', in Lyons and Mathien (eds), *Cultural Resources Remote Sensing*, 209-28, National Park Service, Washington, D.C.

Ebert, J.I. et al., 1980. 'Remote sensing in large scale cultural resources survey: a case study from the Arctic', in Lyons and Mathien (eds) *Cultural Resources Remote Sensing*, 7-54, National Park Service, Washington, D.C.

Egloff, M., 1981. 'Versunkene Dörfer der Urnenfelderzeit im Neuenburger See', *Archäologisches Korrespondenzblatt*, Mainz, 11, 55-63.

Evans, R., 1972. 'Air photographs for soil survey in Lowland England: soil patterns', *Photogrammetric Record*, 7, 302-22.

Evenari, M., Shanan, L. and Tadmor, N., 1971. *The Negev: the challenge of a desert*. Harvard University Press.

Fleming, A., 1983. 'The prehistoric landscape of Dartmoor, part 2', *Proc. Prehist. Soc.*, 49, 195-242.

Ford, W.J., 1971. Preliminary report in *Archaeological Excavations 1970*. Department of the Environment.

Fowler, M.L., 1977. 'Aerial archaeology at the Cahokia site', in Lyons and Hitchcock (eds) *Aerial Remote Sensing Techniques in Archaeology*, 65-80. National Park Service, Washington, D.C.

Frere, S.S. and St. Joseph, J.K., 1974. 'The Roman fortress at Longthorpe', *Britannia*, 5, 1-129.

— 1983. *Roman Britain from the Air*. Cambridge University Press.

Gates, T., 1975. *The Middle Thames Valley: an archaeological survey of the river gravels*. Berkshire Arch. Cttee. Publications 1.

Grady, J., 1980. *Environmental Factors in Archaeological Site Locations*. Colorado Bureau of Land Management, Cultural Resources Series 9.

Gregory, S. and Kennedy, D.L., 1985. *Sir Aurel Stein's Limes Report*. British Arch. Repts. International Series 272.

Grimes, W.F., 1943-4. 'Excavations at Stanton Harcourt, Oxon., 1940', *Oxoniensia*, 8-9, 19-63.

Grinsell, L.V., 1941. 'The bronze age round barrows of Wessex', *Proc. Prehist. Soct.* 7, 73-113.

Haigh, J.G.B., 1983. 'Practical methods for the rectification of oblique aerial photographs', in Aspinall and Warren (eds), *Proceedings of the 22nd Symposium on Archaeometry*, 1-10. University of Bradford.

Hampton, J.N., 1974. 'An experiment in multispectral air photography for archaeological research', *Photogrammetric Record*, 8, 37-64.

Hampton, J.N., and Palmer, R., 1977. 'Implications of aerial photography for archaeology', *Archaeol. Journ.*, 134, 157-93.

Harding, A.F., 1981. 'Excavations in the prehistoric ritual complex near Milfield, Northumberland', *Proc. Prehist. Soc.*, 47, 87-136.

Hedges, J.D. and Buckley, D.G., 1981. *Springfield Cursus and the Cursus Problem*. Occasional Paper no. 1, Essex C.C.

Hingley, R. 1979. 'The Upper Thames Valley survey', *Annual Rept. of the Oxfordshire Archaeological Unit*, 1979, 141-2.

Hingley, R. and Miles, D., 1984. 'Aspects of iron age settlement in the Upper Thames Valley', in Cunliffe and Miles (eds), *Aspects of the Iron Age in Central and Southern Britain*, 52-71. Oxford Cttee. for Archaeology. Monograph 2.

Hogg, A.H.A., 1938. 'Preliminary report on the excavation of a long barrow at West Rudham, Norfolk', *Proc. Prehist. Soc.*, 4, 334-6.

Holleyman, G.A., 1948. Letter to *Archaeological Newsletter*, no. 8.

Jobey, G., 1966. 'Excavations on palisaded settlements and cairnfields at Alnham, Northumberland: Part 1, palisaded settlements', *Archaeologia Aeliana*, 4th series, 44, 5-23.

Johnson, N.D., 1983. 'The results of air and ground survey of Bodmin Moor, Cornwall', in Maxwell (ed.), *The Impact of Aerial Reconnaissance on Archaeology*, 5-13. C.B.A. Research Rept. 49.

Jones, M.U., 1979. 'Mucking, Essex: the reality beneath the crop marks', *Aerial Archaeology*, 4, 65-76.

Jones, R.J.A. and Evans, R., 1975. 'Soil and crop marks in the recognition of archaeological sites by air photography', in Wilson (ed.), *Aerial Reconnaissance for Archaeology*, 1-11. C.B.A. Research Report 12.

Kedar, Y., 1967. *The Ancient Agriculture in the Negev Mountains* (in Hebrew). Bialik Institute, Jerusalem.

Kilford, W.K., 1979. *Elementary Air Survey*, 4th ed. Pitman, London.

Krahe, G., 1982. 'Archéologie aérienne en motoplaneur', in Léva (ed.), *Photographie aérienne et prospection géophysique en archéologie*, 197-210. C.I.R.A., Brussels.

Leech, R., 1977. *The Upper Thames Valley in Gloucestershire and Wiltshire: an archaeological survey of the river gravels*. C.R.A.A.G.S. Survey 4.

Léva, C., 1982. 'Recherches d'archéologie aérienne en Belgique', in Léva (ed.), *Photographie aérienne et prospection géophysique en archéologie*, 229-54.

C.I.R.A., Brussels.

Loveday, R. and Petchey, M., 1982. 'Oblong ditches, some new evidence and a discussion', *Aerial Archaeology*, 8, 17-24.

Macinnes, L., 1982. 'Pattern and purpose: the settlement evidence', in Harding (ed.), *Later Prehistoric Settlement in South East Scotland*. 57-73. Dept of Archaeology, University of Edinburgh.

Marsac, M., Riley, D.N. and Scarre, C., 1982. 'Recent discoveries of possible neolithic long mounds in Western France and their British parallels', *Aerial Archaeology*, 8, 1-16.

Maxwell, G.S., 1978. 'Air photography and the work of the Royal Commission on the Ancient and Historical Monuments of Scotland', *Aerial Archaeology*, 2, 37-44.

— 1982. 'Roman temporary camps at Inchtuthil: an examination of aerial photographic evidence', *Scottish Archaeological Review*, 1, 105-13.

May, J., 1970. 'An iron age square enclosure at Aston on Trent, Derbyshire: a report on excavations in 1967', *Derbyshire Archaeol. Journ.*, 90, 10-21.

Miller, P., 1979. 'Aerial photography from radio controlled model aircraft', *Aerial Archaeology*, 4, 11-15.

Mortimer, J.R., 1895. 'The origin of some lines of small pits on Allerton and Ebberston Moors near Scamridge Dikes in the neighbourhood of Scarborough', *Archaeol. Journ.*, 52, 266-70.

Mouterde, R. and Poidebard, A., 1945. *Le limes de Chalcis: organisation de la steppe en Haute Syrie romaine: documents aériens et épigraphiques*. Geuthner, Paris.

Palmer, R., 1976. 'Interrupted ditch enclosures in Britain: the use of aerial photography for comparative studies', *Proc. Prehist. Soc.*, 42, 161-86.

— 1977. 'A computer method for transcribing information graphically from oblique aerial photographs to maps', *Journ. Archaeol. Science*, 4, 283-90.

— 1983. 'Analysis of settlement features in the landscape of prehistoric Wessex', in Maxwell (ed.), *The Impact of Aerial Reconnaissance on Archaeology*, 41-53. C.B.A. Research Report 49.

— 1984. *Danebury, an Iron Age Hillfort in Hampshire: an aerial photographic interpretation of its environs*. R.C.H.M. Supplementary Series 6.

Phillips, C.W., 1935a. 'A re-examination of the Therfield Heath long barrow, Royston, Hertfordshire', *Proc. Prehist. Soc.*. 1, 101-7.

— 1935b. 'The excavation of the Giants' Hills long barrow, Skendleby, Lincs'., *Archaeologia*, 85, 37-106.

Phillips, C.W. (ed.), 1970. *The Fenland in Roman Times*. Royal Geographical Soc., London.

Poidebard, A., 1934. *La trace de Rome dans le désert de Syrie: le limes de Trajan à la conquête arabe: recherches aériennes (1925-1932)*. Geuthner, Paris.

Raistrick, A., 1938. 'Prehistoric cultivations at Grassington, West Yorkshire', *Yorkshire Archaeol. Journ.*, 33, 166-74.

Reaney, D., 1968. 'Beaker burials in South Derbyshire', *Derbyshire Archaeol. Journ.*, 88, 68-81.

Richmond, I.A., 1940. 'The Romans in Redesdale', in Dodds (ed.), *History of Northumberland*, 15, 63-154. Reid, Newcastle.

— 1962. 'The Roman siege works of Masada, Israel', *Journ. Roman Studies* 52, 142-55.

Riley, D.N., 1946. 'The technique of air archaeology', *Archaeol. Journ.*, 101, 1-16.

— 1980a. *Early Landscape from the Air*. Dept. of Prehistory and Archaeology, University of Sheffield.

— 1980b. 'Recent air photographs of Duggleby Howe and the Ferrybridge henge', *Yorkshire Archaeol. Journ.*, 52, 174-8.

— 1982. 'Antiquities recorded by old photographs taken by the Royal Air Force of the desert near Azraq Duruz', in Kennedy, *Archaeological Explorations on the Roman Frontier in North East Jordan*, 345-55. British Arch. Repts. International Series 134.

— 1983. 'The frequency of occurrence of crop marks in relation to soils', in Maxwell (ed.), *The Impact of Aerial Reconnaissance on Archaeology*, 59-73. C.B.A. Research Report 49.

Riley, D.N. et al., 1985. 'The mapping of archaeological evidence from air photographs', *Aerial Archaeology*, 11, 1-30.

RCHME (Royal Commission on Historical Monuments, England) 1970. *County of Dorset, 3, Central Dorset*.

— 1975. *County of Dorset, 5, East Dorset*.

— 1979. *Stonehenge and its Environs*.

St Joseph, J.K., 1965. 'Air reconnaissance in Britain, 1961-4', *Journ. Roman Studies*, 55, 74-89.

— 1969. 'Air reconnaissance in Britain, 1965-8', *Journ. Roman Studies*, 59, 104-28.

— 1973. 'Air reconnaissance in Roman Britain, 1969-72', *Journ. Roman Studies*, 63, 214-46.

Scarre, C., 1984. 'A century of research on the Peu-Richardien', *Antiquity*, 58, 15-24.

Schmidt, E.F., 1940. *Flights over Ancient Cities of Iran*. University of Chicago Press.

Schmiedt, G., 1970. *Atlante aerofotografico delle sedi umane in Italia. Vol. 2, Le sedi antiche scomparse*. Istituto Geografico Militare, Firenze.

Schoder, R.V., 1974. *Ancient Greece from the Air*. Thames and Hudson, London.

Schorr, T.S., 1974. 'A bibliography with historical sketch', in Vogt (ed.), *Aerial Photography in Anthropological Field Research*, 163-88. Harvard University Press.

Scollar, I., 1965. *Archäologie aus der Luft*. Rheinland Verlag, Dusseldorf.

— 1978. 'Computer image processing for archaeological air photographs', *World Archaeology*, 10, 71-87.

Segal, A., 1983. *The Byzantine City of Shivta (Esbeita), Negev Desert, Israel*. British Arch. Repts. International Series 179.

Siemens, A.H. and Puleston, D.E., 1972. 'Ridged fields and associated features in Southern Campeche: new perspectives on the lowland Maya', *American Antiquity*, 37, 228-39.

Spratt, D.A., 1982. *Prehistoric and Roman Archaeology of*

North-East Yorkshire, British Arch. Repts. British Series 104.

Stead, I.M., 1979. *The Arras Culture*. Yorkshire Philosophical Soc., York.

Stein, Sir A., 1919. 'Air photography of ancient sites', *Geog. Journ.*, 54, 200.

Stevens, C.E., 1958. 'African cornfields: a review', *Antiquity*, 32, 25-9.

Thomas, R. and Wallis, J., 1981. 'The Drayton cursus', *Oxfordshire Archaeol. Unit Annual Report*, 184-91.

Vatcher, F. de M., 1961. 'The excavation of the long mortuary enclosure on Normanton Down, Wilts.', *Proc. Prehist. Soc.*, 27, 160-73.

Vogt, E.Z. (ed.), 1974. *Aerial Photography in Anthropological Field Research*. Harvard University Press.

Ward-Perkins, J.B., 1974. *Cities of Ancient Greece and Italy: planning in classical antiquity*. Sidgwick and Jackson, London.

Webster, G. and Hobley, B., 1965. 'Aerial reconnaissance over the Warwickshire Avon', *Archaeol. Journ.*, 121, 1-22.

Whimster, R.P., 1981. *Burial Practices in Iron Age Britain.*

British Arch. Repts. British Series 90.

Whittlesey, J.H., Myers, J.W. and Allen, C.C., 1977. 'The Whittlesey Foundation 1976 field season', *Journ. of Field Archaeology*, 4, 181-96.

Williams, A., 1946-7. 'Excavations at Langford Downs, Oxon.', *Oxoniensia*, 11-12, 44-64.

Wilson, D.R., 1975. 'Photographic techniques in the air', in Wilson (ed.), *Aerial Reconnaissance for Archaeology*, 12-31. C.B.A. Research Report 12.

— 1982a. *Air Photo Interpretation for Archaeologists*. Batsford, London.

— 1982b. 'Deployment of Roman troops in Britain as revealed by air photography', in Léva (ed.), *Photographie aérienne et prospection géophysique en archéologie*, 303-20. C.I.R.A., Brussels.

— 1984. 'The plan of Viroconium Cornoviorum', *Antiquity*, 58, 117-20.

Wolf, P.R., 1974. *Elements of Photogrammetry*. MacGraw-Hill, New York.

Woodcock, W.E., 1976. 'Aerial reconnaissance and photogrammetry with small cameras', *Photogrammetric Engineering and Remote Sensing*, 42, 503-11.

Index